Sketching Men

HOW TO DRAW LIFELIKE MALE FIGURES
A COMPLETE COURSE FOR BEGINNERS

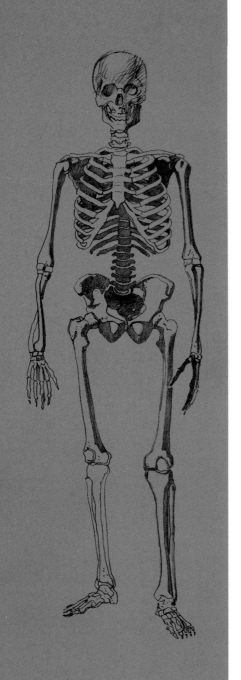

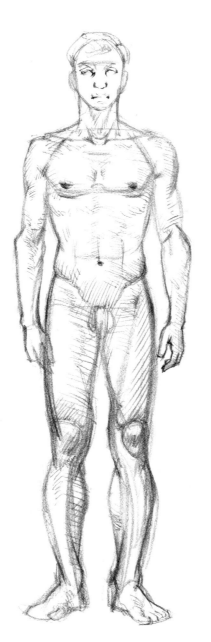

Koichi Hagawa

**Edited by
Tsubura Kadomaru**

TUTTLE Publishing
Tokyo | Rutland, Vermont | Singapore

Table of Contents

Learning to Sketch a Person Quickly

This book explains various methods for sketching a man. A kinetic pose that can only be held for an instant, or a cool movement that can be seen in a sports scenario and so on are suited to drawing quickly in one go, so that the moment is not lost.

Although such sketches should be rendered in lines with a sense of speed, if the lines are irregular, the accuracy of the drawing is lacking. Learn the standard rules for drawing the human figure, and master the skills needed for efficient sketching in a short amount of time.

> *Whether or not you look at a model when drawing isn't the key issue. What's important is that you draw a picture that meets your objectives!*

Goal 1

We'll start by focusing on drawing an idealized male form, and from there go on to the depiction of various morphologies, as well as learning how to deal with simplified expressions.

> *The real objective is to sketch a dynamic, realistic person. That's all!*

> *Even if you are using reference photos, you should feel free to alter the form to suit your personal aesthetic!*

Goal 2

I will propose several techniques for quickly drawing a human figure that suits your purposes. I'll also discuss artistic concepts and highlight some specific drawing practices.

An Example of a Traced Drawing | **An Example of a Line Drawing** | **An Example of a Tonal Drawing**

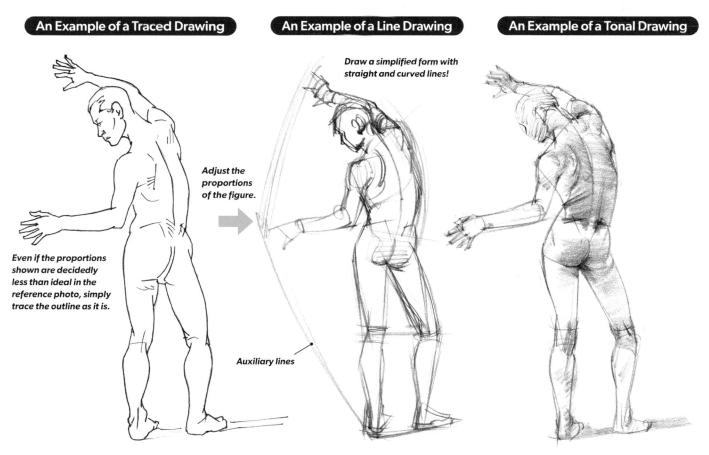

Draw a simplified form with straight and curved lines!

Adjust the proportions of the figure.

Even if the proportions shown are decidedly less than ideal in the reference photo, simply trace the outline as it is.

Auxiliary lines

▲ An example of a tracing from a reference photo. Even if the contours are accurate, the dynamic quality of the body doesn't come through in the drawing.

▲ An example of a quick sketch where the basic structure of the body is captured with as few lines as possible. Aim to spend 1 to 3 minutes for this type of sketch.

▲ An example where tones (shading) have been added to a figure drawn with simple lines. The focus is on the hip area, to create a form that suggests more movement. Aim to spend 7 to 10 minutes on this type of sketch.

Aim to Create Quick, Simplified Drawings in a Short Amount of Time

Point 1

"Traced drawings" of reference photos are shown next to drawings for the sake of comparison. Please compare and study the "traced drawings," "line drawings" and "tonal drawings."

- Which parts have been changed into simplified forms?
- What are the key points of the human figure?
- Hints for what to emphasize and what to abbreviate, and how to find them.

The example works in this book have been created using reference photos of professional models. As you will see, even if the original pose is beautiful, it's hard to express its attractiveness if you use a monotonous line as in the "traced drawings."

Point 2

The objective of each work is explained with "line drawings" and "tonal drawings."

- Capture the powerful life force that can be observed in the pose of a human figure with very simple "line drawings" executed in a short period of time. (This is a practice method called gesture drawing. See page 6.)
- In "tonal drawings," light and dark and strong and weak nuances are added with shades following the form.

1. The sense of volume of the body
2. The relative positions of the parts of the body
3. Depict three dimensionality and space with light and shadow
4. Depict texture

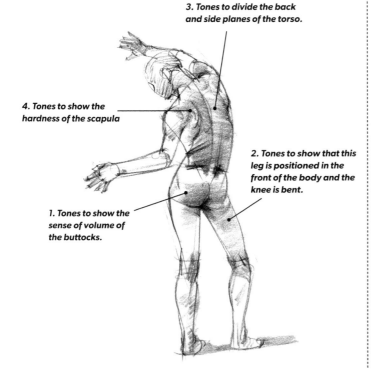

3. Tones to divide the back and side planes of the torso.

4. Tones to show the hardness of the scapula

2. Tones to show that this leg is positioned in the front of the body and the knee is bent.

1. Tones to show the sense of volume of the buttocks.

Point 3

Draw at least 3 to 4 sketches of the same pose. Just use a fresh sheet of paper on top of the previous one to start a new sketch. You can compare the sketch you're working on with the previous one to see how you have changed your objectives.

From rough sketches of the body's construction to line drawings to tonal drawings, execute several sketches while changing your objectives.

1 An example of a "tonal drawing" of a standing pose. Do the next drawing with fewer lines.

2 Put a blank piece of paper on top of the previous drawing to get ready. B4 size (9.8 x 13.9 inches/250 x 353 mm—a bit wider than U.S. legal size paper) copier paper, which is easy to move your hand around on, has been used. If the drawing isn't going well, it's better to just put on another piece of paper and start again, than trying to erase and correct.

3 Use the shape of the previous drawing that you can see through the paper as a guide for drawing. Correct the parts that were bothering you in the previous sketch in the new one. You can add a thick, soft tone by holding the pencil on its side to draw.

1

Drawing the Human Figure Quickly

This chapter introduces you to the quick sketching techniques and various tips for capturing the human figure that are used in this book. The ratios of the human body are especially important basics. The basic proportions of the front, three-quarters, side and back views of the human figure, how to draw each shape, and the parts of the body that are handy to memorize, as well as its focal points, are explained. Particular attention is paid to drawing the back, which has many attractive concave and convex areas.

The Merits of Quick Sketching

1) Gesture Drawing is Well-suited to Time-limited Sketching

Gesture drawing is a drawing method where the overall human figure is roughly captured in a short amount of time. It's a popular method for drawing a figure in motion. It's a way of sketching the overall form with free and relaxed lines, and it's ideal for quickly capturing a pose. The "gesture" in gesture drawing refers to the movements and position of the model. Even if the model is simply standing still, the figure nonetheless has the "movement" of balancing itself on two legs. And of course, gesture drawing is ideal for sketching strenuous poses that can only be held for a very short amount of time.

Drawing with purpose

The overall objective of a gesture drawing is to simplify the construction of the figure, and to get used to depicting the human figure through a set of fixed rules. Gesture drawing, where a variety of poses are drawn in quick succession, is a convenient method for warming up for a detailed drawing, or for laying down the *guidelines** for a difficult pose. Rather than just drawing aimlessly, try to grasp the flow of the movement and position in order to capture a really lively pose. Not only will this be good practice for drawing the dynamic poses you see in sports and the like, it also gives you the ability to draw a quick sketch to explain "I saw a person doing this" to someone.

****Guidelines:** *Temporary indicator marks and lines made at the start of a drawing*

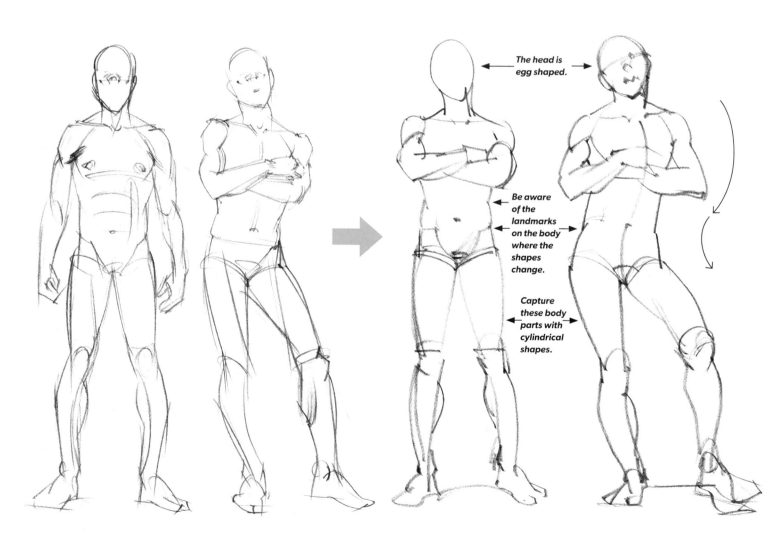

The head is egg shaped.

Be aware of the landmarks on the body where the shapes change.

Capture these body parts with cylindrical shapes.

▲ A quick line drawing using curved and straight lines, using a reference photo.

▲ Example drawings where the shapes are really simplified, and the movement and flow of the body are explored. The left pose—where the weight of the body is supported by both legs—is more stable, while the one on the right—where the weight is on the right leg—shows a more graceful form.

Begin by capturing the major gestures

Start the drawing by creating the large, even exaggerated, movements. Boldly indicate the direction and momentum of the movement. It's difficult to add large movements to the drawing of a pose with minor adjustments after the fact, but if you can capture the flow of the movement at the outset, it's surprisingly easy to make adjustments to the parts of the body.

Focus on the whole, and don't worry about the details!

Repeatedly execute quick, time-limited drawings while aiming to depict a well-balanced pose. In order to get used to drawing the human form, start practicing by omitting the small details, such as the facial features. If you need to indicate the direction or angle of the head, you can indicate the positions of the eyes and nose.

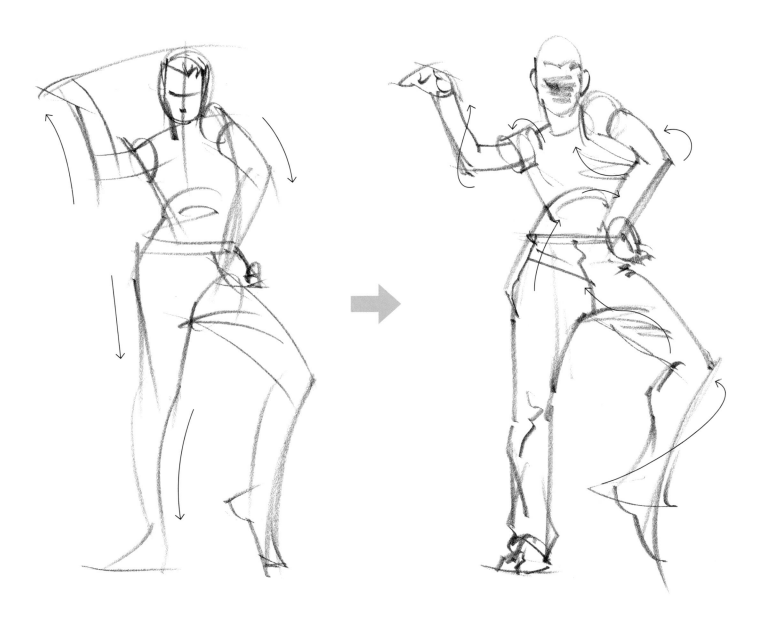

▲ A sketch where the large overall movements are captured with strong, taut lines. The lines add liveliness to this dance-like pose.

▲ An example of a drawing that was started by putting a fresh sheet of paper on top of a previous sketch. The characteristics of the pose have been emphasized so that the momentum of the movement is not lost. The folds of the clothes and so on have been suggested while the shape of the figure has been adjusted.

2) Capture the Form Through "Stretching" and "Shortening"

Gesture Drawing Practice

It's a good idea to work from reference photos when practicing the basics of gesture drawing. It's difficult at first to capture a pose just from your imagination, so start by observing. What should you observe? Don't just pay attention to the shape of the form; pay attention to which parts are "stretched" and which parts are "shortened" when looking at the pose.

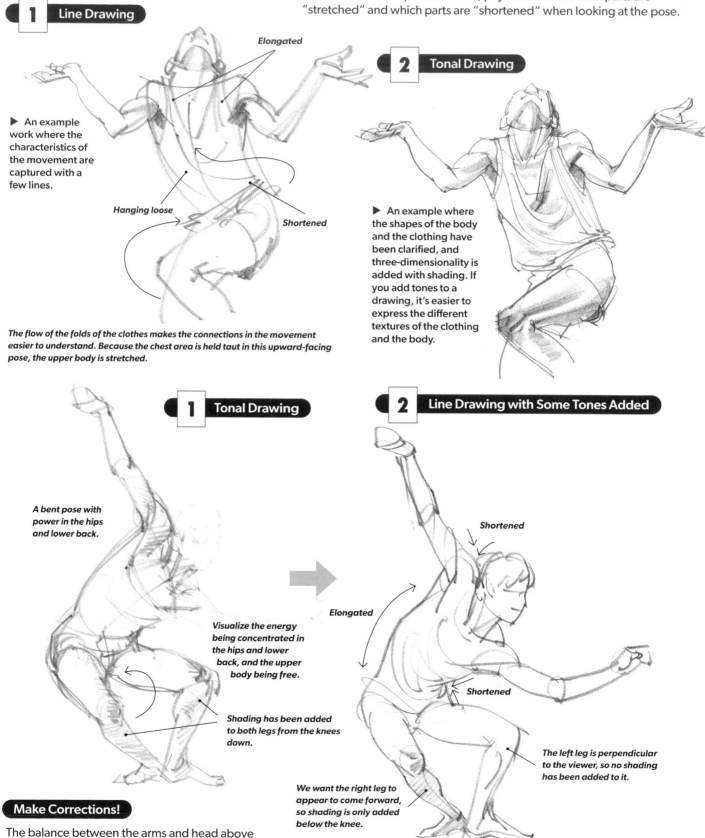

1 Line Drawing

Elongated

▶ An example work where the characteristics of the movement are captured with a few lines.

Hanging loose

Shortened

The flow of the folds of the clothes makes the connections in the movement easier to understand. Because the chest area is held taut in this upward-facing pose, the upper body is stretched.

2 Tonal Drawing

▶ An example where the shapes of the body and the clothing have been clarified, and three-dimensionality is added with shading. If you add tones to a drawing, it's easier to express the different textures of the clothing and the body.

1 Tonal Drawing

A bent pose with power in the hips and lower back.

Visualize the energy being concentrated in the hips and lower back, and the upper body being free.

Shading has been added to both legs from the knees down.

Make Corrections!

The balance between the arms and head above were bothersome. So, I erased those parts, put on a new sheet of paper, and tried drawing again.

2 Line Drawing with Some Tones Added

Shortened

Elongated

Shortened

The left leg is perpendicular to the viewer, so no shading has been added to it.

We want the right leg to appear to come forward, so shading is only added below the knee.

Because this is a stable pose with a low center of gravity, the dynamic movement of the upper body becomes possible. Pay attention to the "stretching" and "shortening" of the upper body, and draw the movement rapidly.

Gesture Drawing Steps Part 1

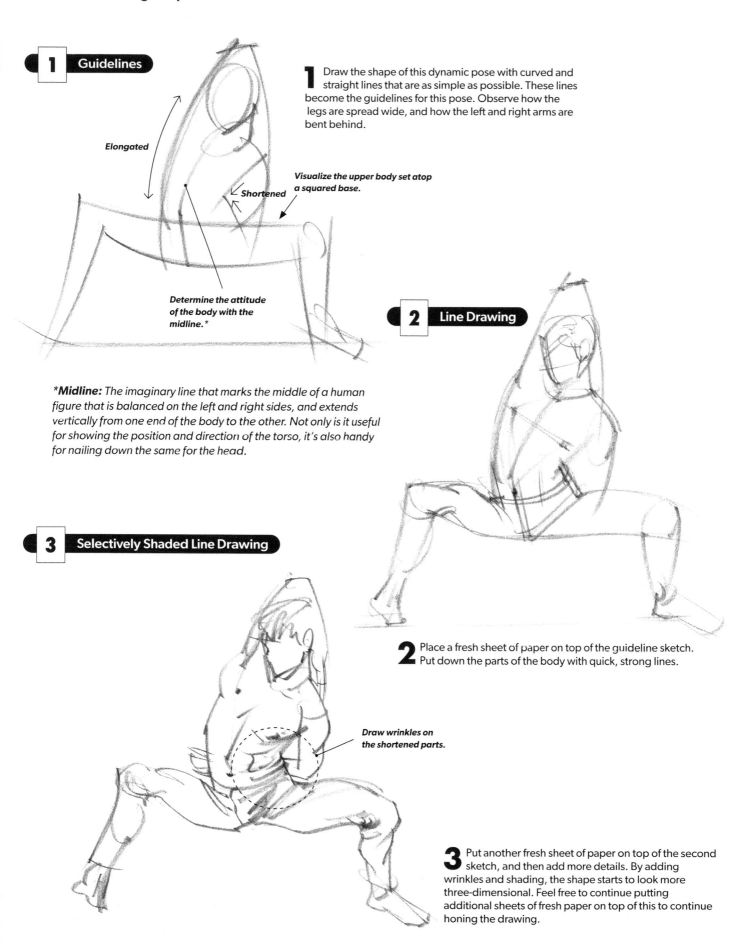

1 **Guidelines**

Elongated

Shortened

Visualize the upper body set atop a squared base.

*Determine the attitude of the body with the midline.**

1 Draw the shape of this dynamic pose with curved and straight lines that are as simple as possible. These lines become the guidelines for this pose. Observe how the legs are spread wide, and how the left and right arms are bent behind.

****Midline:** *The imaginary line that marks the middle of a human figure that is balanced on the left and right sides, and extends vertically from one end of the body to the other. Not only is it useful for showing the position and direction of the torso, it's also handy for nailing down the same for the head.*

2 **Line Drawing**

3 **Selectively Shaded Line Drawing**

2 Place a fresh sheet of paper on top of the guideline sketch. Put down the parts of the body with quick, strong lines.

Draw wrinkles on the shortened parts.

3 Put another fresh sheet of paper on top of the second sketch, and then add more details. By adding wrinkles and shading, the shape starts to look more three-dimensional. Feel free to continue putting additional sheets of fresh paper on top of this to continue honing the drawing.

Gesture Drawing Steps Part 2

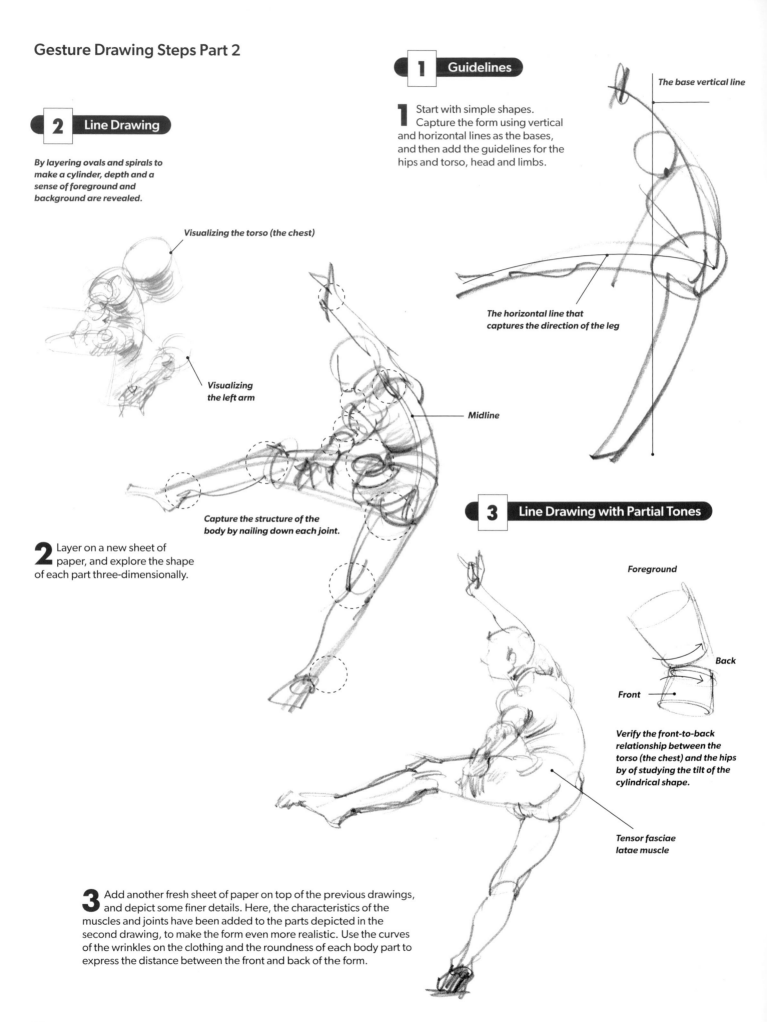

1 Start with simple shapes. Capture the form using vertical and horizontal lines as the bases, and then add the guidelines for the hips and torso, head and limbs.

The base vertical line

The horizontal line that captures the direction of the leg

2 Line Drawing

By layering ovals and spirals to make a cylinder, depth and a sense of foreground and background are revealed.

Visualizing the torso (the chest)

Visualizing the left arm

Midline

Capture the structure of the body by nailing down each joint.

2 Layer on a new sheet of paper, and explore the shape of each part three-dimensionally.

3 Line Drawing with Partial Tones

Foreground

Back

Front

Verify the front-to-back relationship between the torso (the chest) and the hips by of studying the tilt of the cylindrical shape.

Tensor fasciae latae muscle

3 Add another fresh sheet of paper on top of the previous drawings, and depict some finer details. Here, the characteristics of the muscles and joints have been added to the parts depicted in the second drawing, to make the form even more realistic. Use the curves of the wrinkles on the clothing and the roundness of each body part to express the distance between the front and back of the form.

3) Include the Essential Elements

See the Positive and Negative Shapes

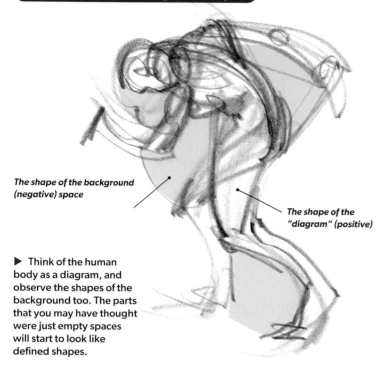

The shape of the background (negative) space

The shape of the "diagram" (positive)

▶ Think of the human body as a diagram, and observe the shapes of the background too. The parts that you may have thought were just empty spaces will start to look like defined shapes.

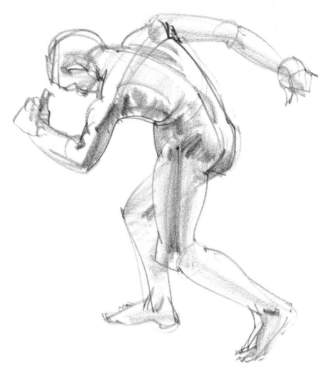

▲ Pay attention to the shapes made in the background space by the gaps between the limbs and the torso and so on, and try to create shapes with a sense of tension. The relationship between the object (the figure) and the background are also called positive vs. negative, and both are important elements that support the beauty of the form (see page 32).

Think in Terms of Cylinders

Use wrinkles that are like spirals wrapped around a cylinder, to express a feeling of rising motion!

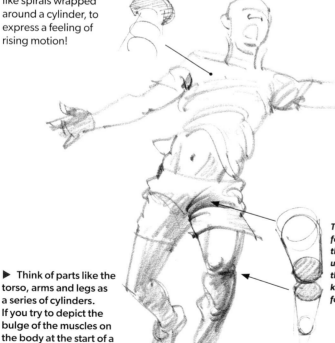

The wrinkles that form on the base of the cylinder of the upper leg reinforce the feeling that the knee is coming forward.

▶ Think of parts like the torso, arms and legs as a series of cylinders. If you try to depict the bulge of the muscles on the body at the start of a drawing, it becomes difficult to understand the overall balance of the figure. Instead, try to capture the relative positions of each part as simple shapes at the beginning.

Capture the Opposing Pairs

▲ Make sure the bulges of each body part are not symmetrical! If you draw the curves on both sides alternately, the natural rhythm of the form becomes apparent.

4) Capture the Vitality of the Figure with "Undulation" and "Weight"

Analyze an upstretched movement

Whether you stand or sit on the ground, your posture and movements are affected by gravity. When depicting a pose where the subject is standing on both legs, you can show the strength of rising upward against the pull of gravity. It's an "undulating" motion, rather like a plant that grows upward.

Drawing a pose with strong movement where the hips of the figure are low and the body has a sense of stability is meaningful too. Observe which part is bearing the weight of the body, and depict a human figure full of vitality.

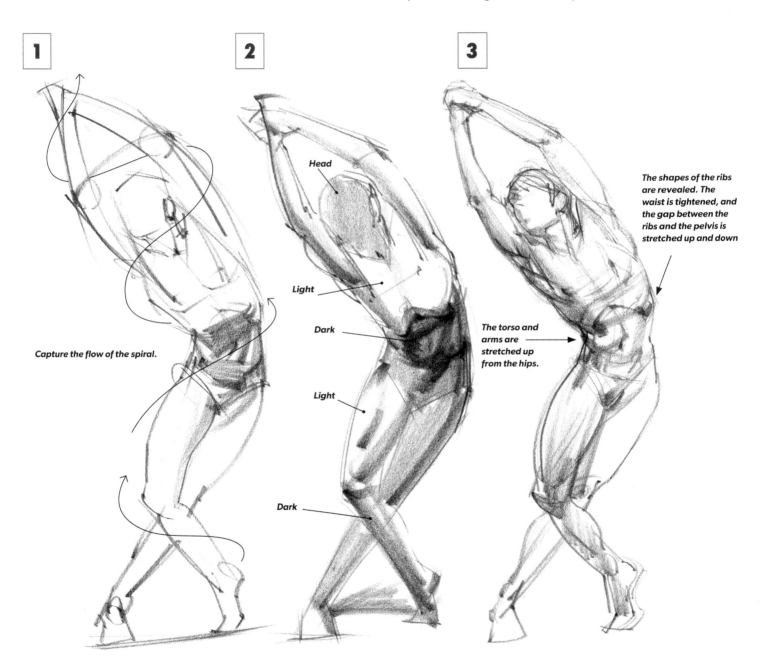

1

Capture the flow of the spiral.

2

Head

Light

Dark

Light

Dark

3

The shapes of the ribs are revealed. The waist is tightened, and the gap between the ribs and the pelvis is stretched up and down

The torso and arms are stretched up from the hips.

▲ An example where the body is drawn as an undulation of a spiral. The focus is on the twist of the bent shape of the body, and the weight-bearing left leg and the tensed hip.

▲ An example where light and dark tones are added to the spiraling lines to bring out the three-dimensionality of the figure. The concave and convex parts of the body, which are hard to understand when it's seen from the front, are easier to see now.

▲ An example where the raised ribs and the muscles and joints of the body have been added, to depict a pose that is stretched upward.

Trying Out a Time-limited Drawing

Try actually drawing a male figure. In this pose the dynamic back can be seen well.

1) Analyzing the Movement of the Lowered Hips

Aim to use as few lines as possible, so the spontaneity of the guidelines is not lost. You can also start with a drawing with tones, if you want to practice depicting the figure three-dimensionally.

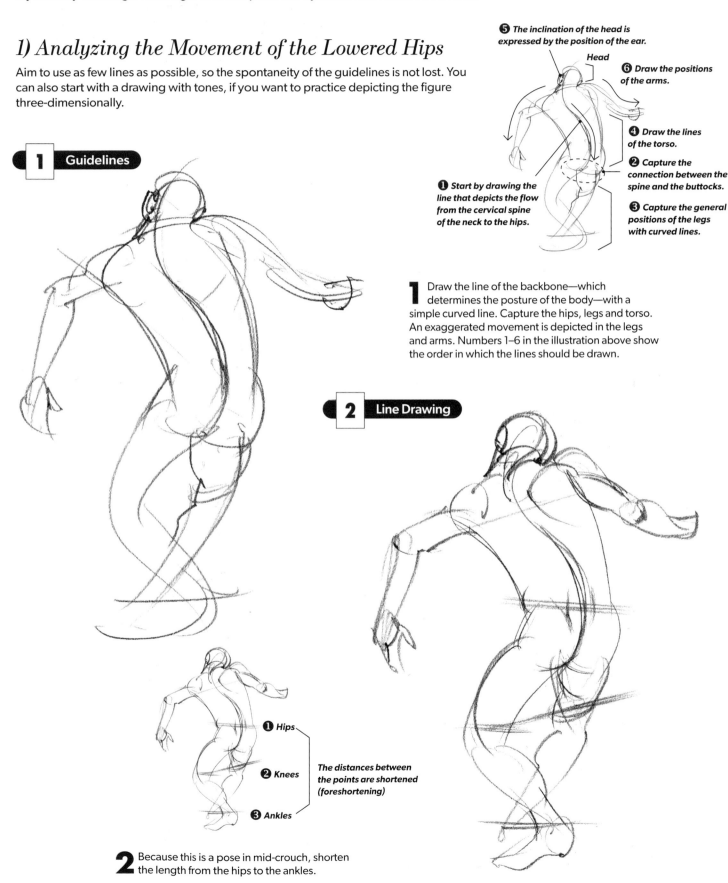

❺ *The inclination of the head is expressed by the position of the ear.*

Head

❻ *Draw the positions of the arms.*

❹ *Draw the lines of the torso.*

❷ *Capture the connection between the spine and the buttocks.*

❸ *Capture the general positions of the legs with curved lines.*

❶ *Start by drawing the line that depicts the flow from the cervical spine of the neck to the hips.*

1 Guidelines

1 Draw the line of the backbone—which determines the posture of the body—with a simple curved line. Capture the hips, legs and torso. An exaggerated movement is depicted in the legs and arms. Numbers 1–6 in the illustration above show the order in which the lines should be drawn.

2 Line Drawing

❶ *Hips*

❷ *Knees*

❸ *Ankles*

The distances between the points are shortened (foreshortening)

2 Because this is a pose in mid-crouch, shorten the length from the hips to the ankles.

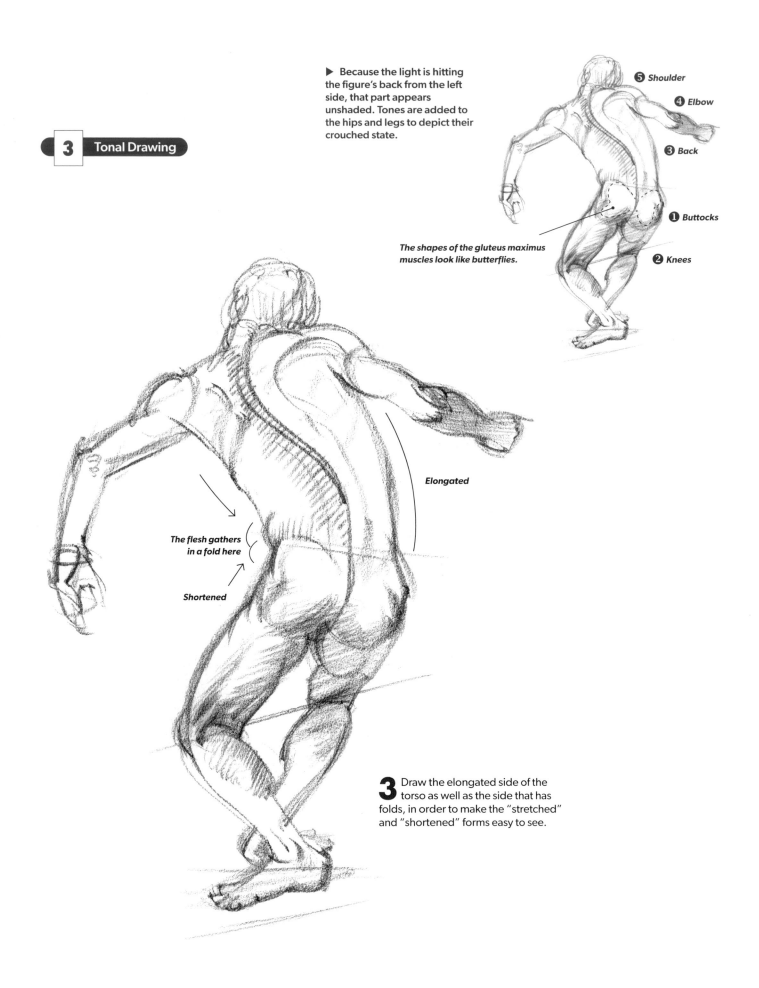

3 Tonal Drawing

▶ Because the light is hitting the figure's back from the left side, that part appears unshaded. Tones are added to the hips and legs to depict their crouched state.

⑤ *Shoulder*

④ *Elbow*

③ *Back*

① *Buttocks*

② *Knees*

The shapes of the gluteus maximus muscles look like butterflies.

Elongated

The flesh gathers in a fold here

Shortened

3 Draw the elongated side of the torso as well as the side that has folds, in order to make the "stretched" and "shortened" forms easy to see.

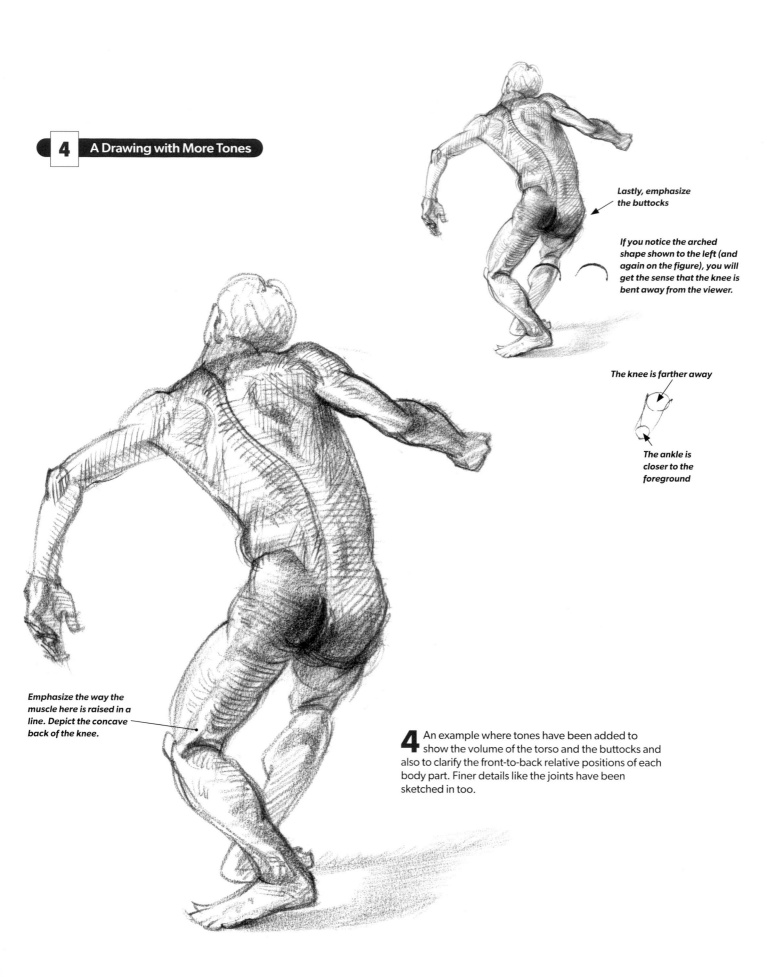

Lastly, emphasize the buttocks

If you notice the arched shape shown to the left (and again on the figure), you will get the sense that the knee is bent away from the viewer.

The knee is farther away

The ankle is closer to the foreground

Emphasize the way the muscle here is raised in a line. Depict the concave back of the knee.

4 An example where tones have been added to show the volume of the torso and the buttocks and also to clarify the front-to-back relative positions of each body part. Finer details like the joints have been sketched in too.

2) Changing the Viewing Angle

When you want to understand a pose, it's useful to observe it from various angles to gain that information too. If the bent legs or arms and so on are hard to grasp from just one angle, just changing the position slightly can help the figure become a lot easier to understand. Draw the pose with lowered hips that we've been describing from page 13 on from a different angle.

Start with the line of the back as with the drawings on page 13.

❶ *Draw the line of the backbone, and show the flow from the hips to the neck.*

❷ *Make the connection between the backbone and the buttocks.*

❸ *Roughly capture the positions of the legs with curved lines.*

❹ *Draw the lines of the torso.*

❺ *Draw the head as a round object.*

❻ *Draw the positions of the arms and the connection between the left and right shoulders, then determine the positions of the elbows.*

1 Guidelines

2 Line Drawing

1 Draw the movement with vigorous lines. Numbers 1–6 in the illustration above indicate the general order in which to draw the lines.

The lines of the protruding scapulae (the shoulder blades).

The butterfly-shaped gluteus maximus muscles.

2 Capture the key points of the figure with shapes that are as simplified as possible.

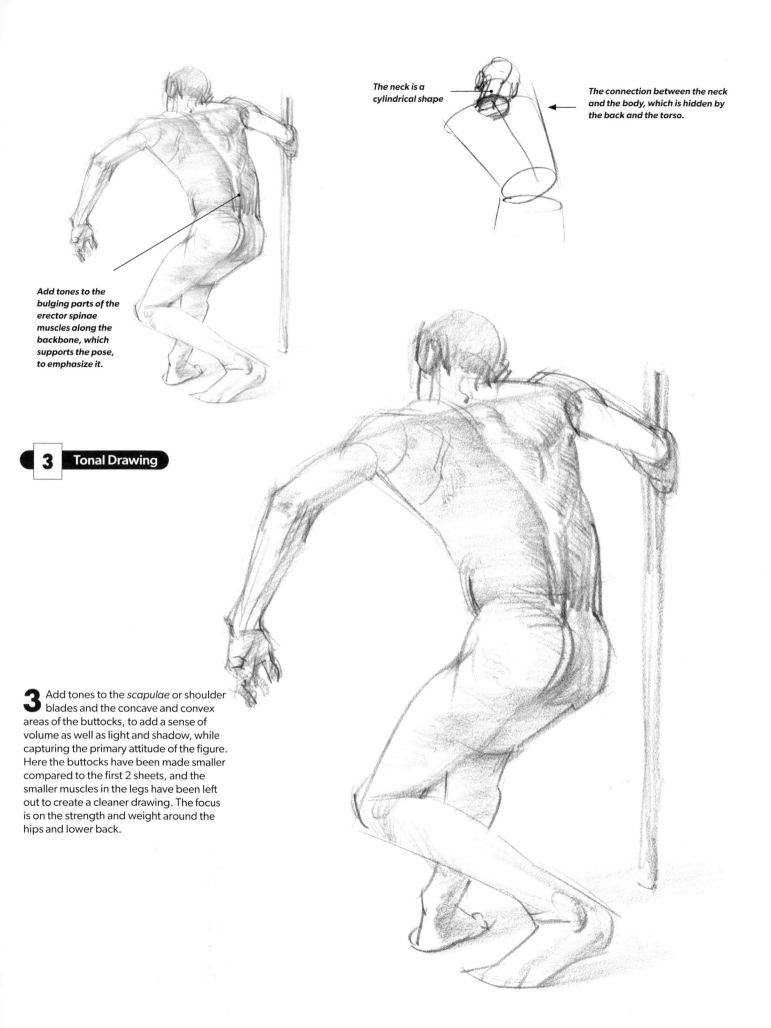

The neck is a cylindrical shape

The connection between the neck and the body, which is hidden by the back and the torso.

Add tones to the bulging parts of the erector spinae muscles along the backbone, which supports the pose, to emphasize it.

3 Tonal Drawing

3 Add tones to the *scapulae* or shoulder blades and the concave and convex areas of the buttocks, to add a sense of volume as well as light and shadow, while capturing the primary attitude of the figure. Here the buttocks have been made smaller compared to the first 2 sheets, and the smaller muscles in the legs have been left out to create a cleaner drawing. The focus is on the strength and weight around the hips and lower back.

3) Varying the Pose

Draw a variation of the "lowered hips pose" we have been working on so far, where the upper body is somewhat stretched out. The pose is captured from an angle where the right side is visible.

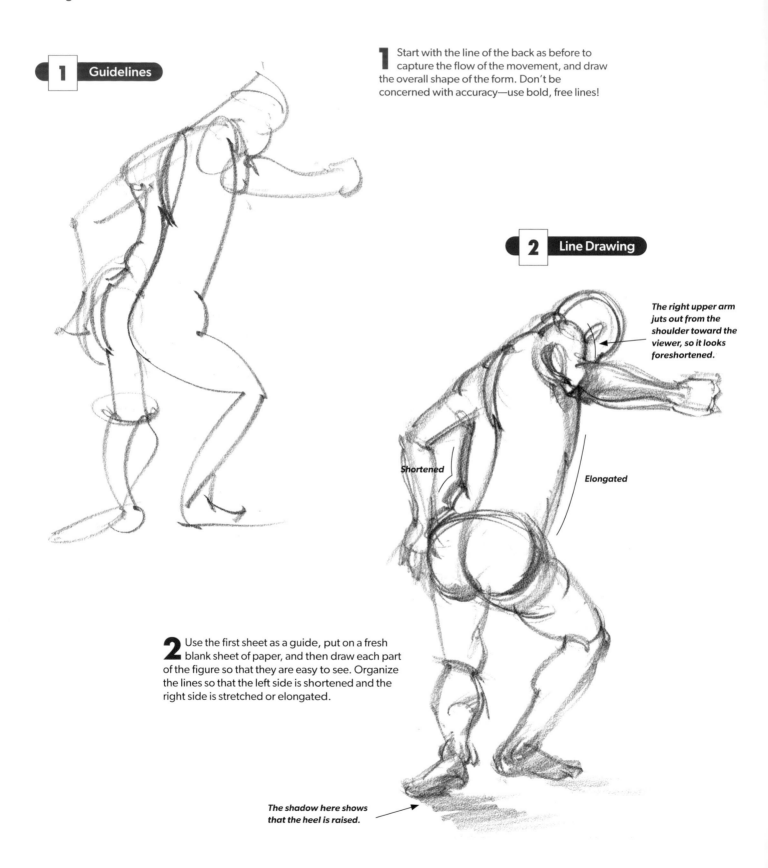

1 Guidelines

1 Start with the line of the back as before to capture the flow of the movement, and draw the overall shape of the form. Don't be concerned with accuracy—use bold, free lines!

2 Line Drawing

The right upper arm juts out from the shoulder toward the viewer, so it looks foreshortened.

Shortened

Elongated

2 Use the first sheet as a guide, put on a fresh blank sheet of paper, and then draw each part of the figure so that they are easy to see. Organize the lines so that the left side is shortened and the right side is stretched or elongated.

The shadow here shows that the heel is raised.

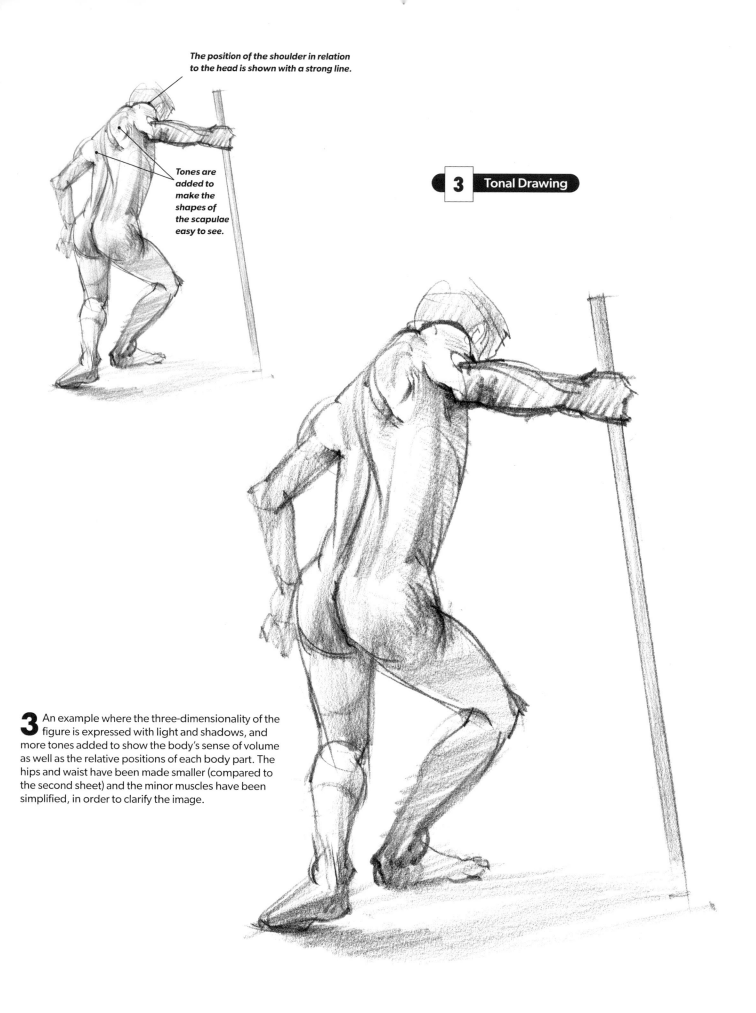

The position of the shoulder in relation to the head is shown with a strong line.

Tones are added to make the shapes of the scapulae easy to see.

3 Tonal Drawing

3 An example where the three-dimensionality of the figure is expressed with light and shadows, and more tones added to show the body's sense of volume as well as the relative positions of each body part. The hips and waist have been made smaller (compared to the second sheet) and the minor muscles have been simplified, in order to clarify the image.

Memorize the Ratios and Key Elements of the Human Form

In order to draw the movement of the body with freedom, memorize the basic ratios and key elements of the human figure. We'll start by drawing a standing male figure from the front and sketching the diagonal, side and back views that match it. A straight standing pose doesn't show much in the way of movement, so it's difficult to depict. Think about the ratios as you practice drawing the various poses we will be working on later. If you follow the steps as described, you can create a human figure with ideal proportions, where the height of the head is $1/7$ to $1/8$ the height of the entire body. The arms and other body parts can look short depending on the posture of the body as well as the viewing angle, so be mindful of the ratios.

1) Drawing a Standing Pose from the Front

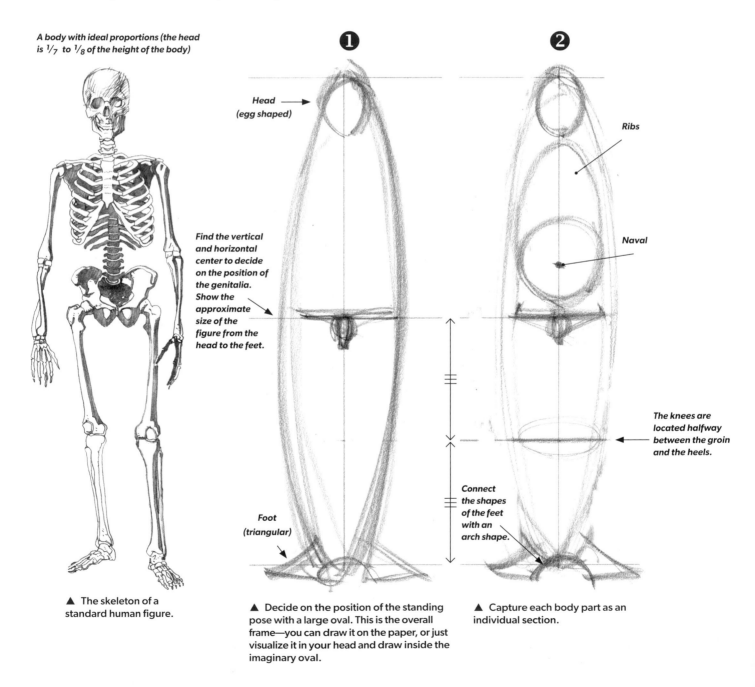

A body with ideal proportions (the head is $1/7$ to $1/8$ of the height of the body)

❶

Head
(egg shaped)

Find the vertical and horizontal center to decide on the position of the genitalia. Show the approximate size of the figure from the head to the feet.

Foot
(triangular)

❷

Ribs

Naval

The knees are located halfway between the groin and the heels.

Connect the shapes of the feet with an arch shape.

▲ The skeleton of a standard human figure.

▲ Decide on the position of the standing pose with a large oval. This is the overall frame—you can draw it on the paper, or just visualize it in your head and draw inside the imaginary oval.

▲ Capture each body part as an individual section.

Compare an Extremely Obese Body to an Extremely Emaciated One

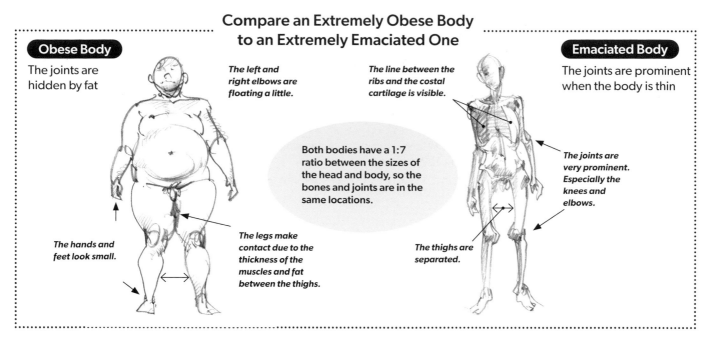

Obese Body

The joints are hidden by fat

The left and right elbows are floating a little.

The line between the ribs and the costal cartilage is visible.

Both bodies have a 1:7 ratio between the sizes of the head and body, so the bones and joints are in the same locations.

Emaciated Body

The joints are prominent when the body is thin

The joints are very prominent. Especially the knees and elbows.

The hands and feet look small.

The legs make contact due to the thickness of the muscles and fat between the thighs.

The thighs are separated.

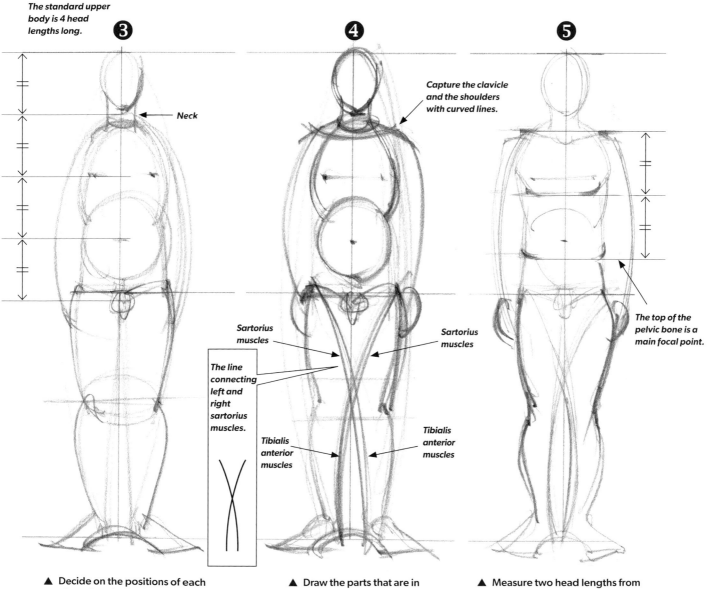

The standard upper body is 4 head lengths long.

❸

Neck

❹

Capture the clavicle and the shoulders with curved lines.

Sartorius muscles

Sartorius muscles

The line connecting left and right sartorius muscles.

Tibialis anterior muscles

Tibialis anterior muscles

❺

The top of the pelvic bone is a main focal point.

▲ Decide on the positions of each part based on the body shape.

▲ Draw the parts that are in pairs with connected curved lines so that they are one unit.

▲ Measure two head lengths from the clavicle to mark the position of the underside of the pectoralis major muscles and the inguinal ligament.

Compare the Female and Male Figures (Front View)

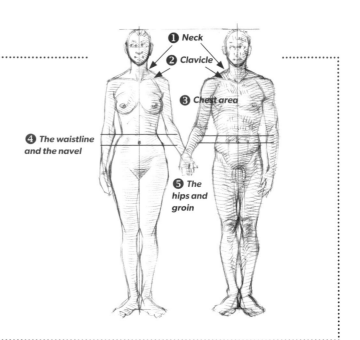

❶ Neck
❷ Clavicle
❸ Chest area
❹ The waistline and the navel
❺ The hips and groin

❶ The trapezius muscles in the female figure are often not well developed, so the neck looks slim. The male neck should be drawn on the thicker side. (Add the Adam's apple when appropriate.)

❷ The line of the clavicle on a female body is straight or slopes down. The male clavicle often curves up at the outside ends.

❸ The ribs of the female figure are narrow, but the ribs on the male figure are wide and large. On the female figure the breasts swell atop the pectoral muscles, while on the male figure the lines of the pectoral muscles are visible.

❹ On a female figure there is a gap between the waistline and the navel. On a male figure the distance between the waist and the navel is short.

❺ The hips of a female figure are wide, soft and rounded with fat, so the groin looks higher. On a male figure the hips are narrow, so the groin looks lower.

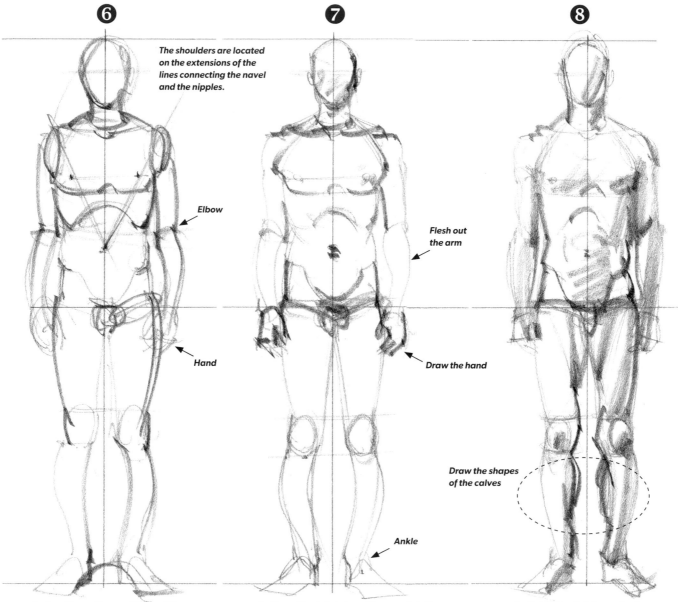

❻

The shoulders are located on the extensions of the lines connecting the navel and the nipples.

Elbow

Hand

▲ Decide on the positions of the parts from the shoulders to the arms.

❼

Flesh out the arm

Draw the hand

Ankle

▲ Draw the joints to add more detail to the form.

❽

Draw the shapes of the calves

▲ Detail the thighs and calves with shadows to make them appear three-dimensional.

9

A moderately muscular figure

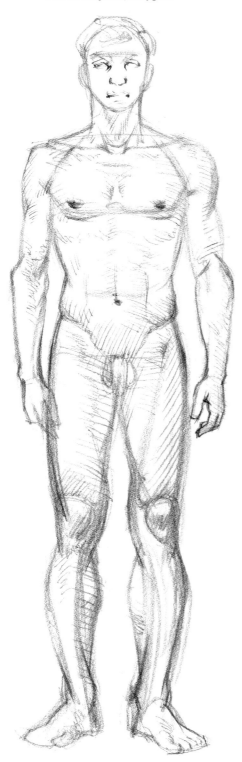

▲ An example of a drawing with tones. Details such as the prominent muscles and the joints have been added. This body type has developed pectoral and abdominal muscles.

The Key Landmarks of the Human Figure for Drawing

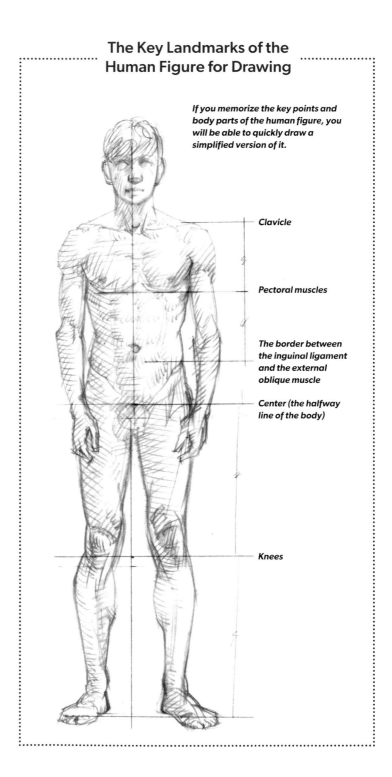

If you memorize the key points and body parts of the human figure, you will be able to quickly draw a simplified version of it.

Clavicle

Pectoral muscles

The border between the inguinal ligament and the external oblique muscle

Center (the halfway line of the body)

Knees

2) Drawing a Three-quarter-angle Pose

Next, we will draw a standing male figure from a three-quarter angle. We'll use perspective depth to give the figure a sense of depth. The lines used to depict a sense of depth are also called linear perspective lines. With the eye level or horizon line set to the hip position, draw lines connecting the left and right paired body parts of the figure and one central vanishing point. An example drawing has been provided to show the basic positions of the body parts, but if you adhere to these positions too strictly your drawing will become stiff, so just use them as a guideline for finding the key points on the figure you are working on.

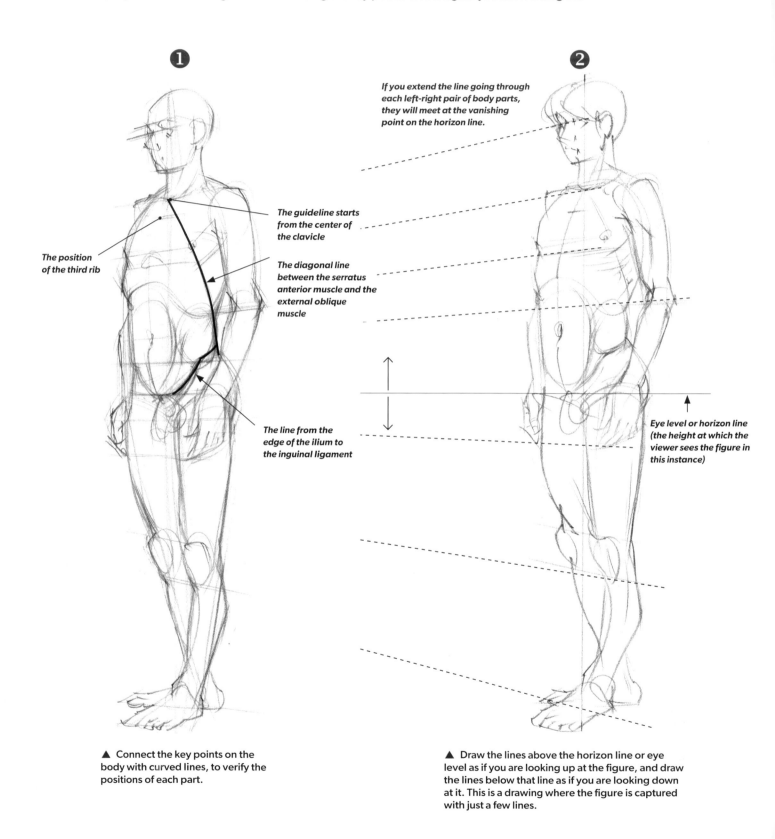

❶

❷

If you extend the line going through each left-right pair of body parts, they will meet at the vanishing point on the horizon line.

The guideline starts from the center of the clavicle

The position of the third rib

The diagonal line between the serratus anterior muscle and the external oblique muscle

The line from the edge of the ilium to the inguinal ligament

Eye level or horizon line (the height at which the viewer sees the figure in this instance)

▲ Connect the key points on the body with curved lines, to verify the positions of each part.

▲ Draw the lines above the horizon line or eye level as if you are looking up at the figure, and draw the lines below that line as if you are looking down at it. This is a drawing where the figure is captured with just a few lines.

❸

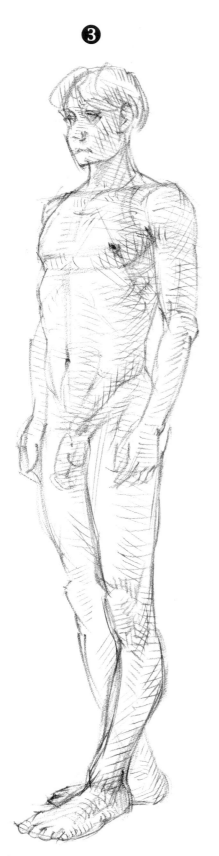

▲ An example of a drawing with shading. A tense standing pose looks rather stiff.

How to Add a Dynamic Quality to a Standing Pose

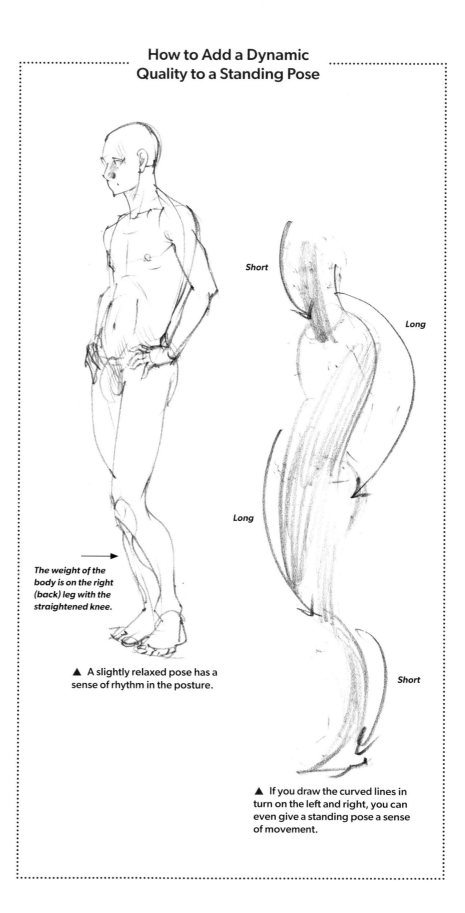

The weight of the body is on the right (back) leg with the straightened knee.

▲ A slightly relaxed pose has a sense of rhythm in the posture.

Short

Long

Long

Short

▲ If you draw the curved lines in turn on the left and right, you can even give a standing pose a sense of movement.

3) Drawing a Sideways Pose

The lumbar spine (the backbone) is bent into an S shape to support the weight of the head. Capture the gentle curve from the neck to the hips, and the hips to the feet, to draw a natural sideways pose.

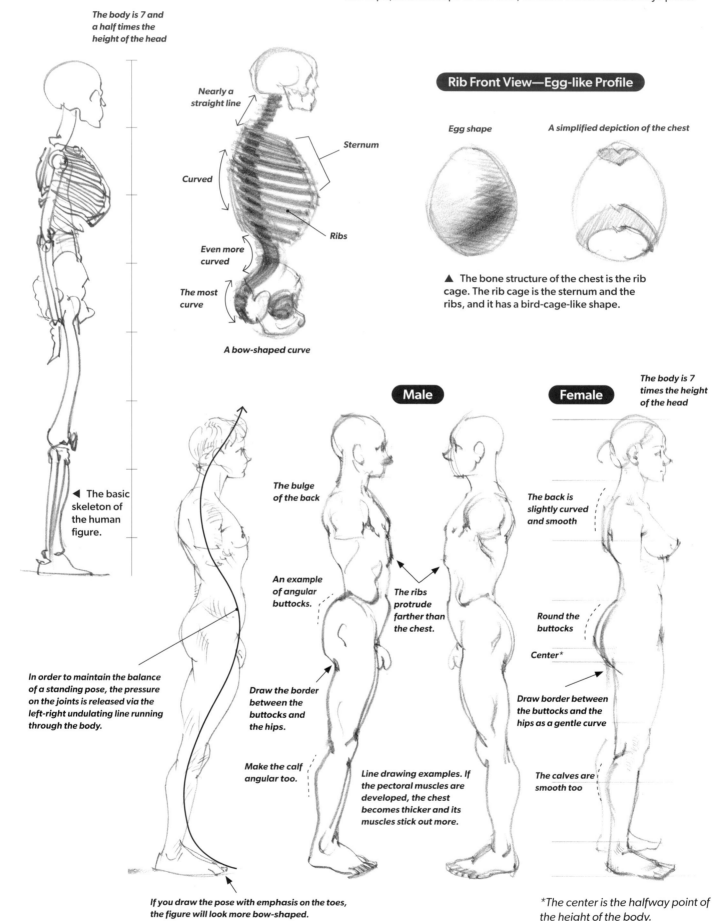

The body is 7 and a half times the height of the head

Nearly a straight line

Sternum

Curved

Ribs

Even more curved

The most curve

A bow-shaped curve

Rib Front View—Egg-like Profile

Egg shape

A simplified depiction of the chest

▲ The bone structure of the chest is the rib cage. The rib cage is the sternum and the ribs, and it has a bird-cage-like shape.

◄ The basic skeleton of the human figure.

In order to maintain the balance of a standing pose, the pressure on the joints is released via the left-right undulating line running through the body.

If you draw the pose with emphasis on the toes, the figure will look more bow-shaped.

Male

Female

The body is 7 times the height of the head

The bulge of the back

An example of angular buttocks.

Draw the border between the buttocks and the hips.

Make the calf angular too.

The ribs protrude farther than the chest.

Line drawing examples. If the pectoral muscles are developed, the chest becomes thicker and its muscles stick out more.

The back is slightly curved and smooth

Round the buttocks

*Center**

Draw border between the buttocks and the hips as a gentle curve

The calves are smooth too

**The center is the halfway point of the height of the body.*

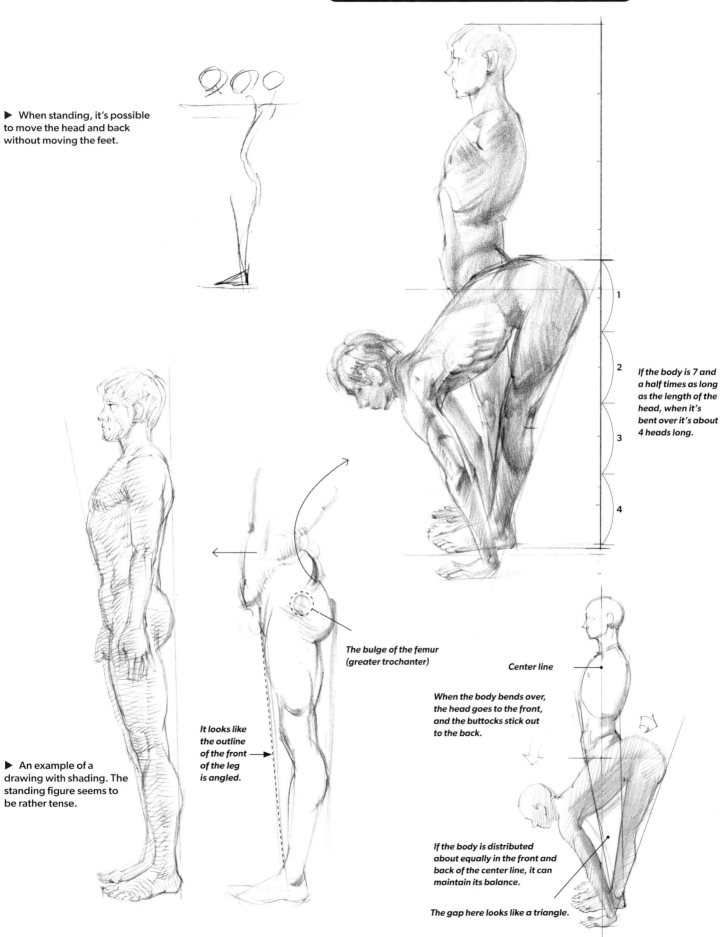

▶ When standing, it's possible to move the head and back without moving the feet.

If the body is 7 and a half times as long as the length of the head, when it's bent over it's about 4 heads long.

▶ An example of a drawing with shading. The standing figure seems to be rather tense.

It looks like the outline of the front of the leg is angled.

The bulge of the femur (greater trochanter)

Center line

When the body bends over, the head goes to the front, and the buttocks stick out to the back.

If the body is distributed about equally in the front and back of the center line, it can maintain its balance.

The gap here looks like a triangle.

4) Drawing a Back View

In this book we focus a lot on the back of the male figure, in which many changes can be seen. A straight standing pose doesn't show a lot of changes, but if the pose changes and the arms move, the convex and concave areas of the back made by the bones and muscles can be seen. The key to drawing the back view of a figure in a short amount of time is still to capture the key points and to simplify the shape.

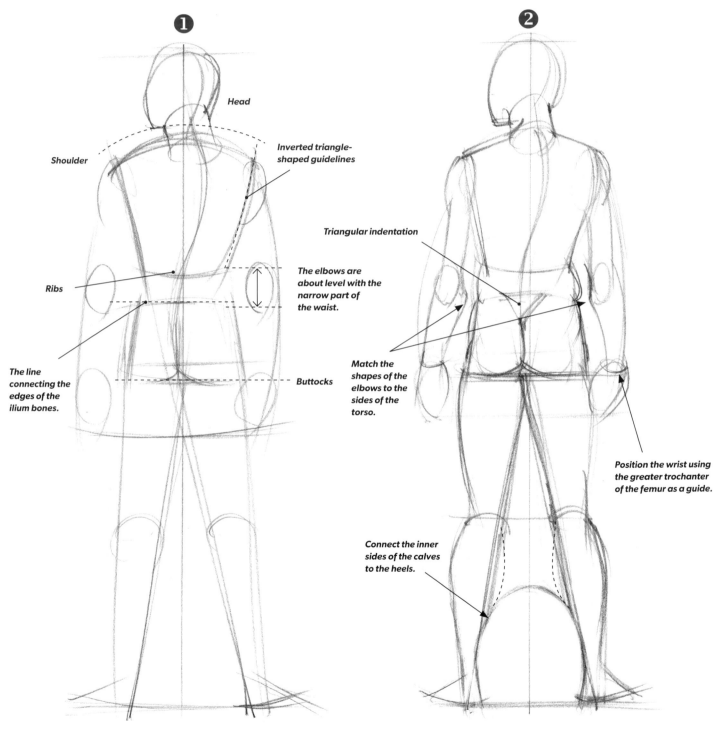

①

Head

Shoulder

Inverted triangle-shaped guidelines

Ribs

The elbows are about level with the narrow part of the waist.

The line connecting the edges of the ilium bones.

Buttocks

②

Triangular indentation

Match the shapes of the elbows to the sides of the torso.

Position the wrist using the greater trochanter of the femur as a guide.

Connect the inner sides of the calves to the heels.

▲ Draw the guidelines with curved and straight lines. Draw the line of the backbone somewhat diagonally so that it curves a bit.

▲ Draw the lines of the arms and legs, using the positions of the joints as guides. Draw the butterfly-like shapes of the gluteus maximus muscles based on the triangular indentation.

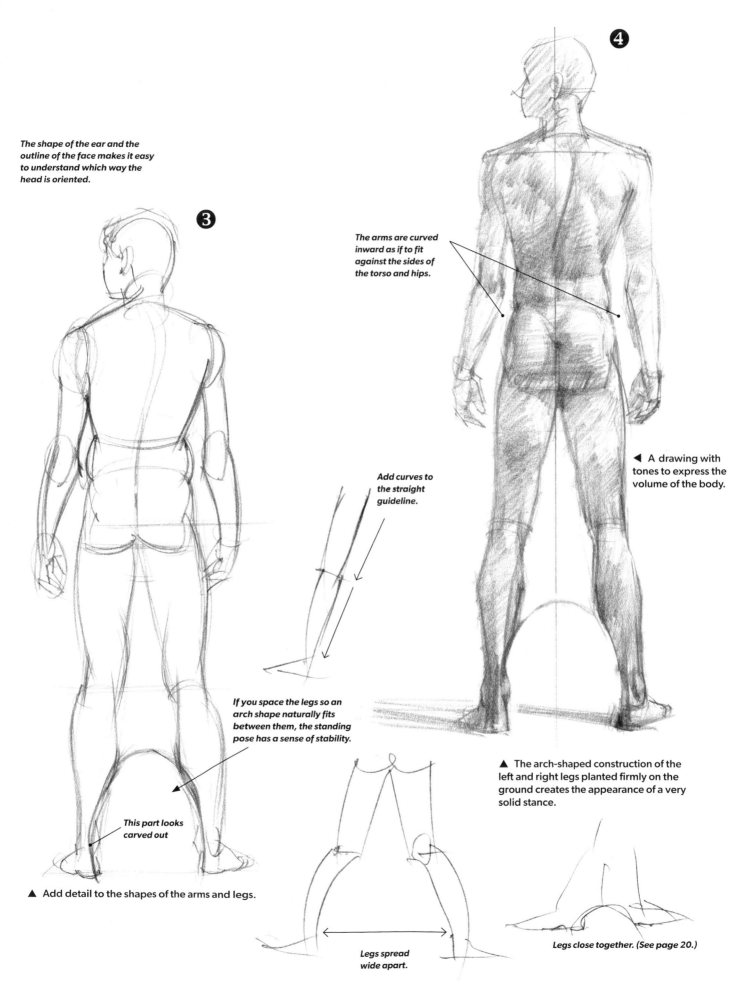

The shape of the ear and the outline of the face makes it easy to understand which way the head is oriented.

❸

The arms are curved inward as if to fit against the sides of the torso and hips.

❹

◀ A drawing with tones to express the volume of the body.

Add curves to the straight guideline.

If you space the legs so an arch shape naturally fits between them, the standing pose has a sense of stability.

This part looks carved out

▲ Add detail to the shapes of the arms and legs.

▲ The arch-shaped construction of the left and right legs planted firmly on the ground creates the appearance of a very solid stance.

Legs spread wide apart.

Legs close together. (See page 20.)

⑤

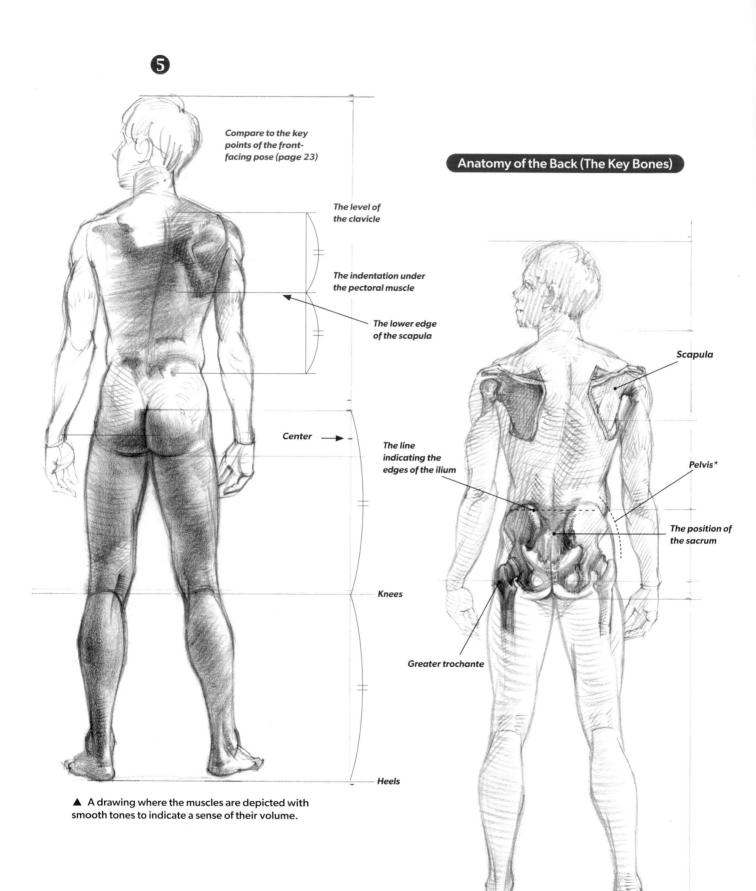

Compare to the key points of the front-facing pose (page 23)

The level of the clavicle

The indentation under the pectoral muscle

The lower edge of the scapula

Center →

Knees

Heels

▲ A drawing where the muscles are depicted with smooth tones to indicate a sense of their volume.

Anatomy of the Back (The Key Bones)

Scapula

Pelvis*

The position of the sacrum

The line indicating the edges of the ilium

Greater trochante

*__Pelvis:__ *A collection of connected bones consisting of the sacrum, ilium, sciatica, pubic bone and coccyx*

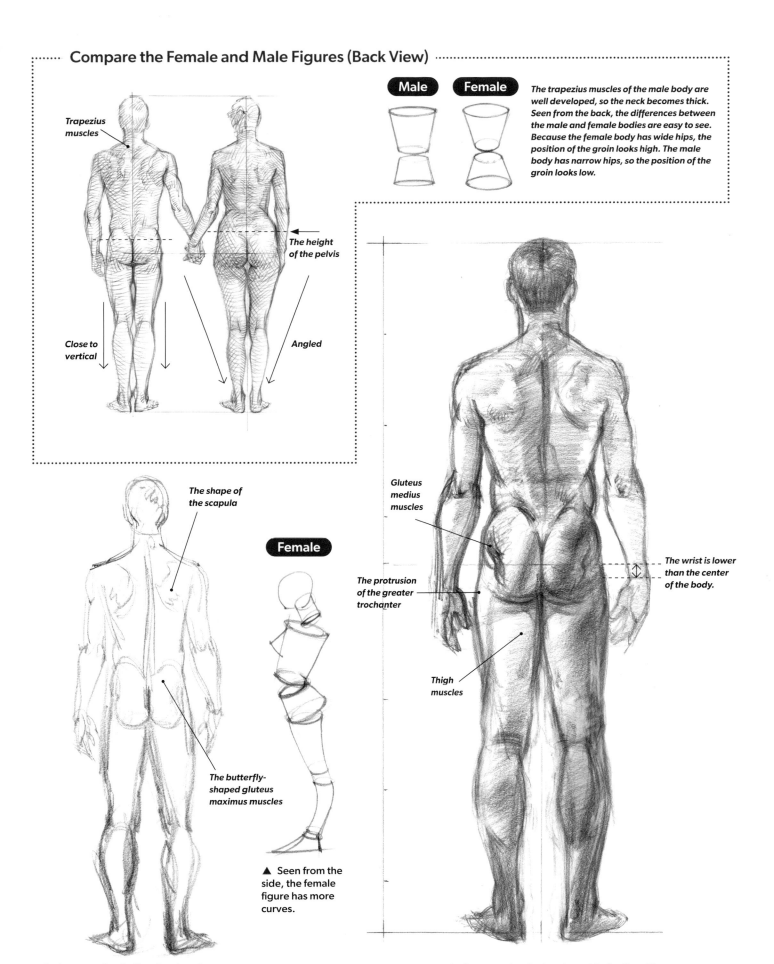

Compare the Female and Male Figures (Back View)

Trapezius muscles

The height of the pelvis

Close to vertical

Angled

Male **Female**

The trapezius muscles of the male body are well developed, so the neck becomes thick. Seen from the back, the differences between the male and female bodies are easy to see. Because the female body has wide hips, the position of the groin looks high. The male body has narrow hips, so the position of the groin looks low.

The shape of the scapula

Female

The butterfly-shaped gluteus maximus muscles

▲ Seen from the side, the female figure has more curves.

Gluteus medius muscles

The protrusion of the greater trochanter

Thigh muscles

The wrist is lower than the center of the body.

▲ An example of a line drawing that captures the key points of the back.

▲ An example of a drawing with shading. The volume and texture of the are expressed.

31

Observe the Body Using Negative and Positive Shapes

When attempting to faithfully render the various parts of the body (the positive shapes), it's helpful sometimes to consider the shapes and sizes of the negative spaces created by the body on the background (see page 11).

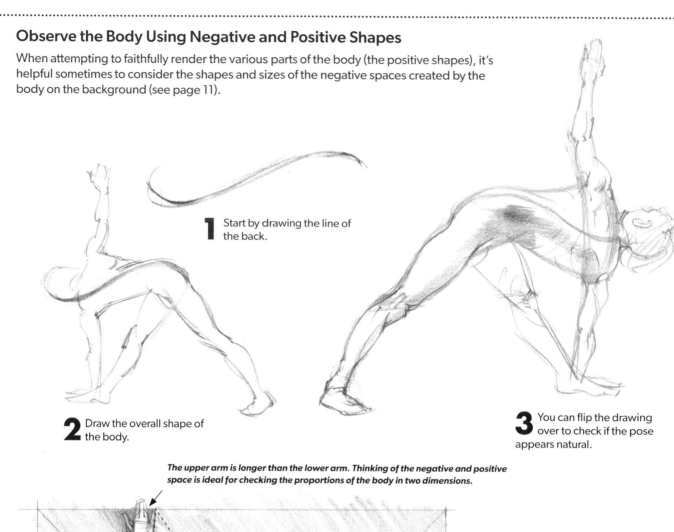

1 Start by drawing the line of the back.

2 Draw the overall shape of the body.

3 You can flip the drawing over to check if the pose appears natural.

The upper arm is longer than the lower arm. Thinking of the negative and positive space is ideal for checking the proportions of the body in two dimensions.

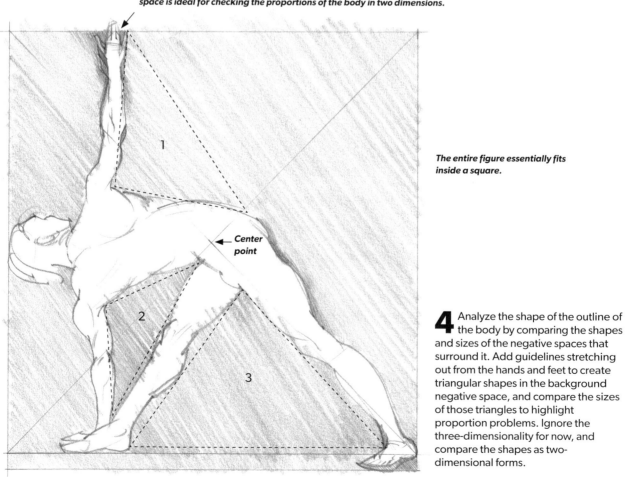

The entire figure essentially fits inside a square.

← *Center point*

4 Analyze the shape of the outline of the body by comparing the shapes and sizes of the negative spaces that surround it. Add guidelines stretching out from the hands and feet to create triangular shapes in the background negative space, and compare the sizes of those triangles to highlight proportion problems. Ignore the three-dimensionality for now, and compare the shapes as two-dimensional forms.

2

Visualizing Human Shapes as Cylinders

When drawing in a short period of time with just a few lines, it's important to simplify your subject. If you visualize them as a collection of cylindrical shapes, you can quickly represent a three-dimensional shape on the flat, two-dimensional surface of the paper. In this chapter we'll use drawings traced from reference photos to explain the key points for converting the human figure into simplified cylindrical shapes.

Using Cylindrical Shapes for a Standing Pose

Capturing the Whole Body and the Parts

One method of rapidly capturing the human figure in a drawing is to think of it in terms of simple geometric shapes. You could use circles and squares, but the cylinder is a perfect shape for thinking of the human body in three dimensions. Consider the shapes and directions of each body part as cylinders too. Use the ratio of the human body on page 20 as a reference to draw figures in an even shorter time period.

Draw a standing pose with closed legs

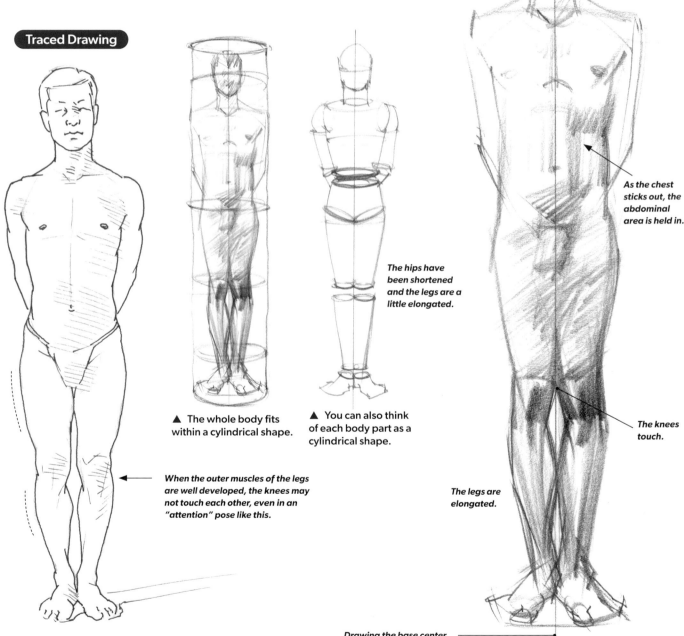

Traced Drawing

Tonal Drawing

As the chest sticks out, the abdominal area is held in.

The hips have been shortened and the legs are a little elongated.

▲ The whole body fits within a cylindrical shape.

▲ You can also think of each body part as a cylindrical shape.

The knees touch.

When the outer muscles of the legs are well developed, the knees may not touch each other, even in an "attention" pose like this.

The legs are elongated.

Drawing the base center line at the start makes it easier to draw the figure.

▲ Think of the whole body as a cylinder. Use the feet on the ground that bear the weight of the body as the starting point, to capture the upward flow.

34

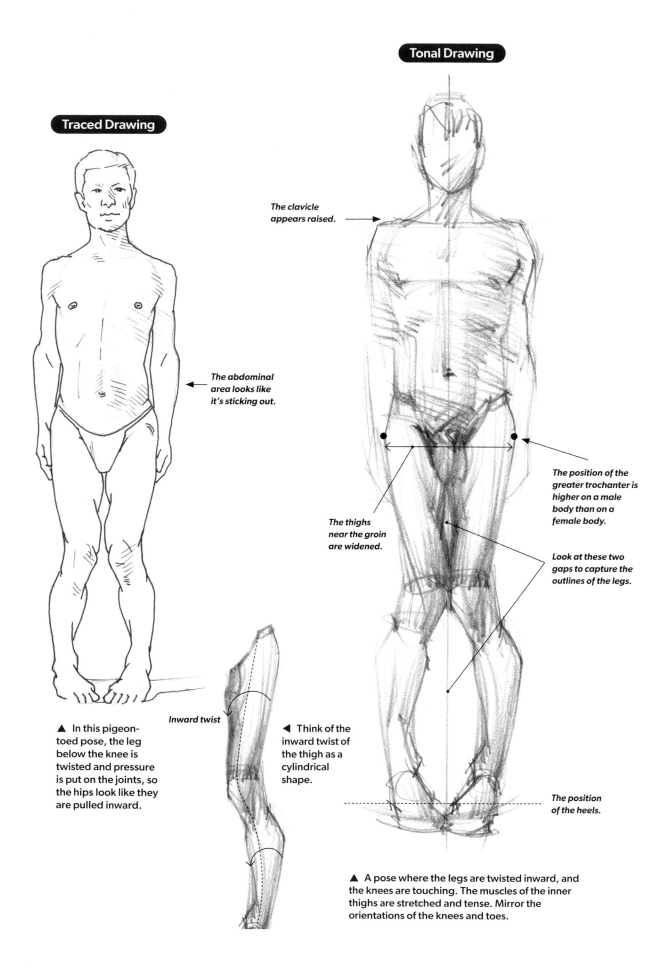

Traced Drawing

Tonal Drawing

The clavicle appears raised. →

← *The abdominal area looks like it's sticking out.*

The thighs near the groin are widened.

The position of the greater trochanter is higher on a male body than on a female body.

Look at these two gaps to capture the outlines of the legs.

The position of the heels.

▲ In this pigeon-toed pose, the leg below the knee is twisted and pressure is put on the joints, so the hips look like they are pulled inward.

Inward twist

◄ Think of the inward twist of the thigh as a cylindrical shape.

▲ A pose where the legs are twisted inward, and the knees are touching. The muscles of the inner thighs are stretched and tense. Mirror the orientations of the knees and toes.

Draw a standing pose with the legs apart

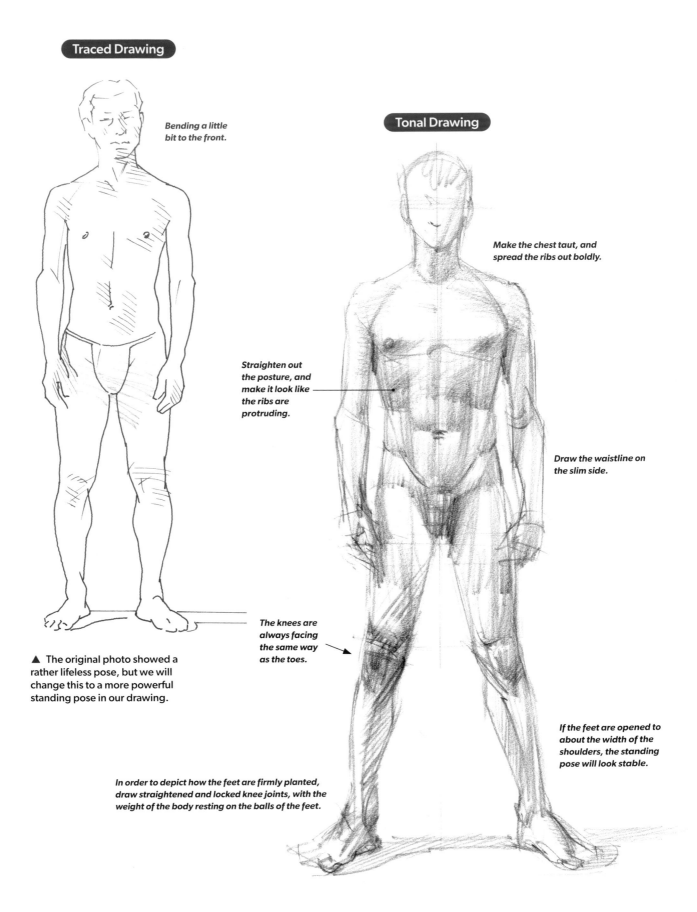

Traced Drawing

Bending a little bit to the front.

Tonal Drawing

Make the chest taut, and spread the ribs out boldly.

Straighten out the posture, and make it look like the ribs are protruding.

Draw the waistline on the slim side.

▲ The original photo showed a rather lifeless pose, but we will change this to a more powerful standing pose in our drawing.

The knees are always facing the same way as the toes.

If the feet are opened to about the width of the shoulders, the standing pose will look stable.

In order to depict how the feet are firmly planted, draw straightened and locked knee joints, with the weight of the body resting on the balls of the feet.

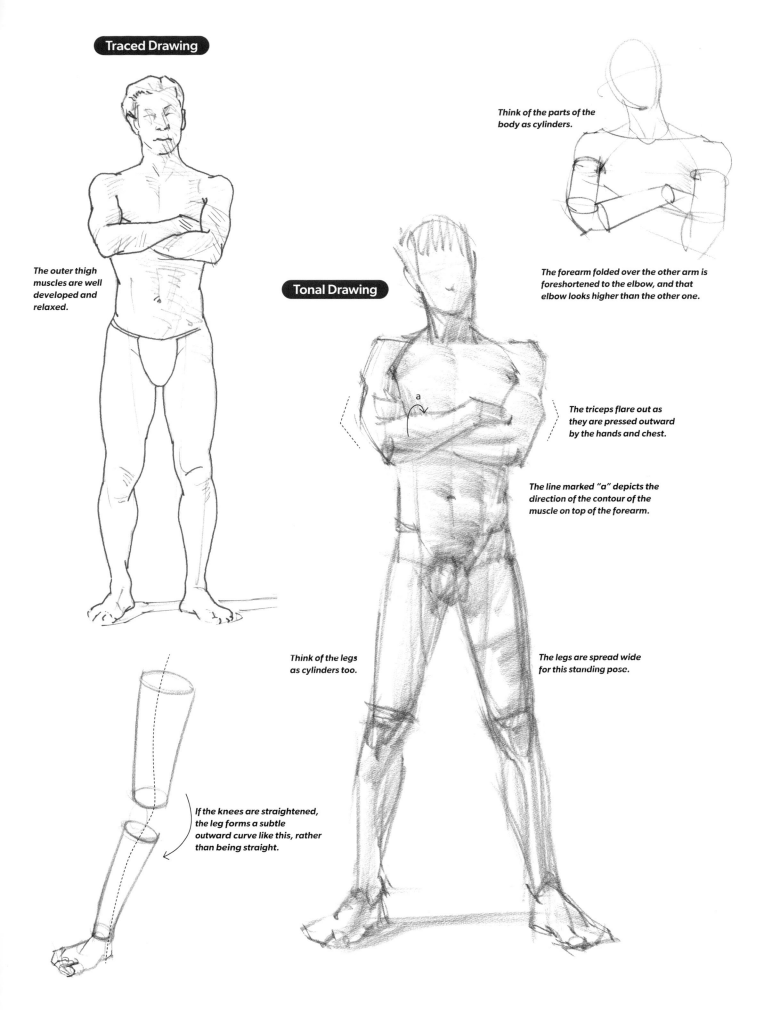

Traced Drawing

The outer thigh muscles are well developed and relaxed.

Think of the parts of the body as cylinders.

Tonal Drawing

The forearm folded over the other arm is foreshortened to the elbow, and that elbow looks higher than the other one.

The triceps flare out as they are pressed outward by the hands and chest.

a

The line marked "a" depicts the direction of the contour of the muscle on top of the forearm.

Think of the legs as cylinders too.

The legs are spread wide for this standing pose.

If the knees are straightened, the leg forms a subtle outward curve like this, rather than being straight.

Using Cylindrical Shapes for a Reclining Pose

If you observe a human figure that is lying down with the feet facing you, the figure looks a lot shorter than it actually is. This way of drawing the figure so that the far end looks small and the parts in the foreground looks large is called "foreshortening." Think of the body as a cylinder to bring out a strong sense of perspective.

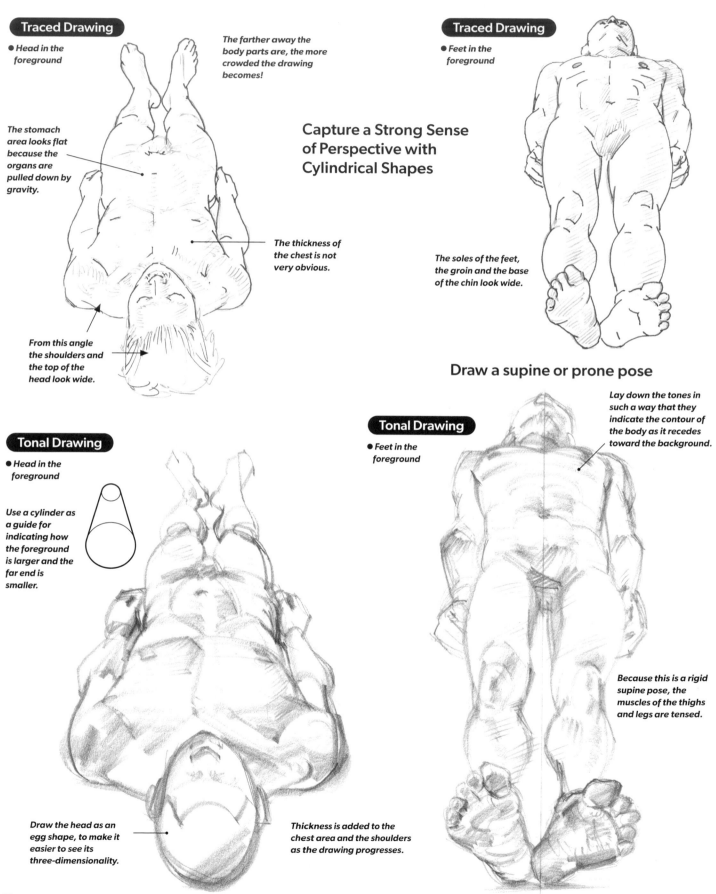

Traced Drawing
- Head in the foreground

The stomach area looks flat because the organs are pulled down by gravity.

The farther away the body parts are, the more crowded the drawing becomes!

From this angle the shoulders and the top of the head look wide.

The thickness of the chest is not very obvious.

Capture a Strong Sense of Perspective with Cylindrical Shapes

Traced Drawing
- Feet in the foreground

The soles of the feet, the groin and the base of the chin look wide.

Draw a supine or prone pose

Tonal Drawing
- Head in the foreground

Use a cylinder as a guide for indicating how the foreground is larger and the far end is smaller.

Draw the head as an egg shape, to make it easier to see its three-dimensionality.

Thickness is added to the chest area and the shoulders as the drawing progresses.

Tonal Drawing
- Feet in the foreground

Lay down the tones in such a way that they indicate the contour of the body as it recedes toward the background.

Because this is a rigid supine pose, the muscles of the thighs and legs are tensed.

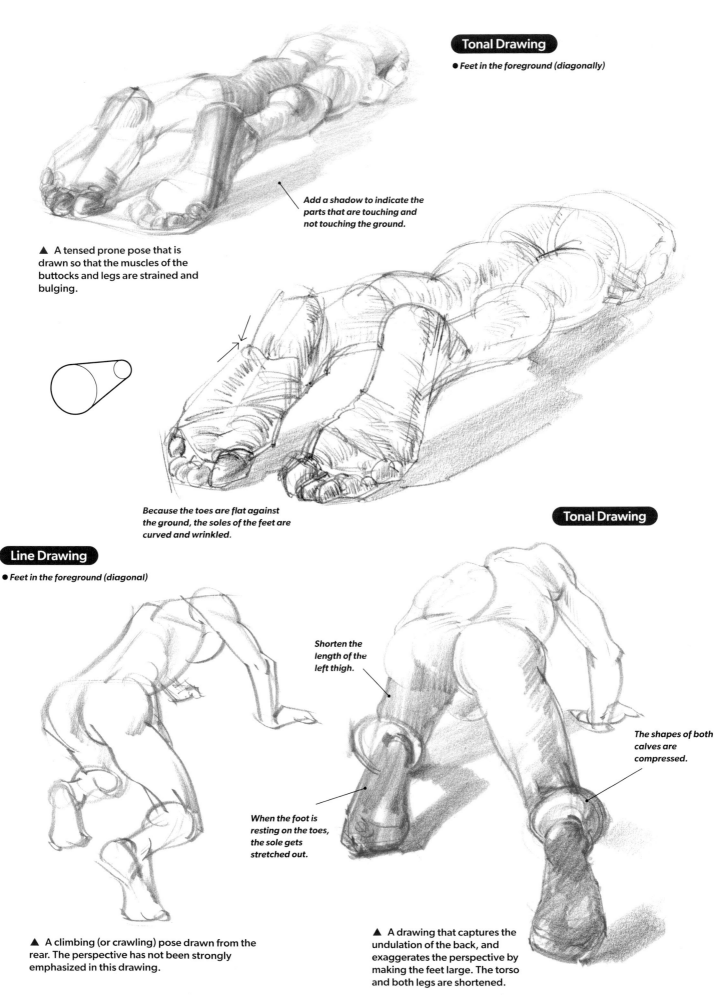

● *Feet in the foreground (diagonally)*

Add a shadow to indicate the parts that are touching and not touching the ground.

▲ A tensed prone pose that is drawn so that the muscles of the buttocks and legs are strained and bulging.

Because the toes are flat against the ground, the soles of the feet are curved and wrinkled.

Tonal Drawing

Line Drawing

● *Feet in the foreground (diagonal)*

Shorten the length of the left thigh.

The shapes of both calves are compressed.

When the foot is resting on the toes, the sole gets stretched out.

▲ A climbing (or crawling) pose drawn from the rear. The perspective has not been strongly emphasized in this drawing.

▲ A drawing that captures the undulation of the back, and exaggerates the perspective by making the feet large. The torso and both legs are shortened.

Using Cylindrical Shapes for a Seated Pose

Cylindrical shapes are used to capture the construction of a seated pose too. Visualize each part of the drawing, such as how the hips are in contact with the chair, how much the upper body is leaning and so on by thinking of the body parts as cylinders.

Draw a Sitting Pose with a Straightened Back

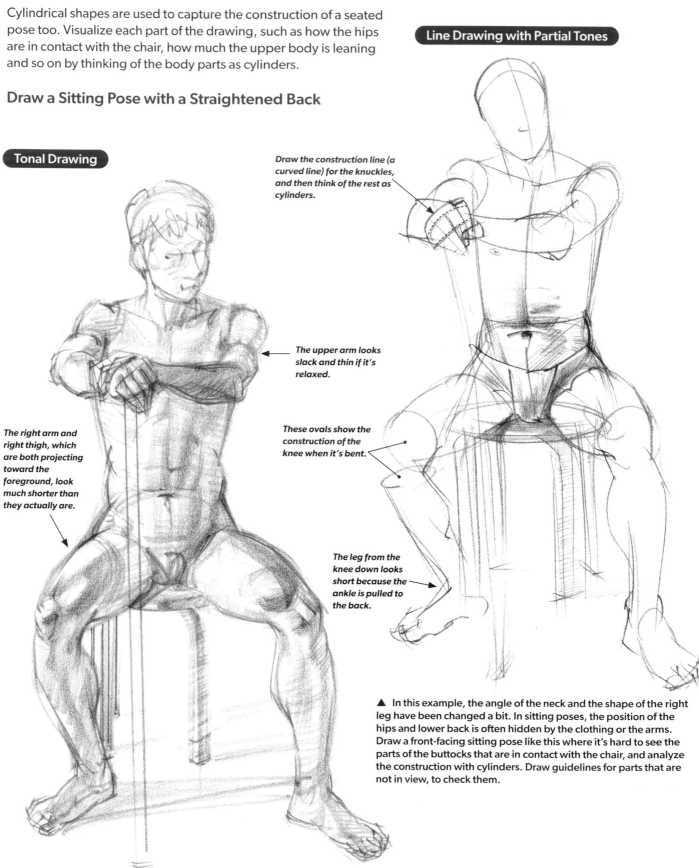

Tonal Drawing

Line Drawing with Partial Tones

Draw the construction line (a curved line) for the knuckles, and then think of the rest as cylinders.

The upper arm looks slack and thin if it's relaxed.

The right arm and right thigh, which are both projecting toward the foreground, look much shorter than they actually are.

These ovals show the construction of the knee when it's bent.

The leg from the knee down looks short because the ankle is pulled to the back.

▲ In this example, the angle of the neck and the shape of the right leg have been changed a bit. In sitting poses, the position of the hips and lower back is often hidden by the clothing or the arms. Draw a front-facing sitting pose like this where it's hard to see the parts of the buttocks that are in contact with the chair, and analyze the construction with cylinders. Draw guidelines for parts that are not in view, to check them.

▲ A sitting pose where the model is leaning on a dowel. Use the pencil held on its side to add tones that express the tension of the muscles or the knobby protruding parts like the knees and elbows.

How the Hips are in Contact with a Chair

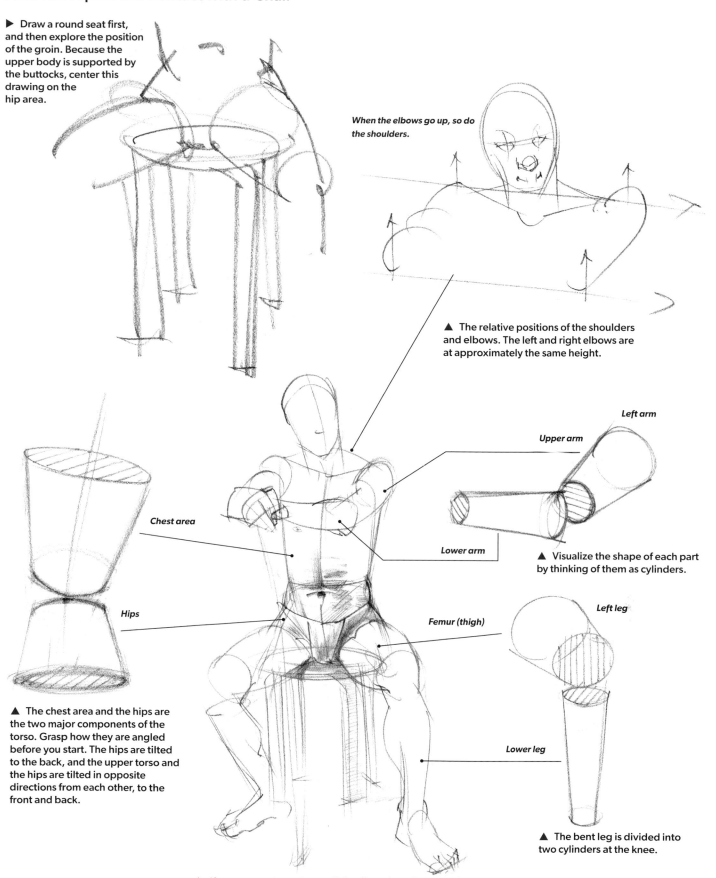

▶ Draw a round seat first, and then explore the position of the groin. Because the upper body is supported by the buttocks, center this drawing on the hip area.

When the elbows go up, so do the shoulders.

▲ The relative positions of the shoulders and elbows. The left and right elbows are at approximately the same height.

Chest area

Hips

Left arm

Upper arm

Lower arm

▲ Visualize the shape of each part by thinking of them as cylinders.

Femur (thigh)

Left leg

Lower leg

▲ The chest area and the hips are the two major components of the torso. Grasp how they are angled before you start. The hips are tilted to the back, and the upper torso and the hips are tilted in opposite directions from each other, to the front and back.

▲ The bent leg is divided into two cylinders at the knee.

▲ If you worry about the small details such as the shapes of the muscles and joints from the start, it's difficult to capture the natural connections and flow from the upper body to the feet. Knees tend to look different from individual to individual, but it works best if you simplify them and draw them as close to oval or square shapes as possible. (The changing shapes of bent knees are explained in Chapter 3, "Representing Each Body Part and Its Muscles.")

Think of the Space of a Sitting Pose as a Box

If you visualize the human figure drawn with cylinders in a box, it becomes it becomes easier to understand the space and its depth. Use the perspective method that was introduced on page 24. When you are looking downward upon a seated figure, the upper sides of the body parts such as the head, shoulders, arms and thighs can be seen clearly. The left and right arms and thighs are respectively on approximately the same plane, so when the lines connecting them are extended, they meet at a far off vanishing point.

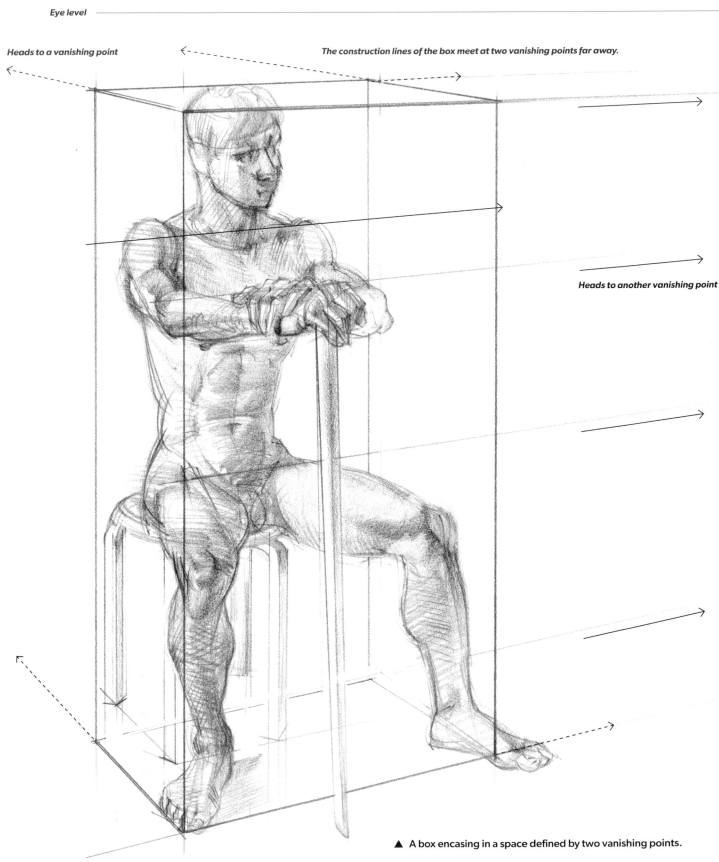

Eye level

Heads to a vanishing point

The construction lines of the box meet at two vanishing points far away.

Heads to another vanishing point

▲ A box encasing in a space defined by two vanishing points.

Draw a Reclined Sitting Pose

Envision this pose where the figure is seated on the edge of the seat and leaning back as a series of cylinders too. The hips become tilted, and you can see the shape of the groin area.

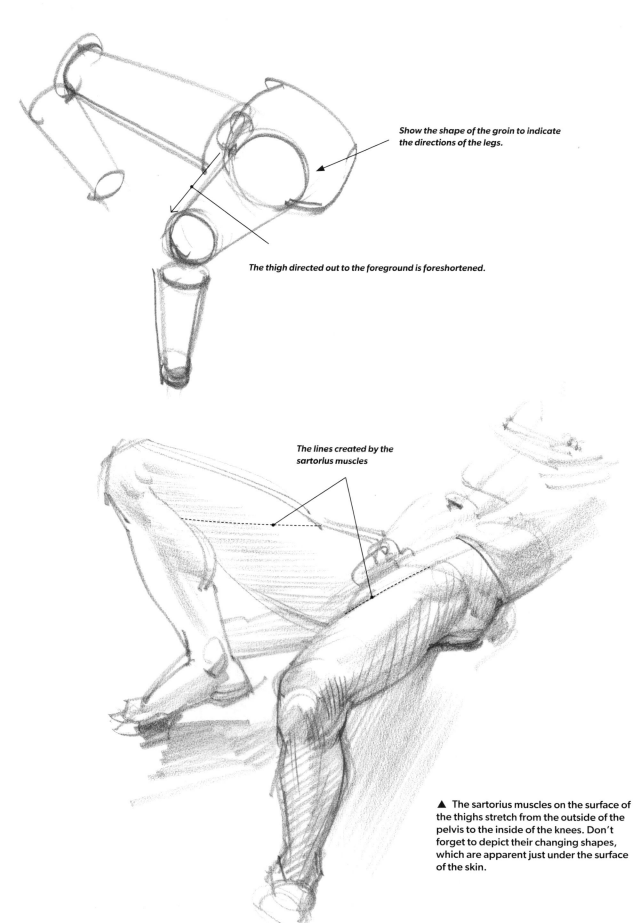

Show the shape of the groin to indicate the directions of the legs.

The thigh directed out to the foreground is foreshortened.

The lines created by the sartorius muscles

▲ The sartorius muscles on the surface of the thighs stretch from the outside of the pelvis to the inside of the knees. Don't forget to depict their changing shapes, which are apparent just under the surface of the skin.

Using Cylindrical Shapes for Arm Poses

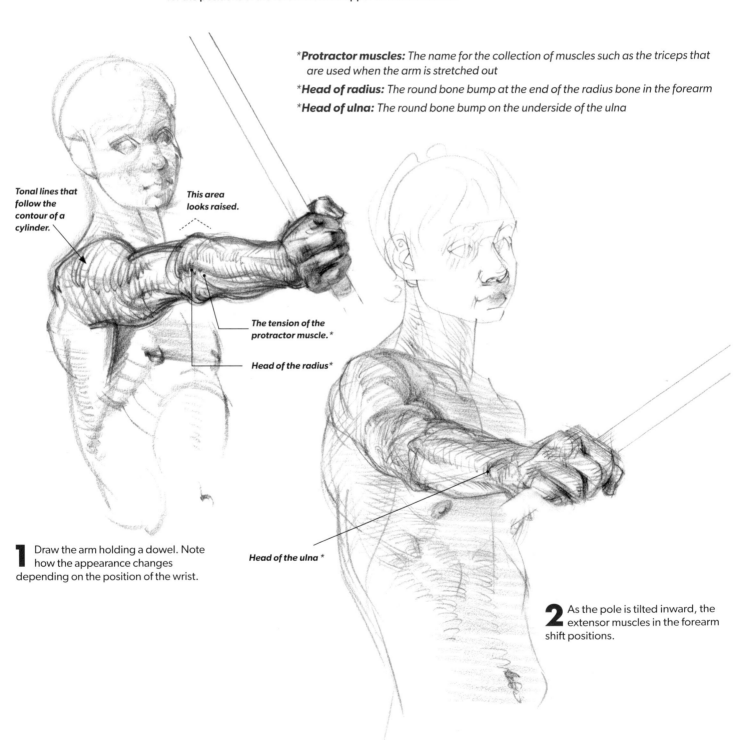

Shoulder

Upper arm

Forearm

Hand

▲ By layering the parts of a body when foreshortening, the depth of the body part (the arm in this case) will be emphasized. Use simplified ovals for the positions of the foreshortened upper arm and shoulder.

Stack the Parts to Show Realistic Foreshortening

We used cylinders to draw the sitting pose with raised elbows on page 40, but this time, examine how to capture an even more foreshortened arm that's raised out to the foreground.

Protractor muscles: The name for the collection of muscles such as the triceps that are used when the arm is stretched out

Head of radius: The round bone bump at the end of the radius bone in the forearm

Head of ulna: The round bone bump on the underside of the ulna

Tonal lines that follow the contour of a cylinder.

This area looks raised.

The tension of the protractor muscle.*

Head of the radius*

1 Draw the arm holding a dowel. Note how the appearance changes depending on the position of the wrist.

Head of the ulna *

2 As the pole is tilted inward, the extensor muscles in the forearm shift positions.

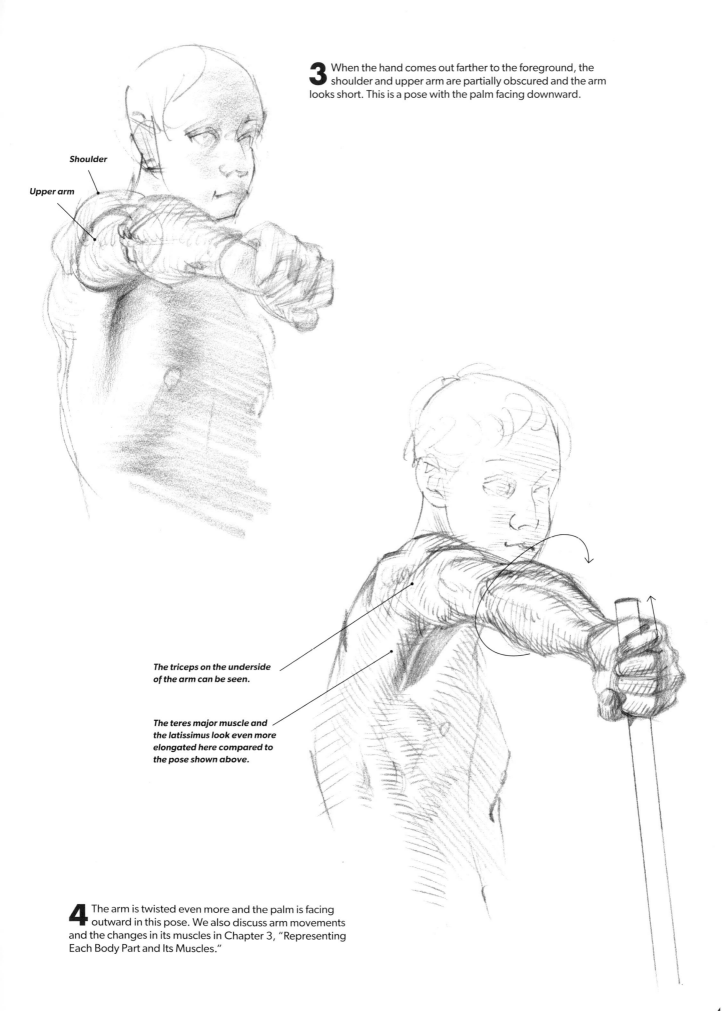

3 When the hand comes out farther to the foreground, the shoulder and upper arm are partially obscured and the arm looks short. This is a pose with the palm facing downward.

Shoulder

Upper arm

The triceps on the underside of the arm can be seen.

The teres major muscle and the latissimus look even more elongated here compared to the pose shown above.

4 The arm is twisted even more and the palm is facing outward in this pose. We also discuss arm movements and the changes in its muscles in Chapter 3, "Representing Each Body Part and Its Muscles."

Shape and Shade the Cylinders with Spiraling Contour Lines

Add curved *contour indicators** to the surface to show the orientation and contour of the cylindrical shape. When textural lines are placed in tight succession like this, they start to approximate light and dark tones. Think of a cylinder as a collection of rings or spiraling lines. To express depth and a sense of the background and foreground, spiral lines following the curving contour of the object are useful. Carefully orient the emphasized portion of the spiral to correctly indicate whether the cylinder is projecting to the foreground or retreating to the background.

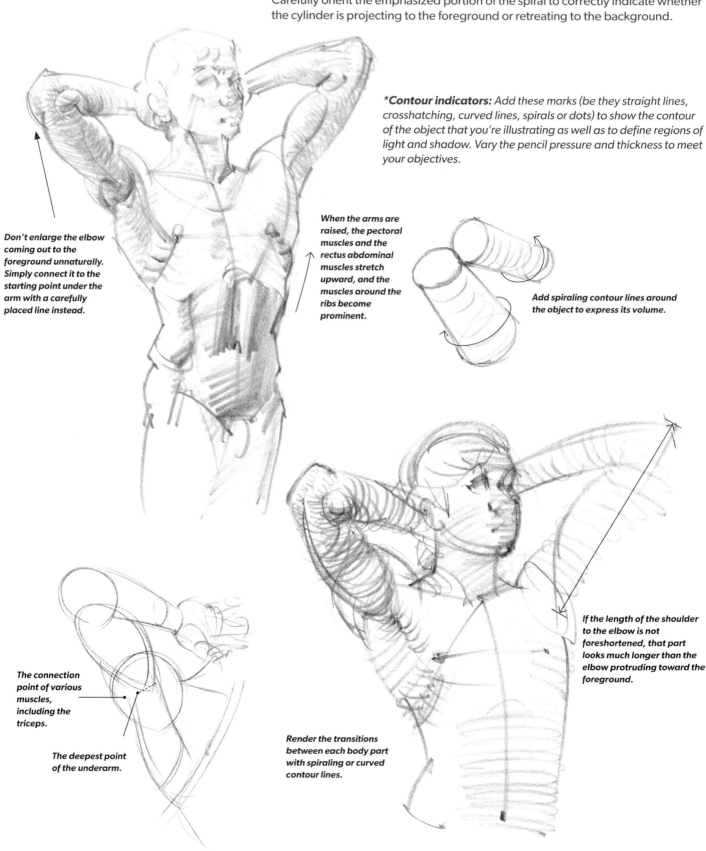

***Contour indicators:** Add these marks (be they straight lines, crosshatching, curved lines, spirals or dots) to show the contour of the object that you're illustrating as well as to define regions of light and shadow. Vary the pencil pressure and thickness to meet your objectives.*

Don't enlarge the elbow coming out to the foreground unnaturally. Simply connect it to the starting point under the arm with a carefully placed line instead.

When the arms are raised, the pectoral muscles and the rectus abdominal muscles stretch upward, and the muscles around the ribs become prominent.

Add spiraling contour lines around the object to express its volume.

The connection point of various muscles, including the triceps.

The deepest point of the underarm.

Render the transitions between each body part with spiraling or curved contour lines.

If the length of the shoulder to the elbow is not foreshortened, that part looks much longer than the elbow protruding toward the foreground.

3

Representing Each Body Part and Its Muscles

When doing a quick sketch of a moving human figure, we start by verifying the positions of the large body parts (the head, chest, hips and torso), and then capture the position of the arms and legs that stretch out from them, as well as the forms of the prominent muscles that connect each part. To do this, it's necessary to understand how each body part looks when it moves, part by part. We'll start with the head and neck, and then proceed to the legs.

Capturing Movements of the Head and Neck

Start by studying the connection between the head and the neck (the cervical region).

Simplify the Head and the Neck

If you simplify the structure of the front-facing head and neck, the head is egg shaped.

And the neck is cylindrical.

Drawing the Movement of the Neck

Head Turned (Looking Back)

Draw the flow of the muscles to connect the head and the shoulders.

The starting point of the neck.

Diamond shape

Render the neck as a cylinder.

The Key Bones and Muscles (Front View)

The circles on the illustration show the protruding parts of the skull.

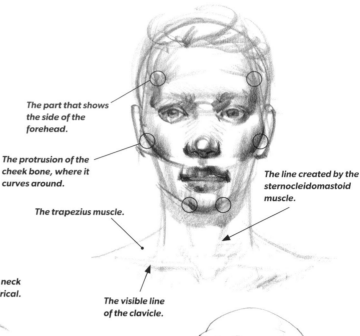

The part that shows the side of the forehead.

The protrusion of the cheek bone, where it curves around.

The trapezius muscle.

The line created by the sternocleidomastoid muscle.

The visible line of the clavicle.

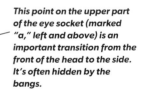

A skull viewed diagonally. The circles on the illustration indicate where it becomes more three-dimensional if you add some tonal lines.

This point on the upper part of the eye socket (marked "a," left and above) is an important transition from the front of the head to the side. It's often hidden by the bangs.

Don't overlook the protrusion of the 7th cervical vertebra.

The trapezius muscle looks as if it is protruding.

The line created by the shape of the scapula.

Chin Raised

The protruding Adam's apple (an inverted triangle).

▲ When the chin is raised, the neck becomes thicker and longer (the sternocleidomastoid muscle becomes taut).

Chin Lowered

▲ When the chin is lowered, the neck looks thinner and shorter (the sternocleidomastoid muscle slackens).

The Key Bones and Muscles (Back)

The border between the head and neck.

The trapezius muscle looks like a diamond-shaped protrusion.

The protrusion of the 7th cervical vertebra.

The protrusion of the 1st thoracic vertebra.

Humerus

Scapula

Chin Lowered (Side View)

◄ If you look at the lowered chin pose from the side, the protrusion of the 7th cervical *vertebra* is easy to see.

Focus on the Muscles of the Neck as You Draw

The Key Bones and Muscles (Side View)

The sternocleidomastoid muscles connect the skull to the clavicle and the sternum. When the neck moves, these muscles bulge out, and the "lines" on the neck become prominent.

The part connected to the sternum.

The part connected to the clavicle.

Only the neck is tilted.

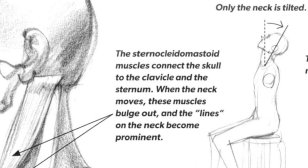

Looking Up (Neck Tilted)

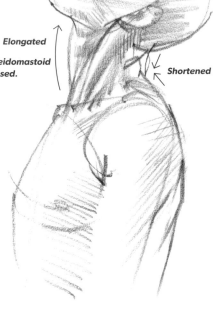

Elongated

The sternocleidomastoid muscle is tensed.

Shortened

Looking Up (Upper Body Tilted)

The upper body is tilted.

When the upper body is tilted backward, the sternocleidomastoid muscle supporting the head becomes tensed.

Looking Diagonally Downward

When the figure looks slightly to the side, the chin goes down.

The lines of the neck bulge out.

The sternocleidomastoid muscle connected to the sternum is more prominent.

Capture these two triangles on the neck.

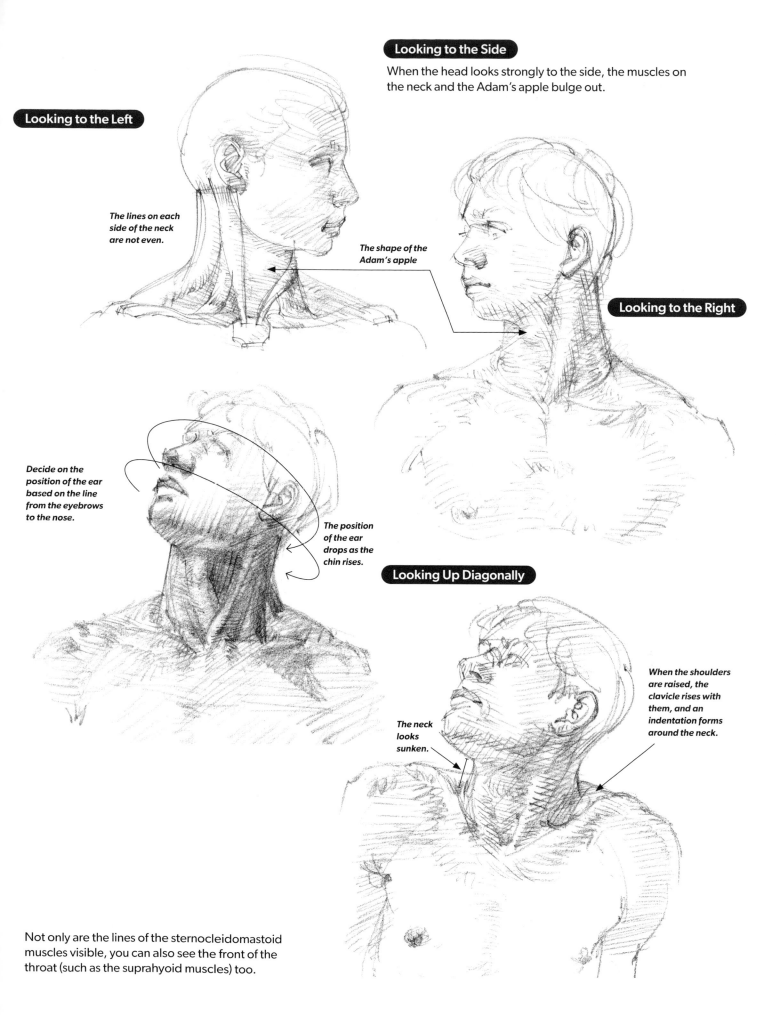

When the head looks strongly to the side, the muscles on the neck and the Adam's apple bulge out.

Looking to the Left

The lines on each side of the neck are not even.

The shape of the Adam's apple

Looking to the Right

Decide on the position of the ear based on the line from the eyebrows to the nose.

The position of the ear drops as the chin rises.

Looking Up Diagonally

The neck looks sunken.

When the shoulders are raised, the clavicle rises with them, and an indentation forms around the neck.

Not only are the lines of the sternocleidomastoid muscles visible, you can also see the front of the throat (such as the suprahyoid muscles) too.

Drawing Strong Movements

In movements where the neck is bent strongly or tilted to the back, the gap between the sternocleidomastoid muscles can look quite prominent.

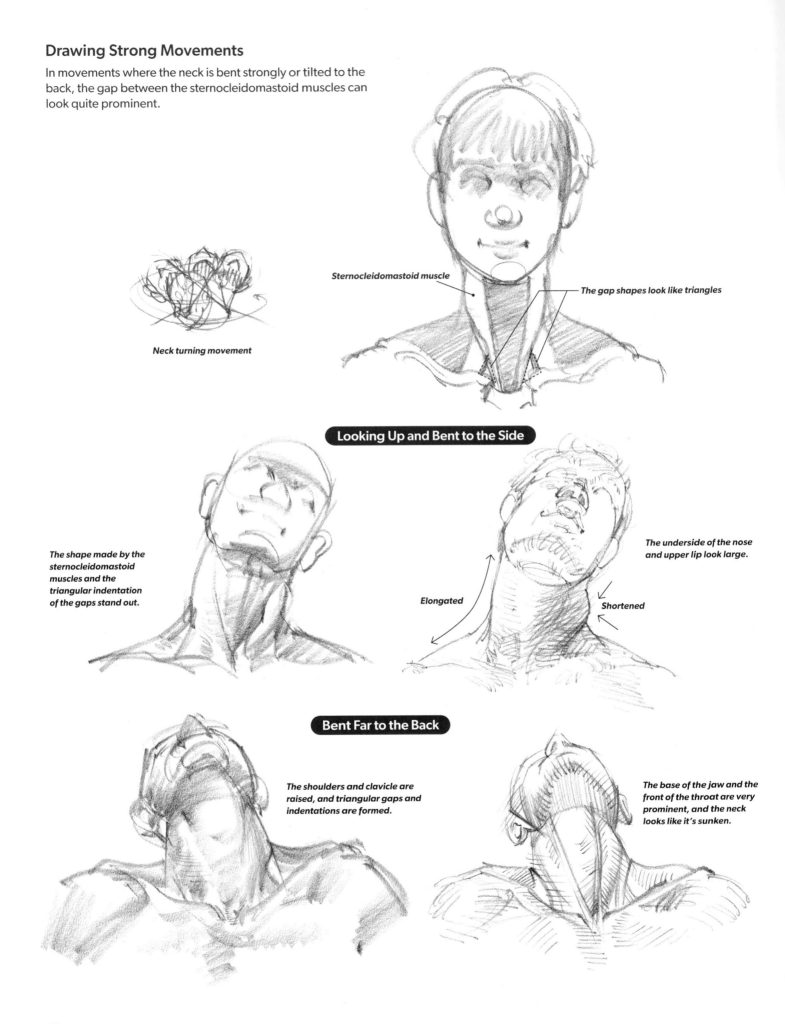

Neck turning movement

Sternocleidomastoid muscle

The gap shapes look like triangles

Looking Up and Bent to the Side

The shape made by the sternocleidomastoid muscles and the triangular indentation of the gaps stand out.

The underside of the nose and upper lip look large.

Elongated

Shortened

Bent Far to the Back

The shoulders and clavicle are raised, and triangular gaps and indentations are formed.

The base of the jaw and the front of the throat are very prominent, and the neck looks like it's sunken.

The Muscles that Stand Out When the Mouth is Opened

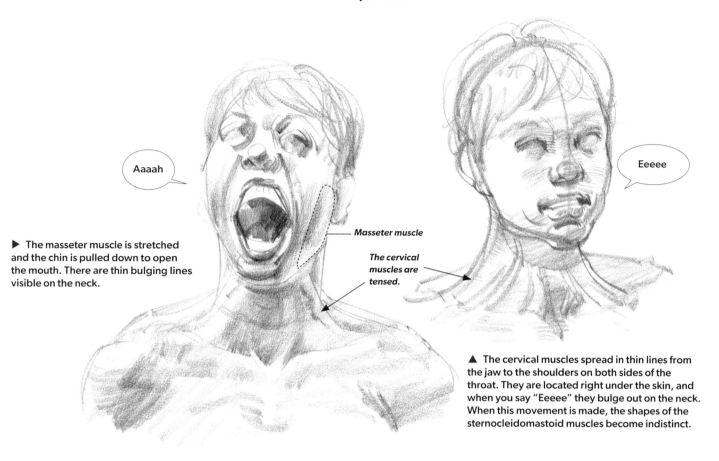

Aaaah

Eeeee

Masseter muscle

The cervical muscles are tensed.

▶ The masseter muscle is stretched and the chin is pulled down to open the mouth. There are thin bulging lines visible on the neck.

▲ The cervical muscles spread in thin lines from the jaw to the shoulders on both sides of the throat. They are located right under the skin, and when you say "Eeeee" they bulge out on the neck. When this movement is made, the shapes of the sternocleidomastoid muscles become indistinct.

Add Light to Dark Tones to Express a Sense of Three-dimensionality and Space

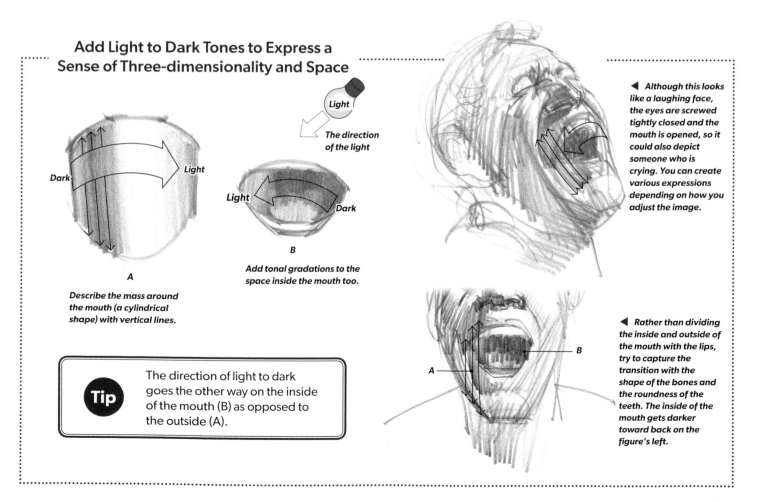

Light

The direction of the light

Dark

Light

Light

Dark

A

B

Describe the mass around the mouth (a cylindrical shape) with vertical lines.

Add tonal gradations to the space inside the mouth too.

◀ Although this looks like a laughing face, the eyes are screwed tightly closed and the mouth is opened, so it could also depict someone who is crying. You can create various expressions depending on how you adjust the image.

A

B

◀ Rather than dividing the inside and outside of the mouth with the lips, try to capture the transition with the shape of the bones and the roundness of the teeth. The inside of the mouth gets darker toward back on the figure's left.

Tip

The direction of light to dark goes the other way on the inside of the mouth (B) as opposed to the outside (A).

Capturing Movements of the Upper Body and Arms

Front and Diagonal Poses

Focus on the movements of the large parts of the torso above the hips (head and chest) and arms. The shapes of the chest and shoulders change corresponding to the movements of the arms.

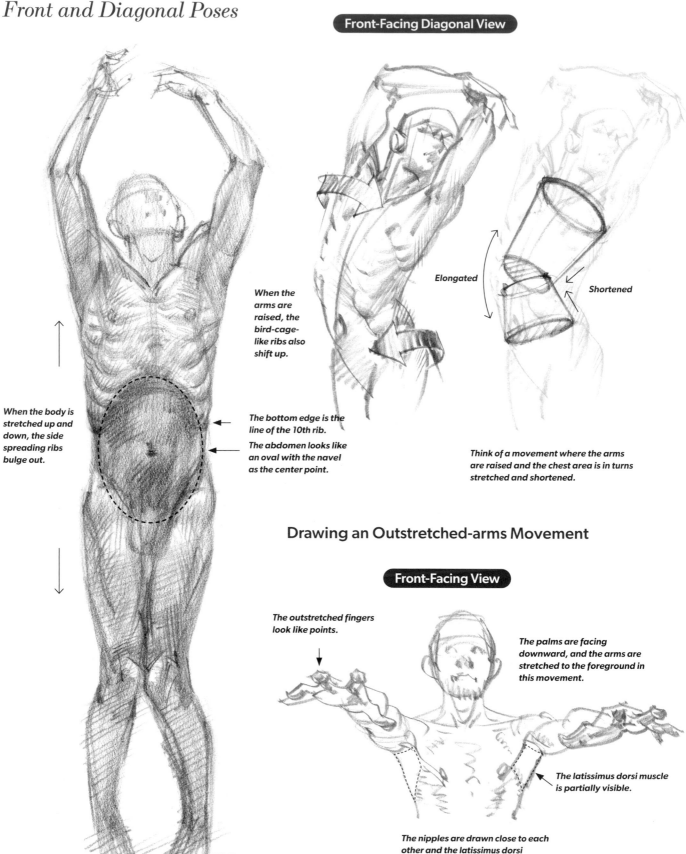

Front-Facing Diagonal View

When the arms are raised, the bird-cage-like ribs also shift up.

When the body is stretched up and down, the side spreading ribs bulge out.

The bottom edge is the line of the 10th rib.

The abdomen looks like an oval with the navel as the center point.

Elongated

Shortened

Think of a movement where the arms are raised and the chest area is in turns stretched and shortened.

Drawing an Outstretched-arms Movement

Front-Facing View

The outstretched fingers look like points.

The palms are facing downward, and the arms are stretched to the foreground in this movement.

The latissimus dorsi muscle is partially visible.

The nipples are drawn close to each other and the latissimus dorsi muscles are stretched apart.

Front View

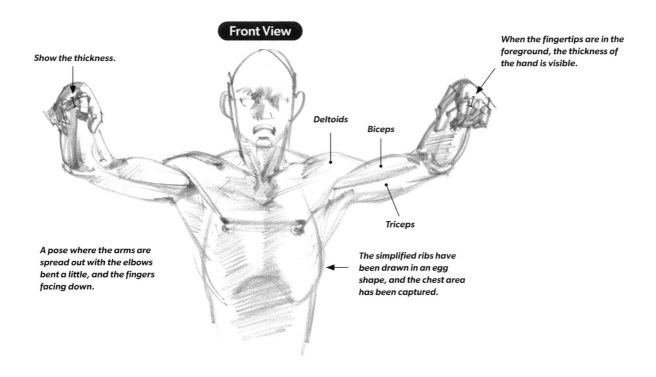

Show the thickness.

When the fingertips are in the foreground, the thickness of the hand is visible.

Deltoids

Biceps

Triceps

A pose where the arms are spread out with the elbows bent a little, and the fingers facing down.

The simplified ribs have been drawn in an egg shape, and the chest area has been captured.

Diagonal & Side View Landmark Bones and Muscles (Side View)

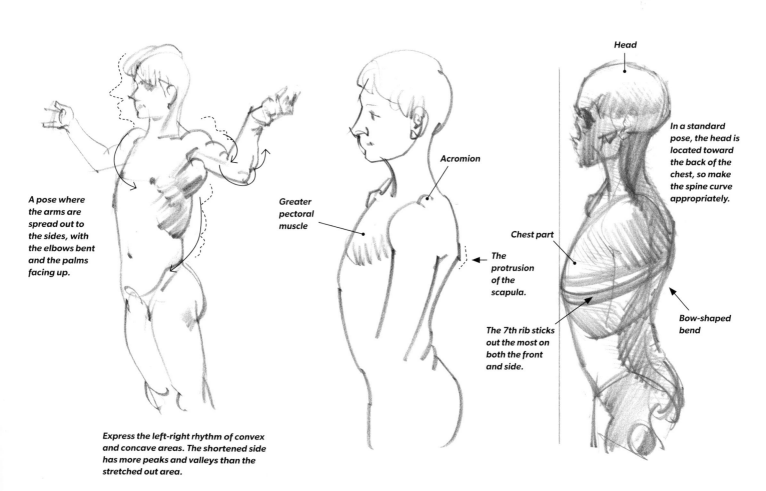

A pose where the arms are spread out to the sides, with the elbows bent and the palms facing up.

Express the left-right rhythm of convex and concave areas. The shortened side has more peaks and valleys than the stretched out area.

Greater pectoral muscle

Acromion

The protrusion of the scapula.

The 7th rib sticks out the most on both the front and side.

Head

In a standard pose, the head is located toward the back of the chest, so make the spine curve appropriately.

Chest part

Bow-shaped bend

Drawing the Movement of One Arm Raised with the Hand Tilted

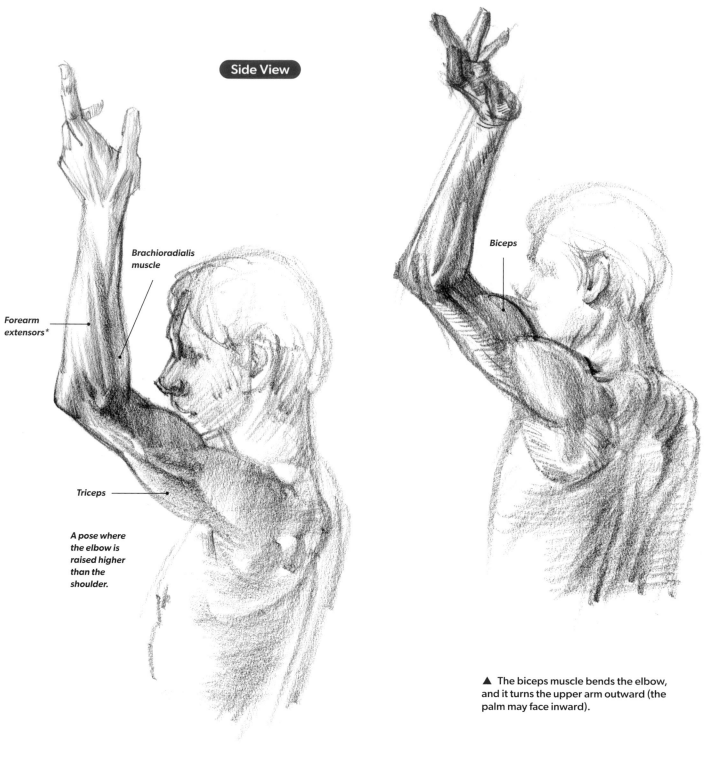

Side View

Brachioradialis
muscle

Biceps

Forearm
extensors*

Triceps

A pose where
the elbow is
raised higher
than the
shoulder.

▲ The biceps muscle bends the elbow,
and it turns the upper arm outward (the
palm may face inward).

▲ The brachioradialis muscle works to
bend the elbow. The triceps in the upper
arm are the muscles that straighten out
the elbow.

*Forearm extensors: The name for the group of muscles that stretch the wrist and fingers.

56

Capture the Rhythm of the Alternating Left-right Continuous Line

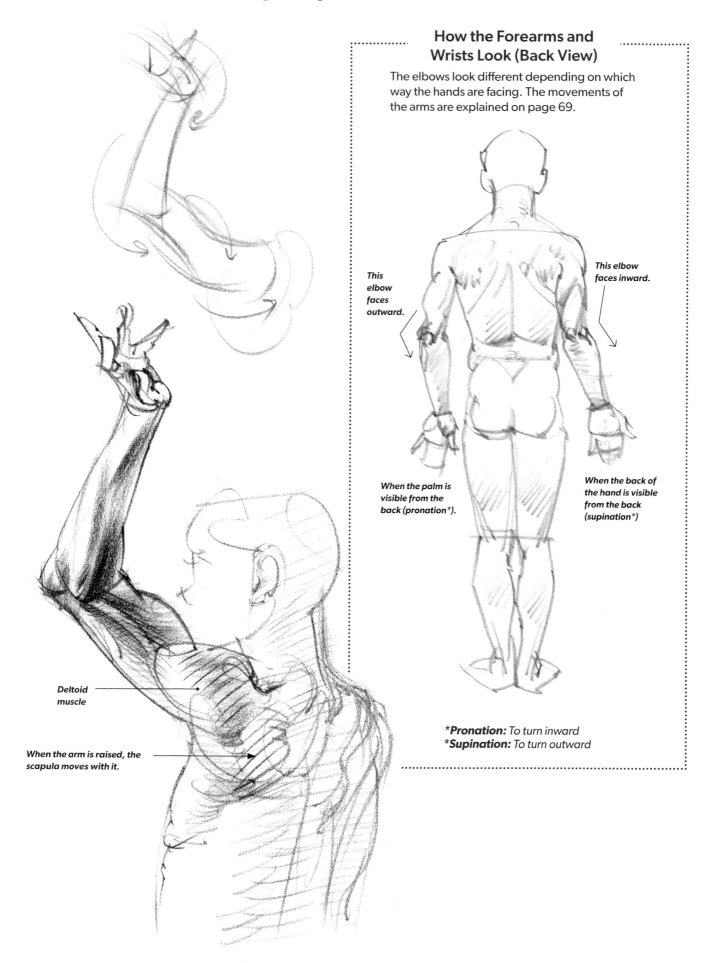

How the Forearms and Wrists Look (Back View)

The elbows look different depending on which way the hands are facing. The movements of the arms are explained on page 69.

This elbow faces outward.

This elbow faces inward.

When the palm is visible from the back (pronation).*

When the back of the hand is visible from the back (supination)*

Pronation: To turn inward
Supination: To turn outward

Deltoid muscle

When the arm is raised, the scapula moves with it.

Capturing Movements of the Back and Arms

Observe the upper body from the back, and draw the various expressions caused by the movements of the arms that can be seen in the muscles of the back.

1) Drawing the Movement of a Gradually Raised Arm

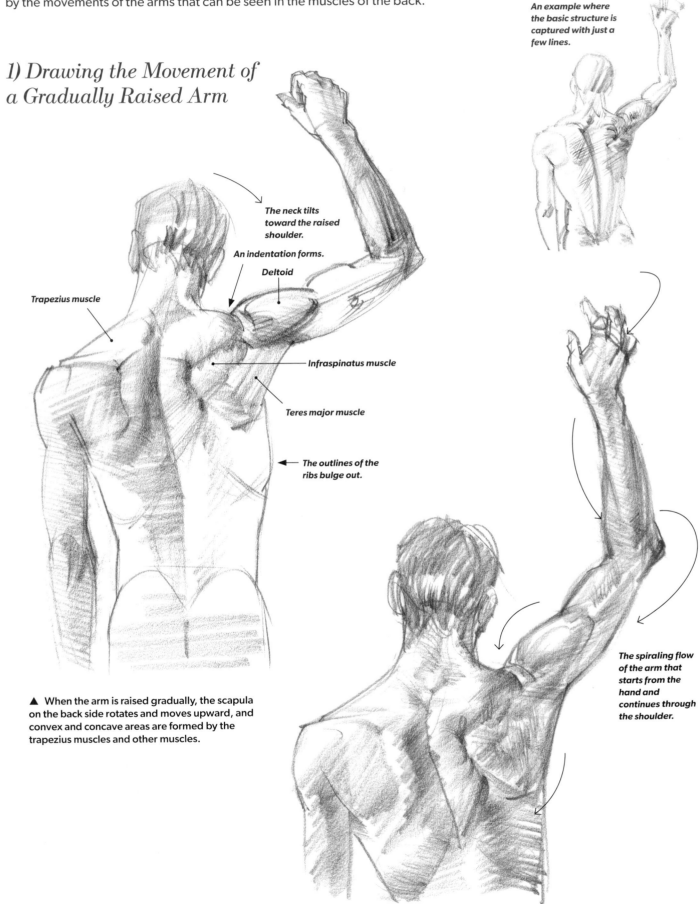

An example where the basic structure is captured with just a few lines.

The neck tilts toward the raised shoulder.

An indentation forms.

Deltoid

Trapezius muscle

Infraspinatus muscle

Teres major muscle

The outlines of the ribs bulge out.

▲ When the arm is raised gradually, the scapula on the back side rotates and moves upward, and convex and concave areas are formed by the trapezius muscles and other muscles.

The spiraling flow of the arm that starts from the hand and continues through the shoulder.

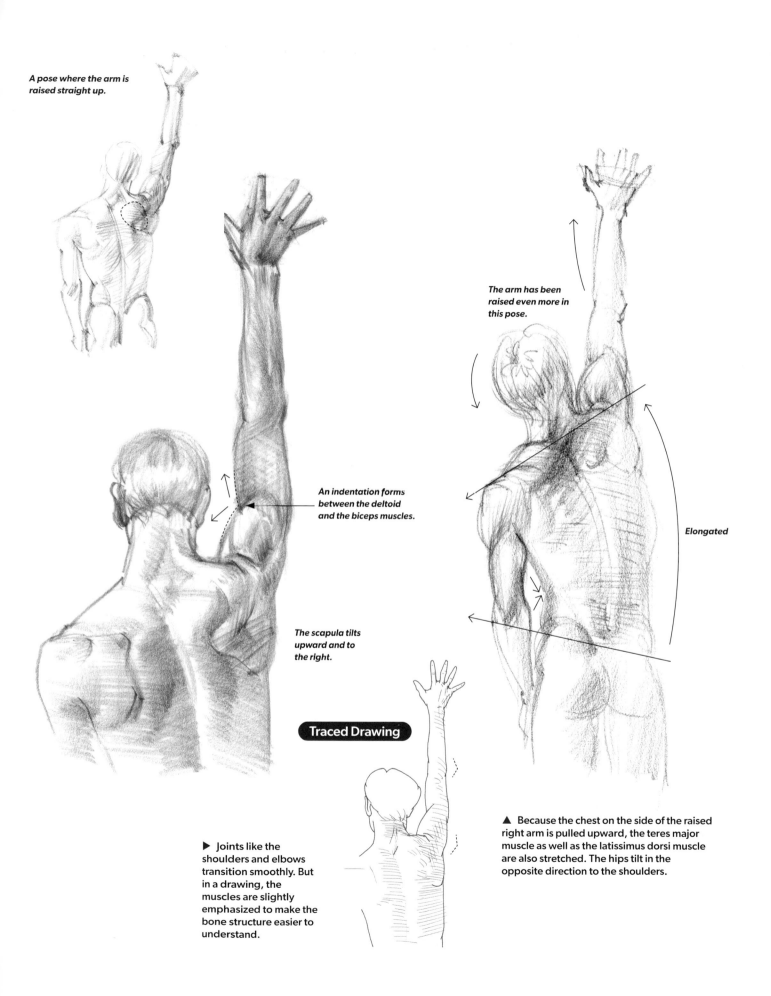

A pose where the arm is raised straight up.

The arm has been raised even more in this pose.

An indentation forms between the deltoid and the biceps muscles.

Elongated

The scapula tilts upward and to the right.

Traced Drawing

▶ Joints like the shoulders and elbows transition smoothly. But in a drawing, the muscles are slightly emphasized to make the bone structure easier to understand.

▲ Because the chest on the side of the raised right arm is pulled upward, the teres major muscle as well as the latissimus dorsi muscle are also stretched. The hips tilt in the opposite direction to the shoulders.

2) Drawing the Movement of an Arm Stretched to the Side and then Lowered

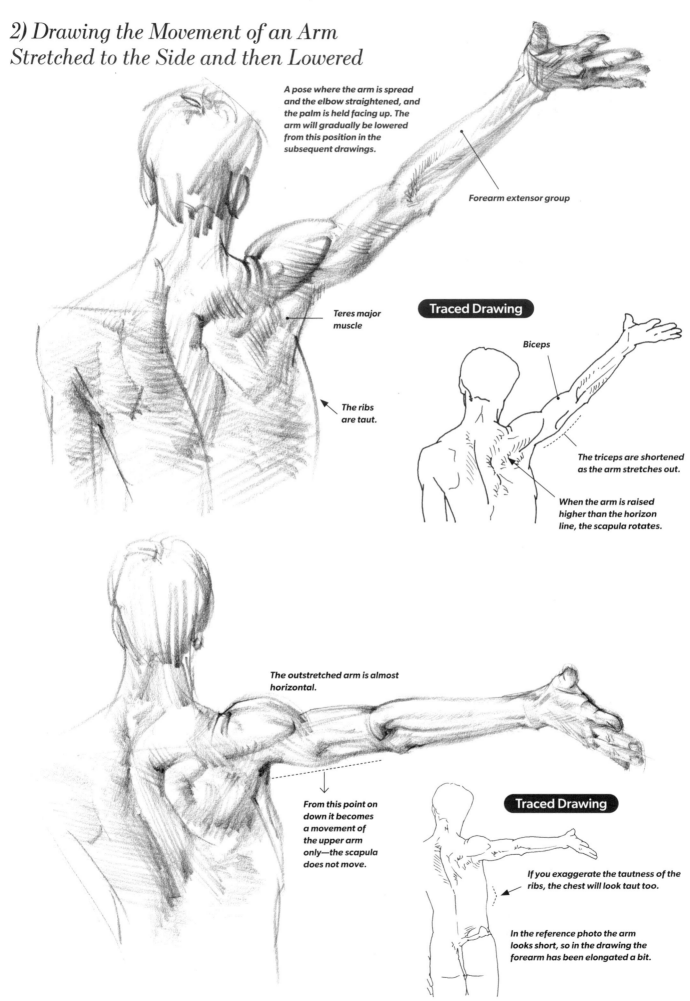

A pose where the arm is spread and the elbow straightened, and the palm is held facing up. The arm will gradually be lowered from this position in the subsequent drawings.

Forearm extensor group

Teres major muscle

The ribs are taut.

Traced Drawing

Biceps

The triceps are shortened as the arm stretches out.

When the arm is raised higher than the horizon line, the scapula rotates.

The outstretched arm is almost horizontal.

From this point on down it becomes a movement of the upper arm only—the scapula does not move.

Traced Drawing

If you exaggerate the tautness of the ribs, the chest will look taut too.

In the reference photo the arm looks short, so in the drawing the forearm has been elongated a bit.

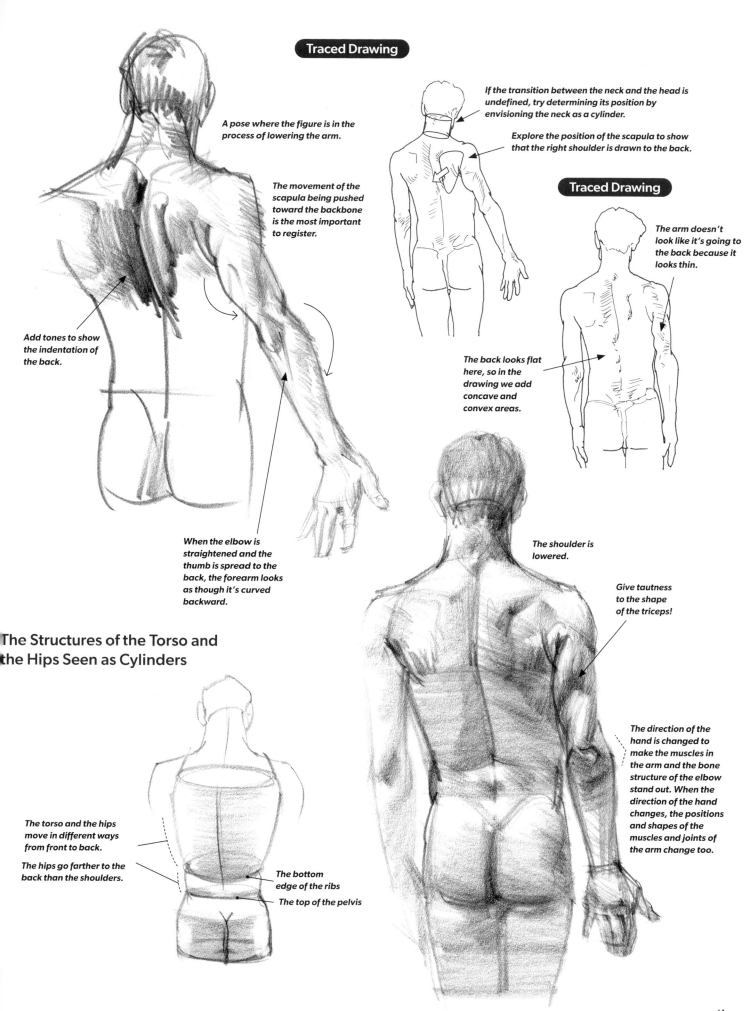

A pose where the figure is in the process of lowering the arm.

The movement of the scapula being pushed toward the backbone is the most important to register.

If the transition between the neck and the head is undefined, try determining its position by envisioning the neck as a cylinder.

Explore the position of the scapula to show that the right shoulder is drawn to the back.

The arm doesn't look like it's going to the back because it looks thin.

Add tones to show the indentation of the back.

The back looks flat here, so in the drawing we add concave and convex areas.

When the elbow is straightened and the thumb is spread to the back, the forearm looks as though it's curved backward.

The shoulder is lowered.

Give tautness to the shape of the triceps!

The Structures of the Torso and the Hips Seen as Cylinders

The direction of the hand is changed to make the muscles in the arm and the bone structure of the elbow stand out. When the direction of the hand changes, the positions and shapes of the muscles and joints of the arm change too.

The torso and the hips move in different ways from front to back.

The hips go farther to the back than the shoulders.

The bottom edge of the ribs

The top of the pelvis

3) Drawing a Bent Elbow Pose

The pose and proportions seen in the reference photo are significantly altered in the drawing.

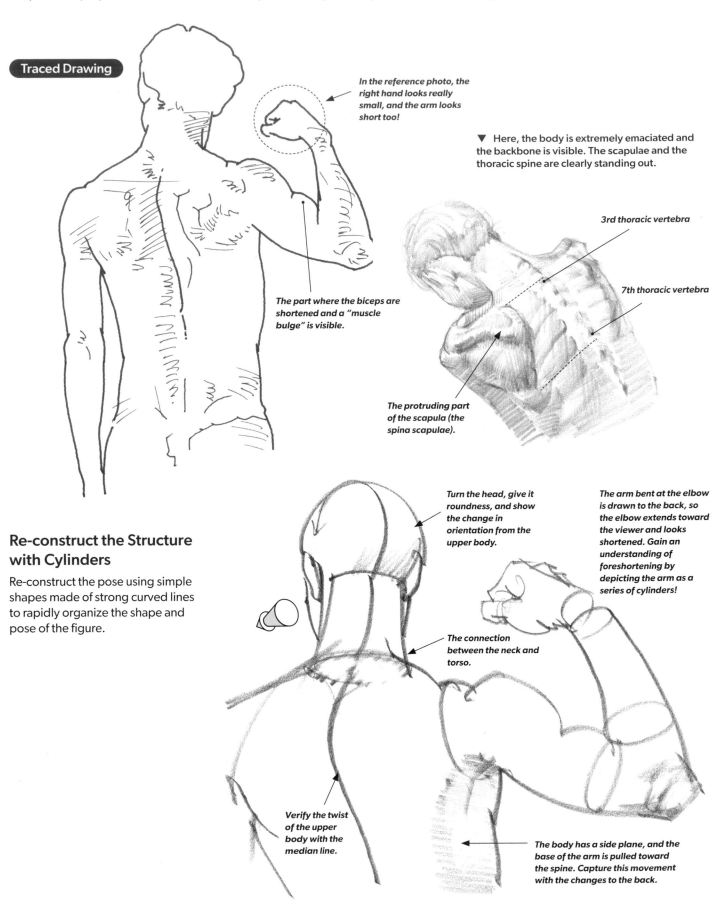

Traced Drawing

In the reference photo, the right hand looks really small, and the arm looks short too!

▼ Here, the body is extremely emaciated and the backbone is visible. The scapulae and the thoracic spine are clearly standing out.

The part where the biceps are shortened and a "muscle bulge" is visible.

3rd thoracic vertebra

7th thoracic vertebra

The protruding part of the scapula (the spina scapulae).

Re-construct the Structure with Cylinders

Re-construct the pose using simple shapes made of strong curved lines to rapidly organize the shape and pose of the figure.

Turn the head, give it roundness, and show the change in orientation from the upper body.

The arm bent at the elbow is drawn to the back, so the elbow extends toward the viewer and looks shortened. Gain an understanding of foreshortening by depicting the arm as a series of cylinders!

The connection between the neck and torso.

Verify the twist of the upper body with the median line.

The body has a side plane, and the base of the arm is pulled toward the spine. Capture this movement with the changes to the back.

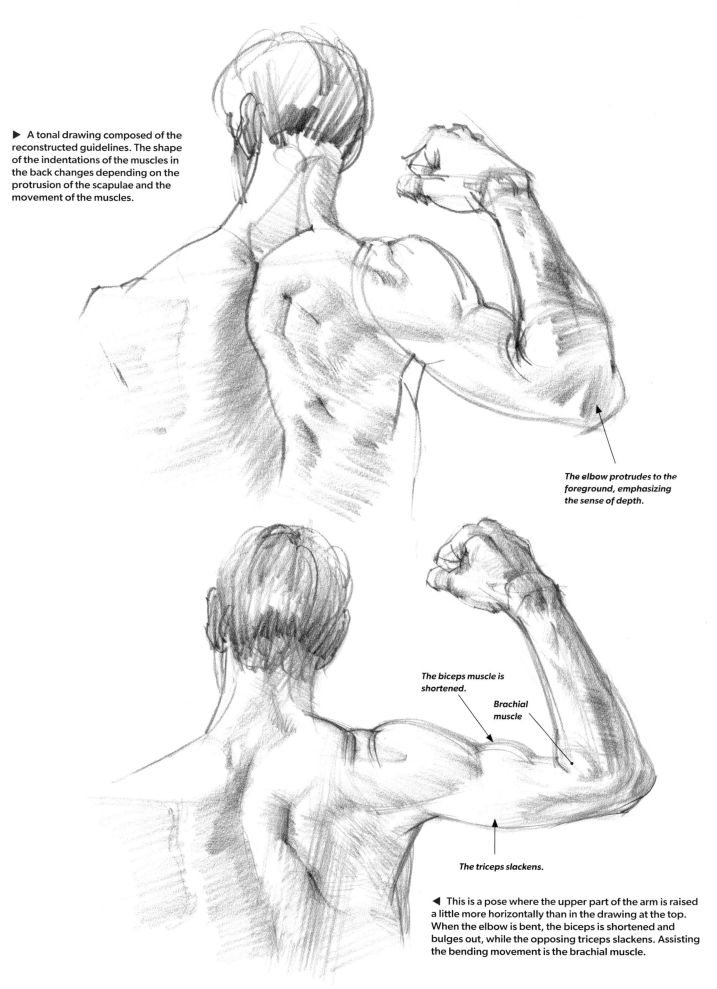

▶ A tonal drawing composed of the reconstructed guidelines. The shape of the indentations of the muscles in the back changes depending on the protrusion of the scapulae and the movement of the muscles.

The elbow protrudes to the foreground, emphasizing the sense of depth.

The biceps muscle is shortened.

Brachial muscle

The triceps slackens.

◀ This is a pose where the upper part of the arm is raised a little more horizontally than in the drawing at the top. When the elbow is bent, the biceps is shortened and bulges out, while the opposing triceps slackens. Assisting the bending movement is the brachial muscle.

4) Drawing the Connection Between the Arm and the Shoulder

The scapula is connected to the top and bottom of the arm and shoulder. In order to draw a realistic back, gain a good understanding of the scapula and the muscles surrounding it.

The Key Bones (Back)

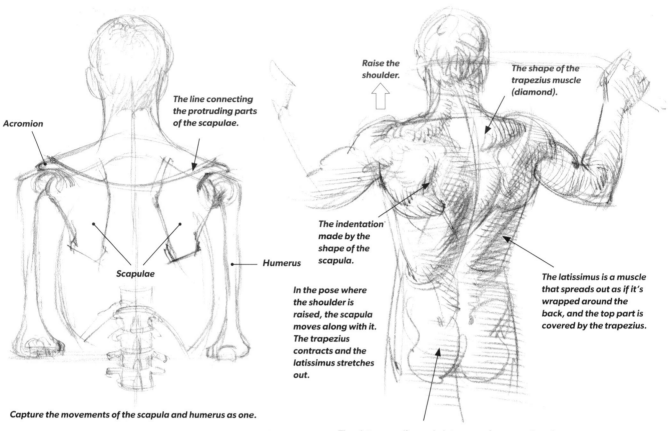

Acromion

The line connecting the protruding parts of the scapulae.

Scapulae

Humerus

Capture the movements of the scapula and humerus as one.

Raise the shoulder.

The shape of the trapezius muscle (diamond).

The indentation made by the shape of the scapula.

In the pose where the shoulder is raised, the scapula moves along with it. The trapezius contracts and the latissimus stretches out.

The latissimus is a muscle that spreads out as if it's wrapped around the back, and the top part is covered by the trapezius.

The gluteus medius and gluteus maximus muscles of the buttocks are simplified as butterfly shapes.

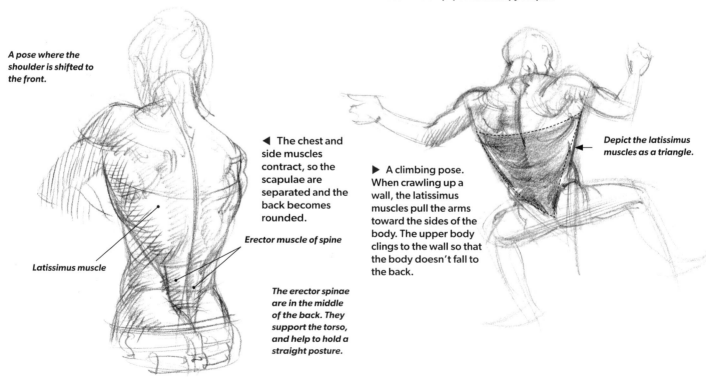

A pose where the shoulder is shifted to the front.

◄ The chest and side muscles contract, so the scapulae are separated and the back becomes rounded.

Erector muscle of spine

Latissimus muscle

The erector spinae are in the middle of the back. They support the torso, and help to hold a straight posture.

▶ A climbing pose. When crawling up a wall, the latissimus muscles pull the arms toward the sides of the body. The upper body clings to the wall so that the body doesn't fall to the back.

Depict the latissimus muscles as a triangle.

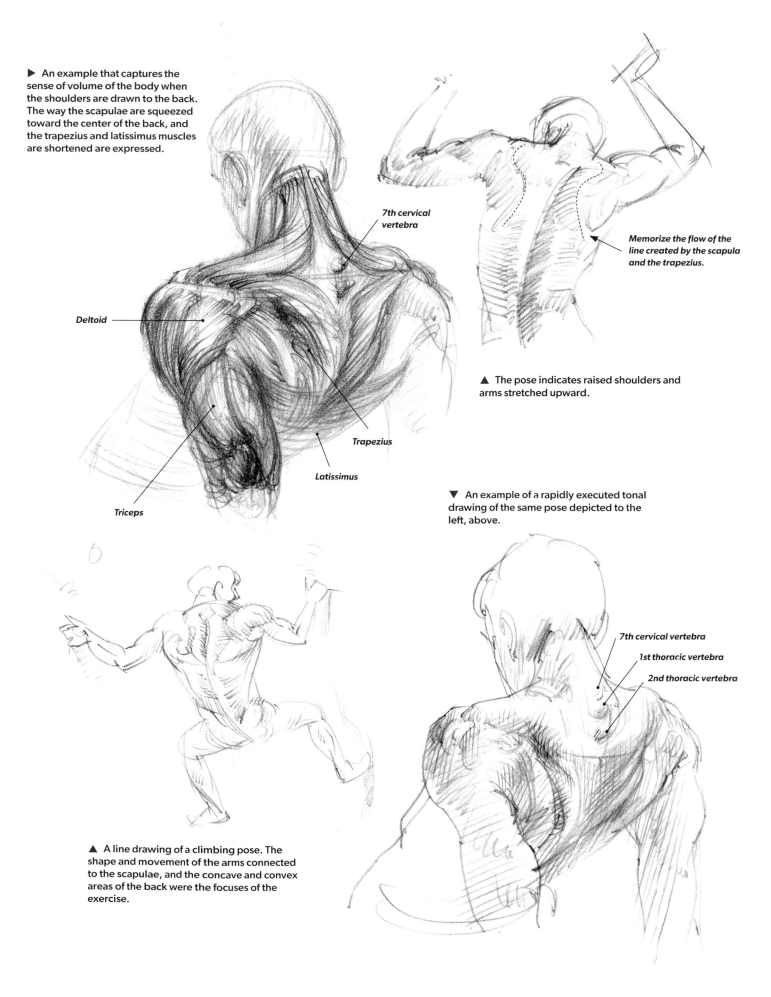

► An example that captures the sense of volume of the body when the shoulders are drawn to the back. The way the scapulae are squeezed toward the center of the back, and the trapezius and latissimus muscles are shortened are expressed.

7th cervical vertebra

Deltoid

Triceps

Trapezius

Latissimus

Memorize the flow of the line created by the scapula and the trapezius.

▲ The pose indicates raised shoulders and arms stretched upward.

▼ An example of a rapidly executed tonal drawing of the same pose depicted to the left, above.

7th cervical vertebra

1st thoracic vertebra

2nd thoracic vertebra

▲ A line drawing of a climbing pose. The shape and movement of the arms connected to the scapulae, and the concave and convex areas of the back were the focuses of the exercise.

5) Drawing Inclined and Twisted Poses

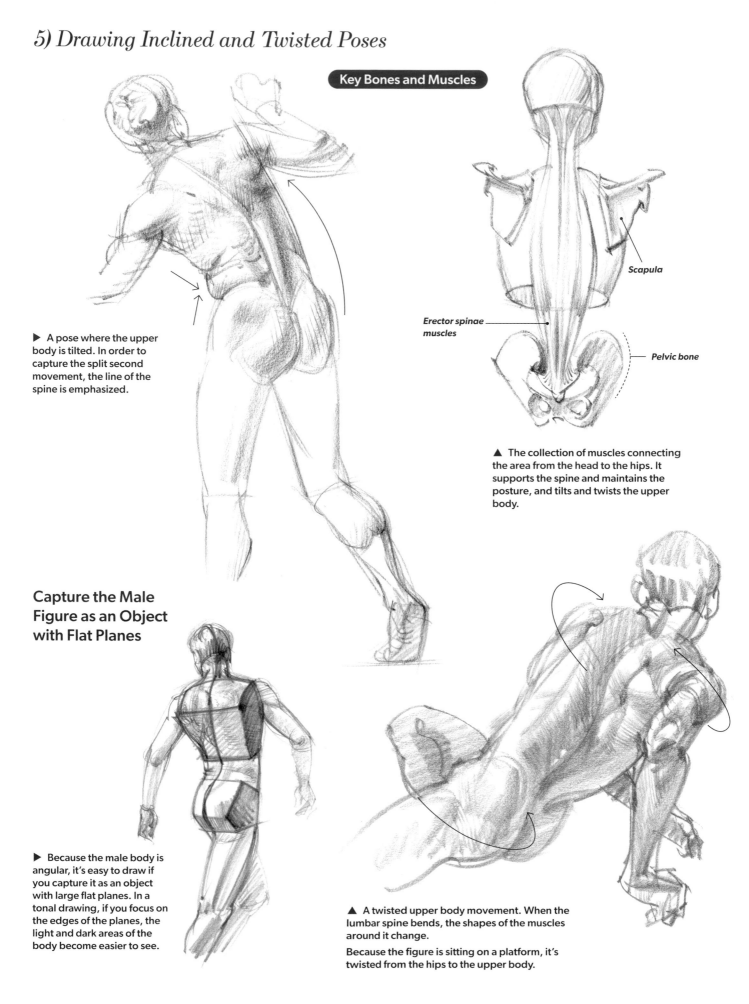

Key Bones and Muscles

Scapula

Erector spinae muscles

Pelvic bone

▶ A pose where the upper body is tilted. In order to capture the split second movement, the line of the spine is emphasized.

▲ The collection of muscles connecting the area from the head to the hips. It supports the spine and maintains the posture, and tilts and twists the upper body.

Capture the Male Figure as an Object with Flat Planes

▶ Because the male body is angular, it's easy to draw if you capture it as an object with large flat planes. In a tonal drawing, if you focus on the edges of the planes, the light and dark areas of the body become easier to see.

▲ A twisted upper body movement. When the lumbar spine bends, the shapes of the muscles around it change.

Because the figure is sitting on a platform, it's twisted from the hips to the upper body.

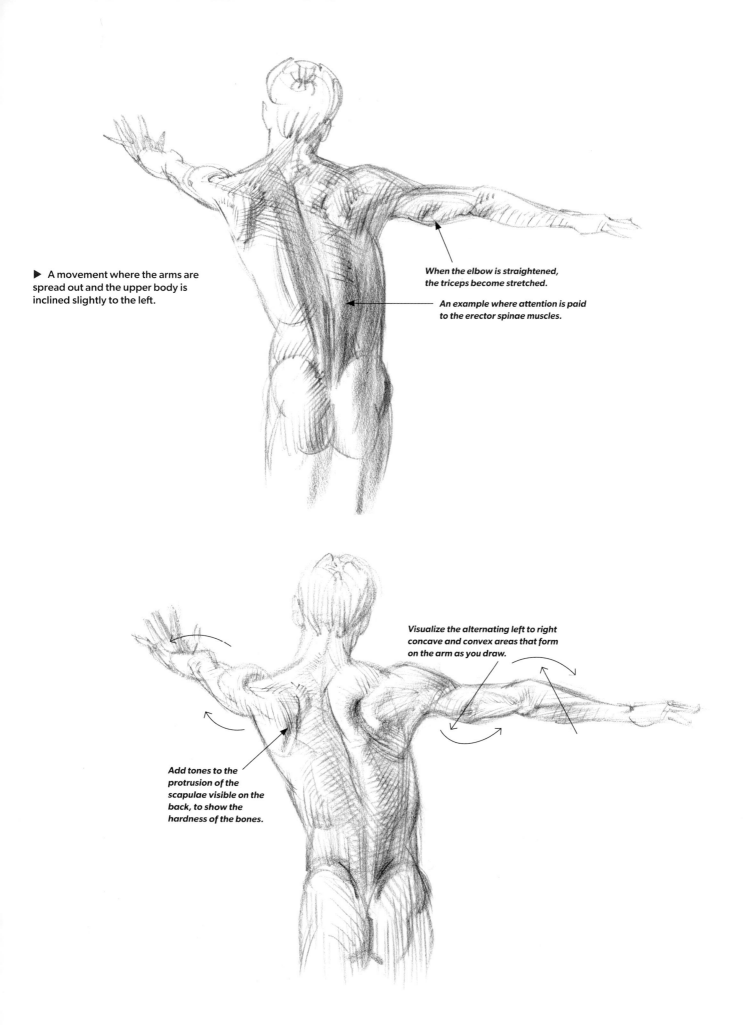

▶ A movement where the arms are spread out and the upper body is inclined slightly to the left.

When the elbow is straightened, the triceps become stretched.

An example where attention is paid to the erector spinae muscles.

Visualize the alternating left to right concave and convex areas that form on the arm as you draw.

Add tones to the protrusion of the scapulae visible on the back, to show the hardness of the bones.

Capturing Movements from the Arm to the Hand

Understand that the movements of the hand are connected to the arm
as you draw. Start by looking at the structure of rotating movements.

1) Think About the Movement of a Rotating Arm

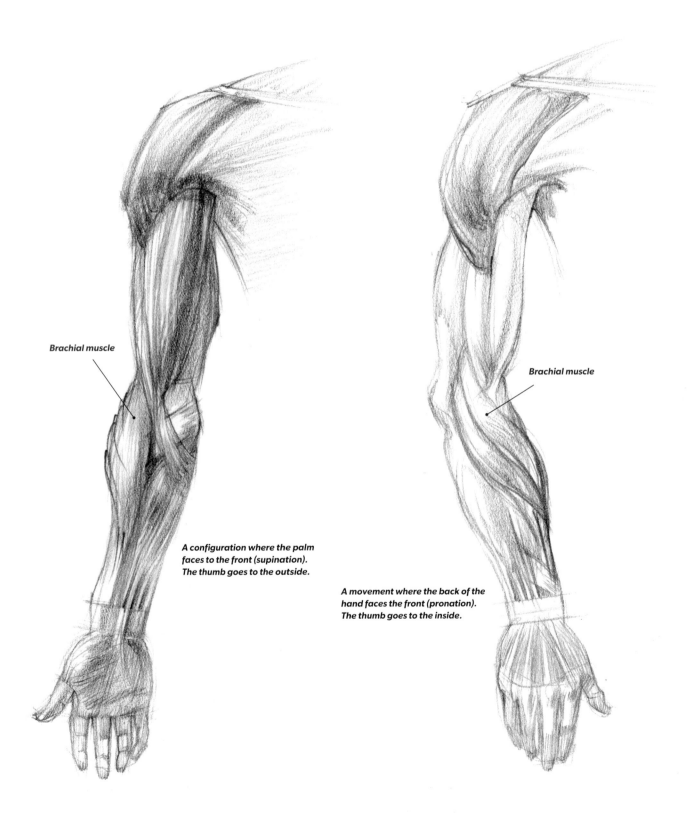

Brachial muscle

Brachial muscle

A configuration where the palm faces to the front (supination). The thumb goes to the outside.

A movement where the back of the hand faces the front (pronation). The thumb goes to the inside.

Changes to the Arm when it Rotates (Front View)

Here are examples where the arm is depicted with simplified lines. The upper arm rotates as does the wrist. When the hand is flipped over, the deltoid changes too.

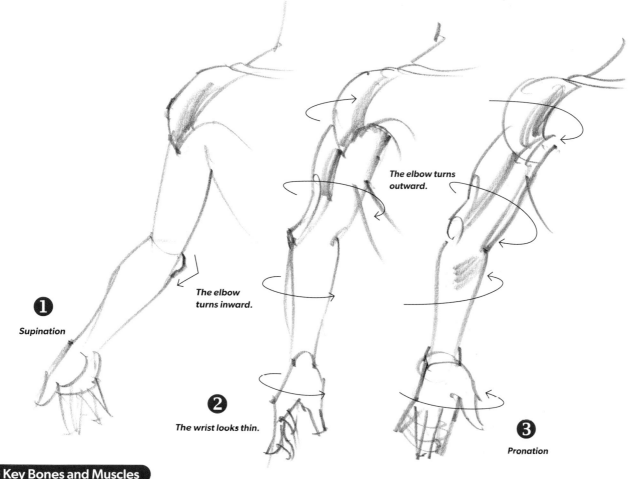

❶ Supination

The elbow turns inward.

The elbow turns outward.

❷

The wrist looks thin.

❸

Pronation

The Key Bones and Muscles

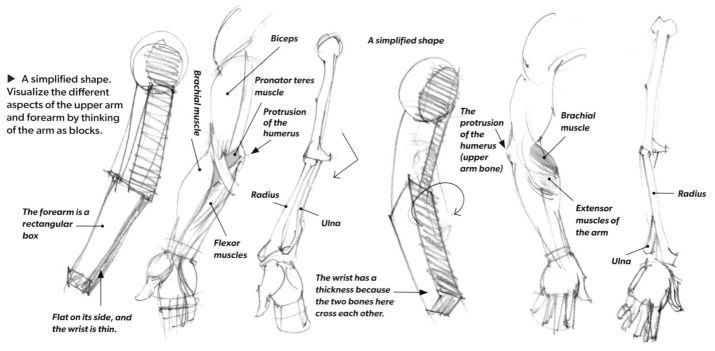

▶ A simplified shape. Visualize the different aspects of the upper arm and forearm by thinking of the arm as blocks.

The forearm is a rectangular box

Flat on its side, and the wrist is thin.

Brachial muscle

Biceps

Pronator teres muscle

Protrusion of the humerus

Flexor muscles

Radius

Ulna

A simplified shape

The protrusion of the humerus (upper arm bone)

The wrist has a thickness because the two bones here cross each other.

Brachial muscle

Extensor muscles of the arm

Radius

Ulna

▲ The muscles of the forearm are parallel to each other.

▲ The two bones of the forearm are also parallel to each other.

▲ The brachial muscles are twisted.

▲ The radius moves to form an X shape with the ulna.

2) Drawing the Positions of the Shoulder to the Hand

Depict the spiraling movement that stretches and twists from the shoulder to the fingertips.

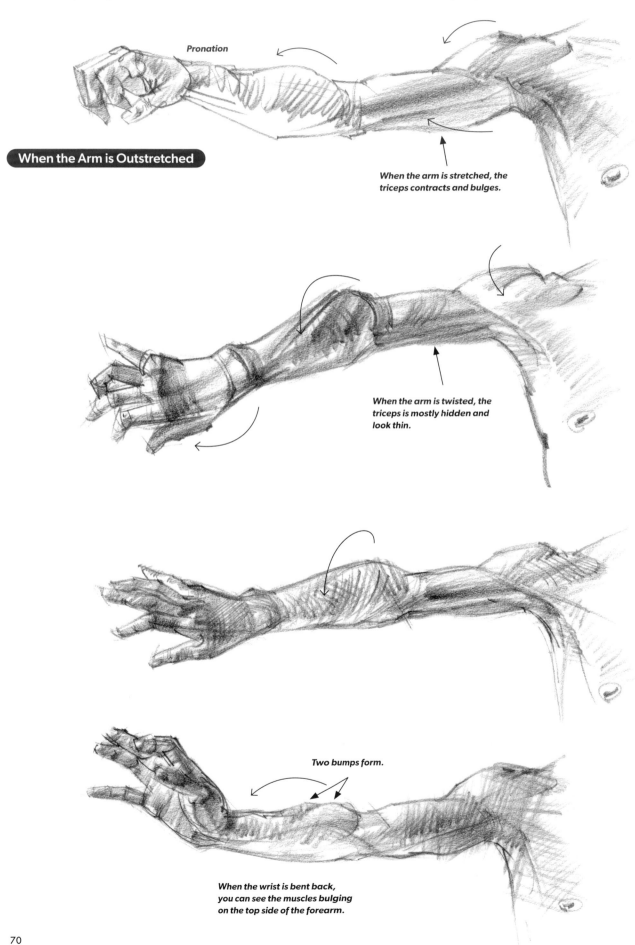

Pronation

When the Arm is Outstretched

When the arm is stretched, the triceps contracts and bulges.

When the arm is twisted, the triceps is mostly hidden and look thin.

Two bumps form.

When the wrist is bent back, you can see the muscles bulging on the top side of the forearm.

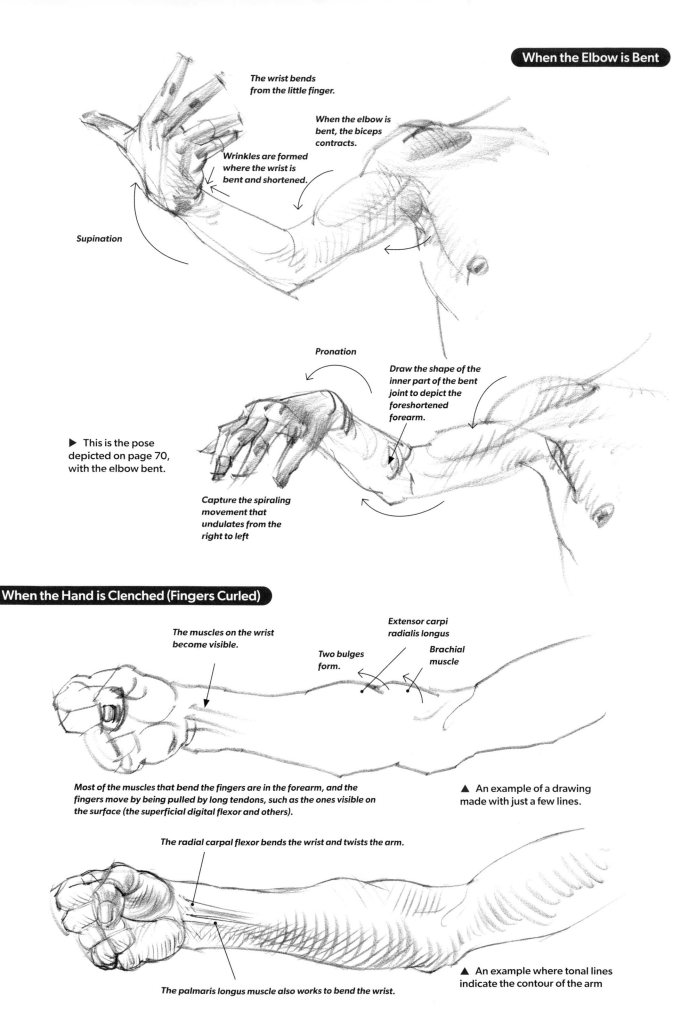

The wrist bends from the little finger.

When the elbow is bent, the biceps contracts.

Wrinkles are formed where the wrist is bent and shortened.

Supination

Pronation

Draw the shape of the inner part of the bent joint to depict the foreshortened forearm.

▶ This is the pose depicted on page 70, with the elbow bent.

Capture the spiraling movement that undulates from the right to left

When the Hand is Clenched (Fingers Curled)

The muscles on the wrist become visible.

Extensor carpi radialis longus

Two bulges form.

Brachial muscle

Most of the muscles that bend the fingers are in the forearm, and the fingers move by being pulled by long tendons, such as the ones visible on the surface (the superficial digital flexor and others).

▲ An example of a drawing made with just a few lines.

The radial carpal flexor bends the wrist and twists the arm.

The palmaris longus muscle also works to bend the wrist.

▲ An example where tonal lines indicate the contour of the arm

71

3) Drawing the Twisting Motion of an Outstretched Hand

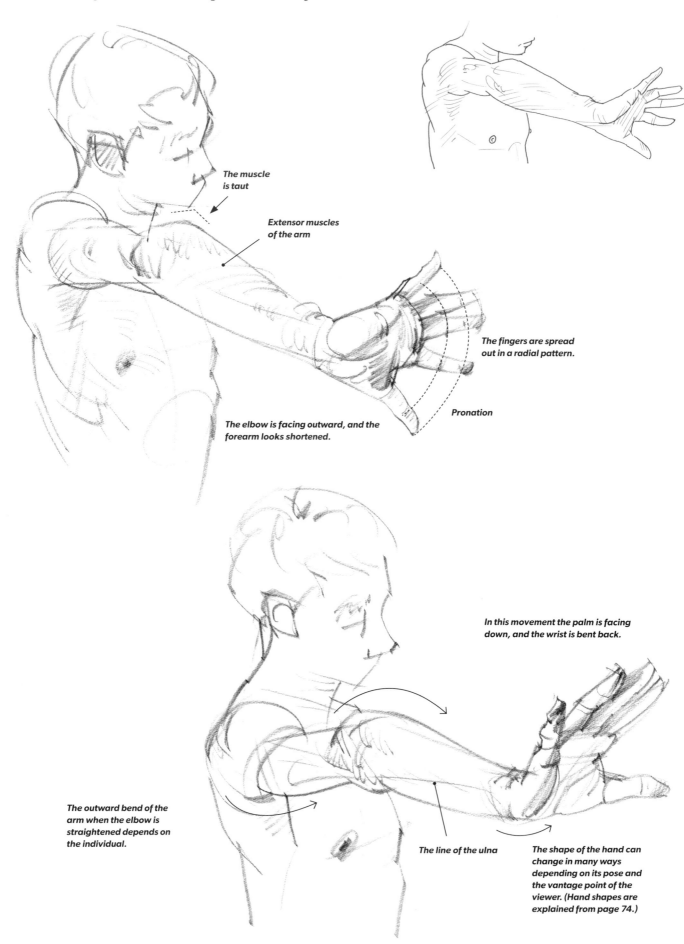

The muscle is taut

Extensor muscles of the arm

The fingers are spread out in a radial pattern.

Pronation

The elbow is facing outward, and the forearm looks shortened.

In this movement the palm is facing down, and the wrist is bent back.

The outward bend of the arm when the elbow is straightened depends on the individual.

The line of the ulna

The shape of the hand can change in many ways depending on its pose and the vantage point of the viewer. (Hand shapes are explained from page 74.)

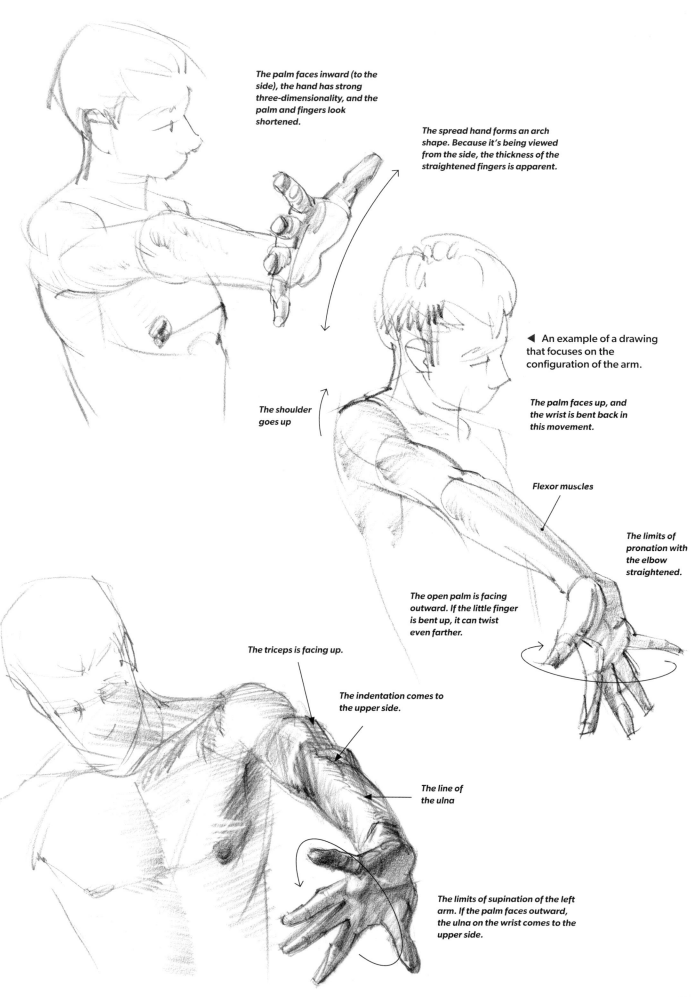

The palm faces inward (to the side), the hand has strong three-dimensionality, and the palm and fingers look shortened.

The spread hand forms an arch shape. Because it's being viewed from the side, the thickness of the straightened fingers is apparent.

◀ An example of a drawing that focuses on the configuration of the arm.

The palm faces up, and the wrist is bent back in this movement.

The shoulder goes up

Flexor muscles

The limits of pronation with the elbow straightened.

The open palm is facing outward. If the little finger is bent up, it can twist even farther.

The triceps is facing up.

The indentation comes to the upper side.

The line of the ulna

The limits of supination of the left arm. If the palm faces outward, the ulna on the wrist comes to the upper side.

Capturing Movements of the Hands and Fingers

Drawing a Tensed Pose

Be aware of whether the muscles are tensed or relaxed as you draw the form. When the fingers are stretched toward or away from you, perspective is applied, so the palm and fingers look shorter than they actually are.

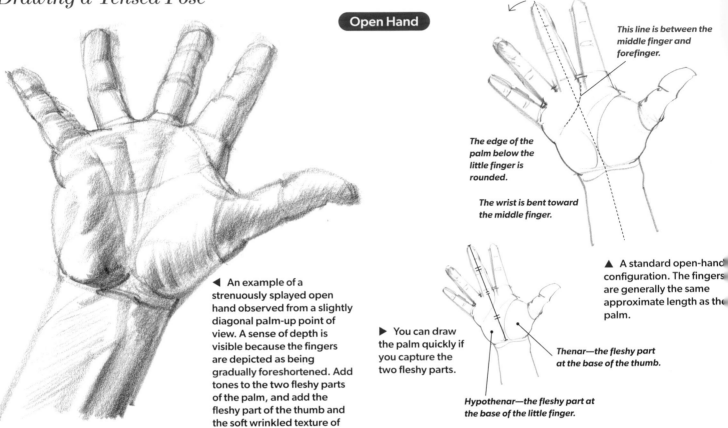

Open Hand

This line is between the middle finger and forefinger.

The edge of the palm below the little finger is rounded.

The wrist is bent toward the middle finger.

▲ A standard open-hand configuration. The fingers are generally the same approximate length as the palm.

▶ You can draw the palm quickly if you capture the two fleshy parts.

Thenar—the fleshy part at the base of the thumb.

Hypothenar—the fleshy part at the base of the little finger.

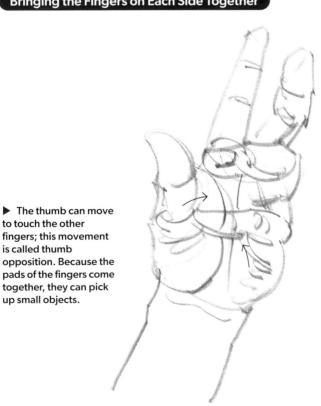

◀ An example of a strenuously splayed open hand observed from a slightly diagonal palm-up point of view. A sense of depth is visible because the fingers are depicted as being gradually foreshortened. Add tones to the two fleshy parts of the palm, and add the fleshy part of the thumb and the soft wrinkled texture of the hypothenar (the outer side of the palm).

Bringing the Fingers on Each Side Together

▶ The thumb can move to touch the other fingers; this movement is called thumb opposition. Because the pads of the fingers come together, they can pick up small objects.

◀ A pose centered around the middle finger and forefinger with the thumb and little finger coming together as if they are wrapping around the hand.

An example where the flow of the shape and wrinkles are captured with just a few lines.

Tonal Drawing

An example where the three-dimensionality is emphasized through dark and light patterns. Because the front and back shapes are defined, the sense of space is heightened.

Light Dark

Think of these two fingers as one unit.

Light

Dark

Pursed Hand Outstretched to the Side

Lines + Tones Drawing

An example of a drawing that combines a line drawing that captures the flow of the wrinkles on the hand with light and dark tones. It expresses the indentation created by the cupped palm. Because the back fingers point toward the foreground, the thickness of the area between the fingers is visible.

Open Hand Stretching Up Diagonally

An example of the back of the hand observed from the side. When the opened hand is tensed, raised lines form on the back of the hand.

Add reflected light* here. Put light tones on the underside of the fingers to give them roundness.

*Reflected light: Light that hits surrounding adjacent surfaces and is reflected back, lightening the shadows. That lightness is placed to show the rounded areas of the shape.

The indentation defined by two tendons here is nicknamed the "anatomical snuffbox!"

Drawing a Relaxed Hand

▶ An example of a drawing of a relaxed, naturally open hand seen from the thumb side. Wrinkles form on the palm and the wrist. You can see the palm and part of the back of the hand from this thumb-side angle, and it's easy to get a sense of the hand's volume.

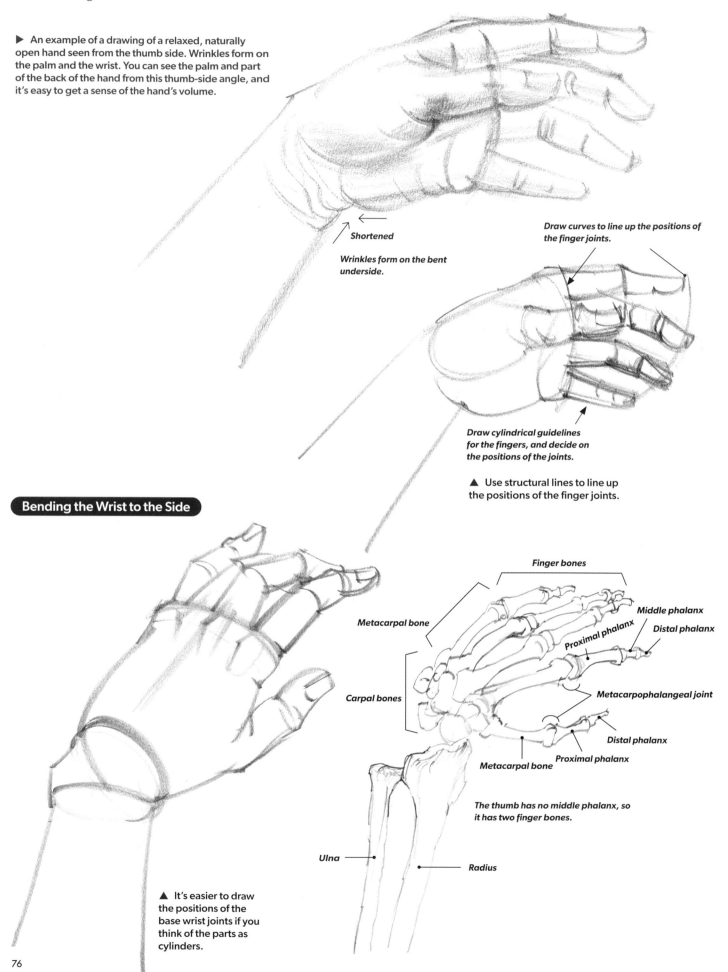

Shortened

Wrinkles form on the bent underside.

Draw curves to line up the positions of the finger joints.

Draw cylindrical guidelines for the fingers, and decide on the positions of the joints.

▲ Use structural lines to line up the positions of the finger joints.

Bending the Wrist to the Side

▲ It's easier to draw the positions of the base wrist joints if you think of the parts as cylinders.

Finger bones

Metacarpal bone

Middle phalanx

Distal phalanx

Proximal phalanx

Carpal bones

Metacarpophalangeal joint

Distal phalanx

Metacarpal bone

Proximal phalanx

The thumb has no middle phalanx, so it has two finger bones.

Ulna

Radius

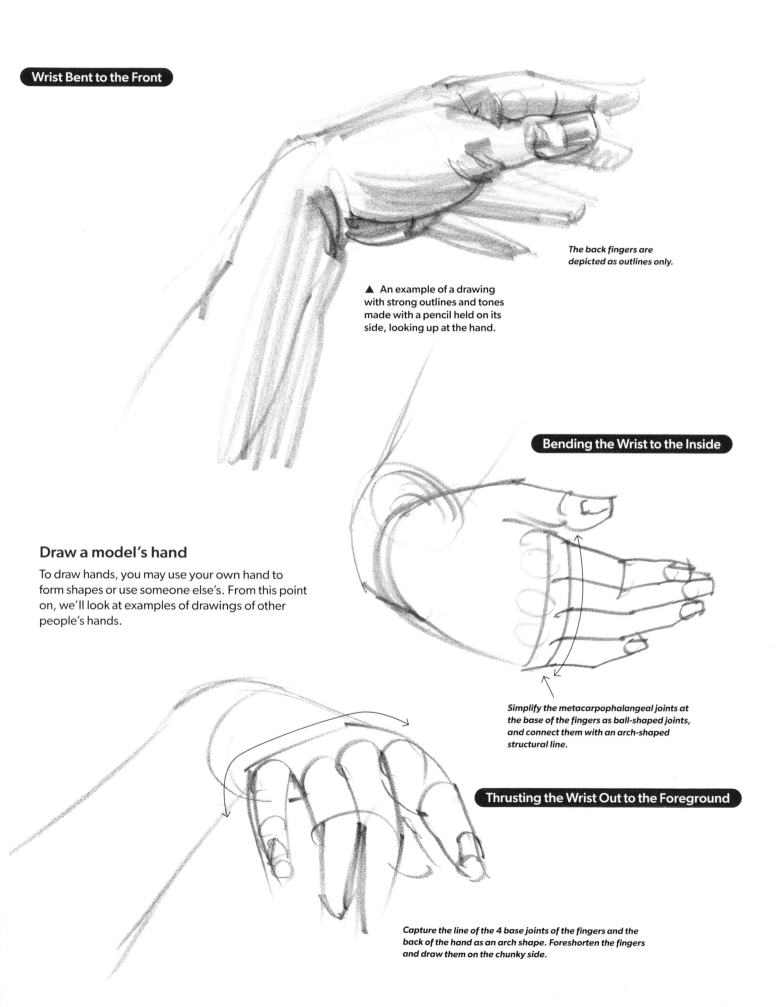

The back fingers are depicted as outlines only.

▲ An example of a drawing with strong outlines and tones made with a pencil held on its side, looking up at the hand.

Bending the Wrist to the Inside

Draw a model's hand

To draw hands, you may use your own hand to form shapes or use someone else's. From this point on, we'll look at examples of drawings of other people's hands.

Simplify the metacarpophalangeal joints at the base of the fingers as ball-shaped joints, and connect them with an arch-shaped structural line.

Thrusting the Wrist Out to the Foreground

Capture the line of the 4 base joints of the fingers and the back of the hand as an arch shape. Foreshorten the fingers and draw them on the chunky side.

The hand form changes when it's even more relaxed

Draw a limply hanging hand from the back of the hand side, and memorize the naturally aligned balance of the fingers. Because the muscles that straighten the fingers are relaxed too, the fingers bend lightly.

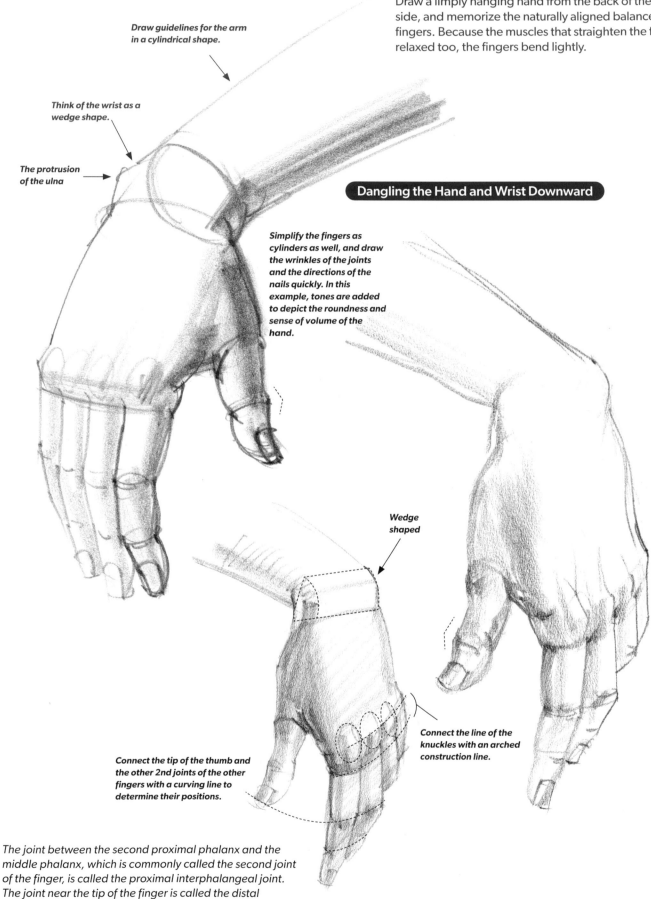

Draw guidelines for the arm in a cylindrical shape.

Think of the wrist as a wedge shape.

The protrusion of the ulna

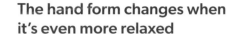

Dangling the Hand and Wrist Downward

Simplify the fingers as cylinders as well, and draw the wrinkles of the joints and the directions of the nails quickly. In this example, tones are added to depict the roundness and sense of volume of the hand.

Wedge shaped

Connect the line of the knuckles with an arched construction line.

Connect the tip of the thumb and the other 2nd joints of the other fingers with a curving line to determine their positions.

The joint between the second proximal phalanx and the middle phalanx, which is commonly called the second joint of the finger, is called the proximal interphalangeal joint. The joint near the tip of the finger is called the distal interphalangeal joint.

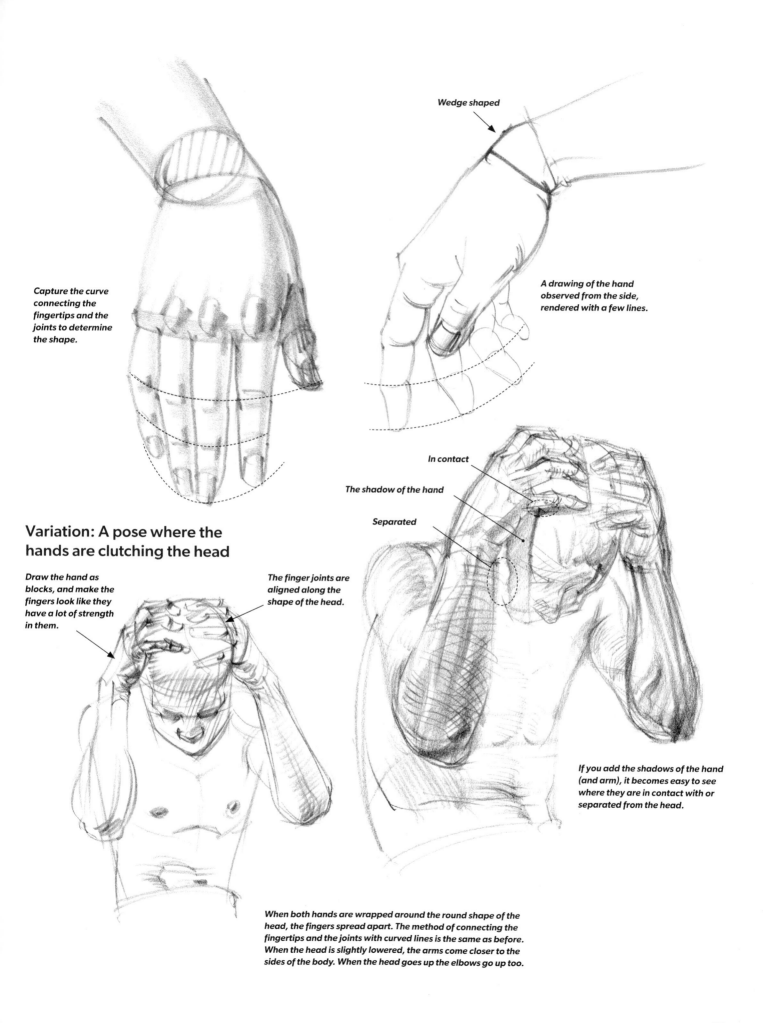

Capture the curve connecting the fingertips and the joints to determine the shape.

Wedge shaped

A drawing of the hand observed from the side, rendered with a few lines.

In contact

The shadow of the hand

Separated

Variation: A pose where the hands are clutching the head

Draw the hand as blocks, and make the fingers look like they have a lot of strength in them.

The finger joints are aligned along the shape of the head.

If you add the shadows of the hand (and arm), it becomes easy to see where they are in contact with or separated from the head.

When both hands are wrapped around the round shape of the head, the fingers spread apart. The method of connecting the fingertips and the joints with curved lines is the same as before. When the head is slightly lowered, the arms come closer to the sides of the body. When the head goes up the elbows go up too.

Holding Objects in the Hands

Draw a spread-open hand that's grasping something, bending the fingers inward to squeeze. Because the thumb moves to oppose the other fingers, the hand can manipulate a variety of tools.

Consider the Grasping Movement

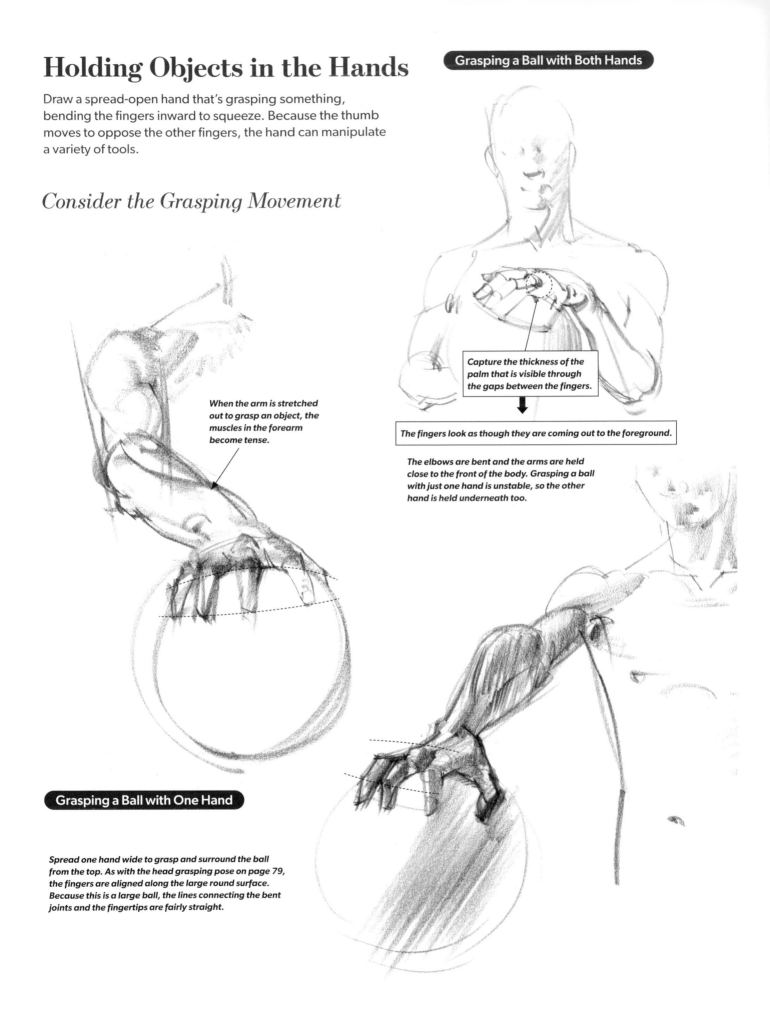

Grasping a Ball with Both Hands

When the arm is stretched out to grasp an object, the muscles in the forearm become tense.

Capture the thickness of the palm that is visible through the gaps between the fingers.

The fingers look as though they are coming out to the foreground.

The elbows are bent and the arms are held close to the front of the body. Grasping a ball with just one hand is unstable, so the other hand is held underneath too.

Grasping a Ball with One Hand

Spread one hand wide to grasp and surround the ball from the top. As with the head grasping pose on page 79, the fingers are aligned along the large round surface. Because this is a large ball, the lines connecting the bent joints and the fingertips are fairly straight.

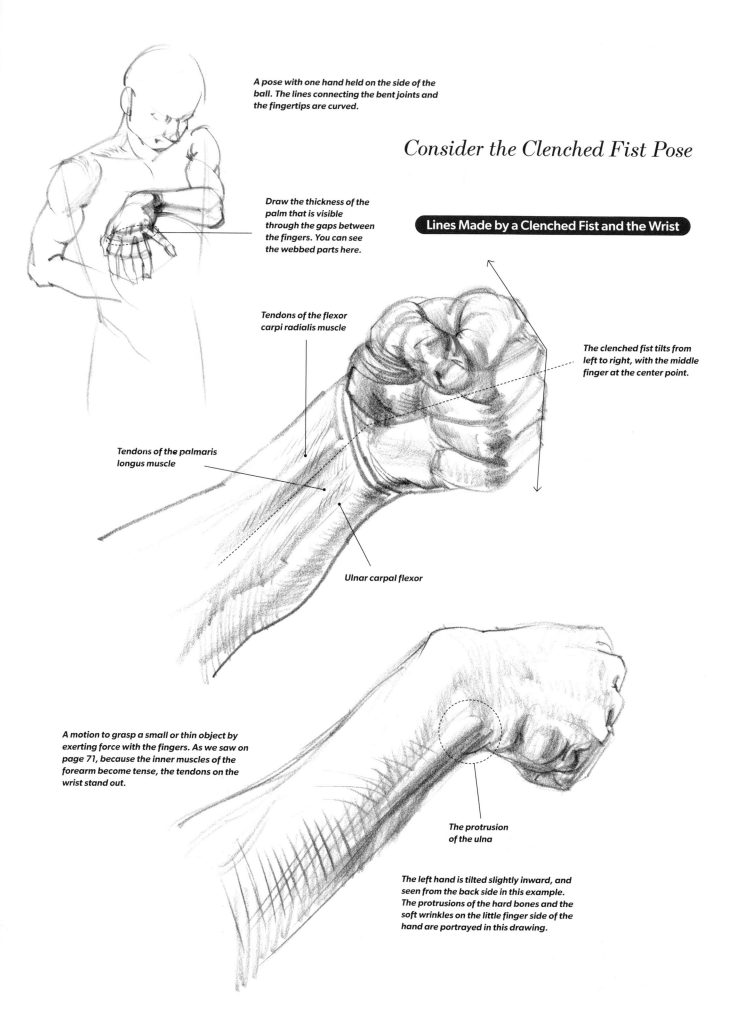

A pose with one hand held on the side of the ball. The lines connecting the bent joints and the fingertips are curved.

Consider the Clenched Fist Pose

Draw the thickness of the palm that is visible through the gaps between the fingers. You can see the webbed parts here.

Lines Made by a Clenched Fist and the Wrist

Tendons of the flexor carpi radialis muscle

The clenched fist tilts from left to right, with the middle finger at the center point.

Tendons of the palmaris longus muscle

Ulnar carpal flexor

A motion to grasp a small or thin object by exerting force with the fingers. As we saw on page 71, because the inner muscles of the forearm become tense, the tendons on the wrist stand out.

The protrusion of the ulna

The left hand is tilted slightly inward, and seen from the back side in this example. The protrusions of the hard bones and the soft wrinkles on the little finger side of the hand are portrayed in this drawing.

Observe a Hand Grasping a Dowel

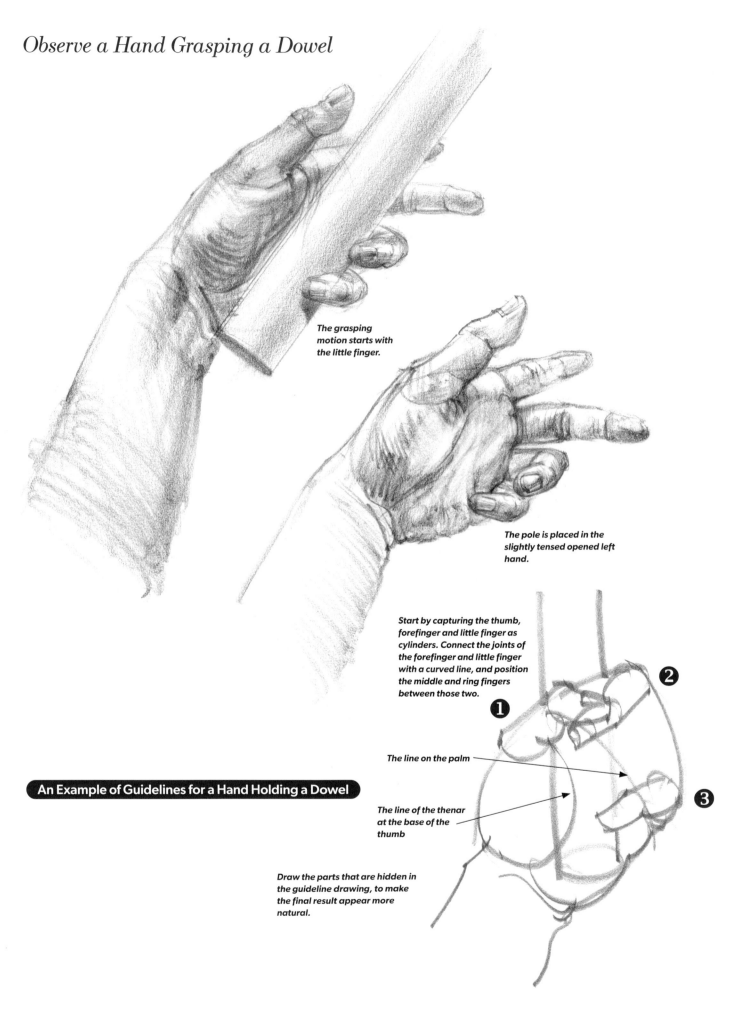

The grasping motion starts with the little finger.

The pole is placed in the slightly tensed opened left hand.

Start by capturing the thumb, forefinger and little finger as cylinders. Connect the joints of the forefinger and little finger with a curved line, and position the middle and ring fingers between those two.

❶

❷

❸

The line on the palm

The line of the thenar at the base of the thumb

An Example of Guidelines for a Hand Holding a Dowel

Draw the parts that are hidden in the guideline drawing, to make the final result appear more natural.

Both Hands Grasping a Dowel Like a Sword

We'll start by drawing a pose where the hands are lightly grasping the dowel. From here, we will change the pressure in the hands.

An Example of Hands Lightly Grasping a Dowel

The palm of the right hand and the back of the left hand from the base of the thumb side are visible. When the hands grasp harder, the tendons on the wrist pop out. If you focus on the direction and thickness of the thumb, it's easier to depict the three-dimensionality of the hands.

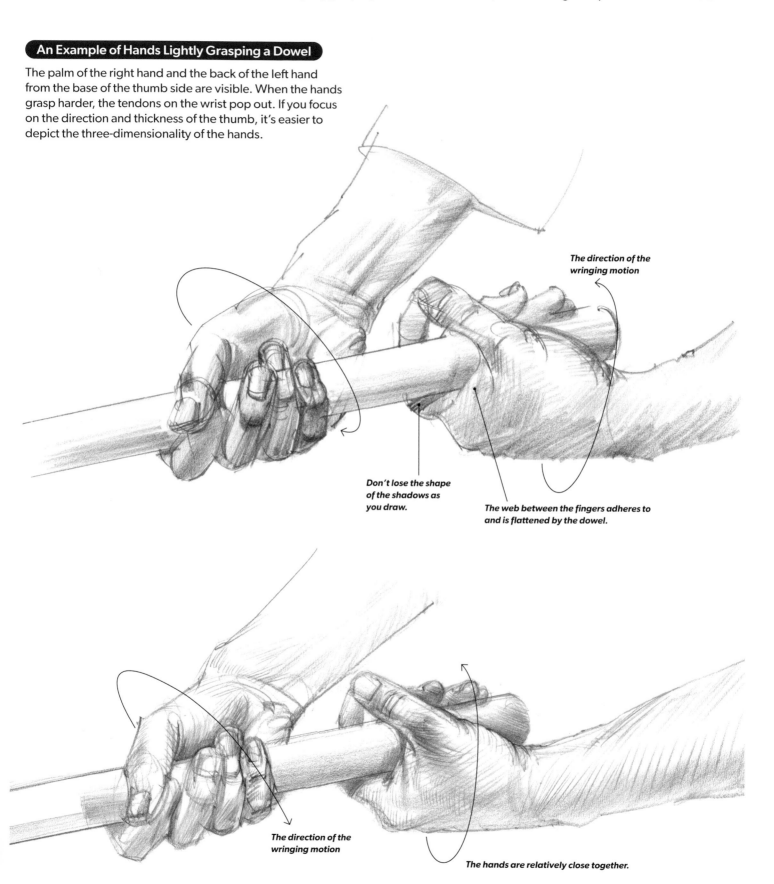

The direction of the wringing motion

Don't lose the shape of the shadows as you draw.

The web between the fingers adheres to and is flattened by the dowel.

The direction of the wringing motion

The hands are relatively close together.

More Dowel Poses: Swinging a Sword Downward

Capturing the Pose with Flat Planes

This pose resembles the "on guard" pose in Kendo (Japanese fencing). The wooden katana sword is squeezed lightly in this pose. Visualize the point of the sword at the throat of the opponent.

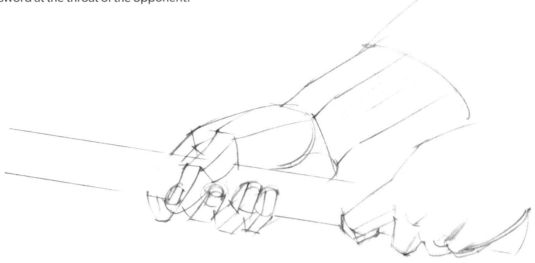

With this block style, it becomes easier to understand the way each part is facing, and you can draw the positions of the joints three-dimensionally. Because light and dark tones change along the edges of the planes, this block drawing is a good reference for adding tonal values later.

A Downswinging Sword Pose

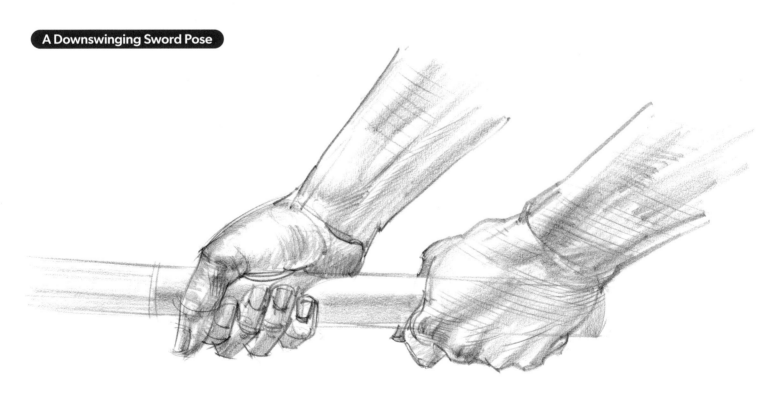

An example of visualizing the fingers, palms, backs of the hands and the arms as a series of planes. Add natural gradations to the flat planes and edges of the block drawing to depict the roundness of the arms and hands.

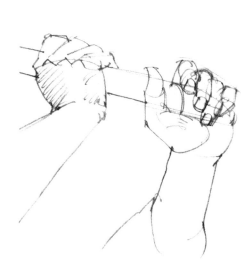

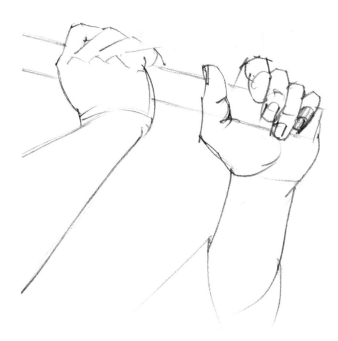

In an up-swung pose, make sure the bottom hand is gripping the handle securely starting with the little finger, so that the sword does not fly out of the hands when it's swung down.

In poses where a sword is swung up, if the lower hand is gripping the handle securely—starting with the little finger—the sword will not slip.

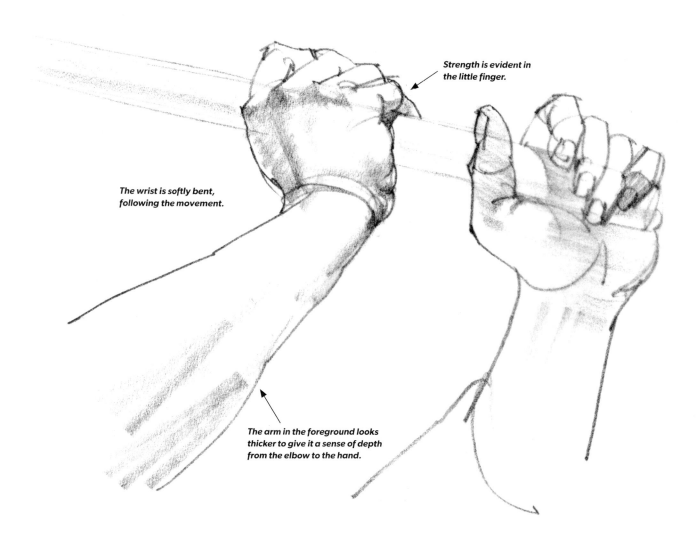

Strength is evident in the little finger.

The wrist is softly bent, following the movement.

The arm in the foreground looks thicker to give it a sense of depth from the elbow to the hand.

More Sword Poses: On-guard Example

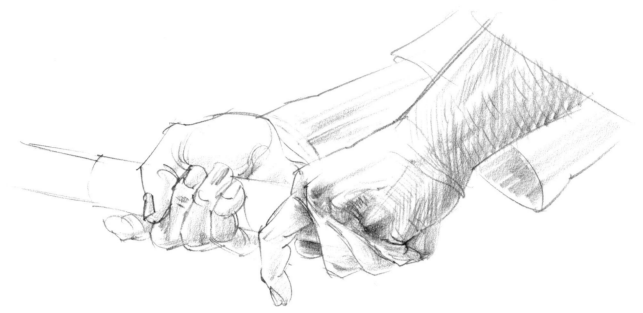

The hands viewed from a diagonal upper angle.
Because the outlines of the hands are overlapping,
emphasize the tones on the back of the left hand to
give it a strong presence.

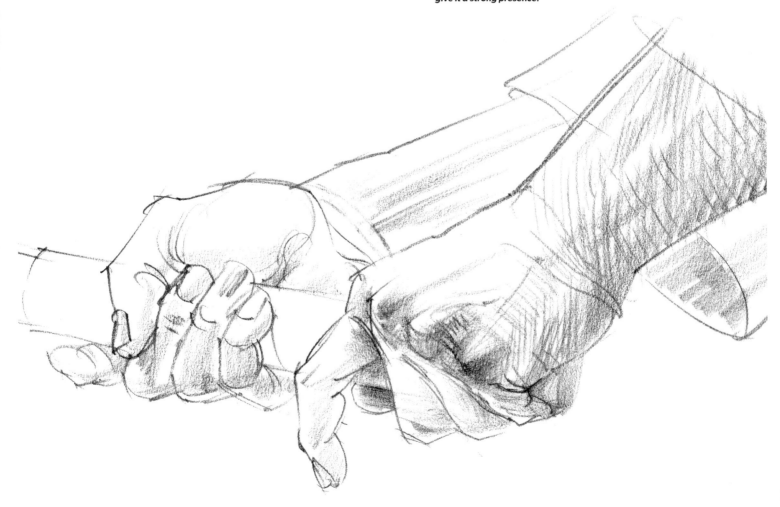

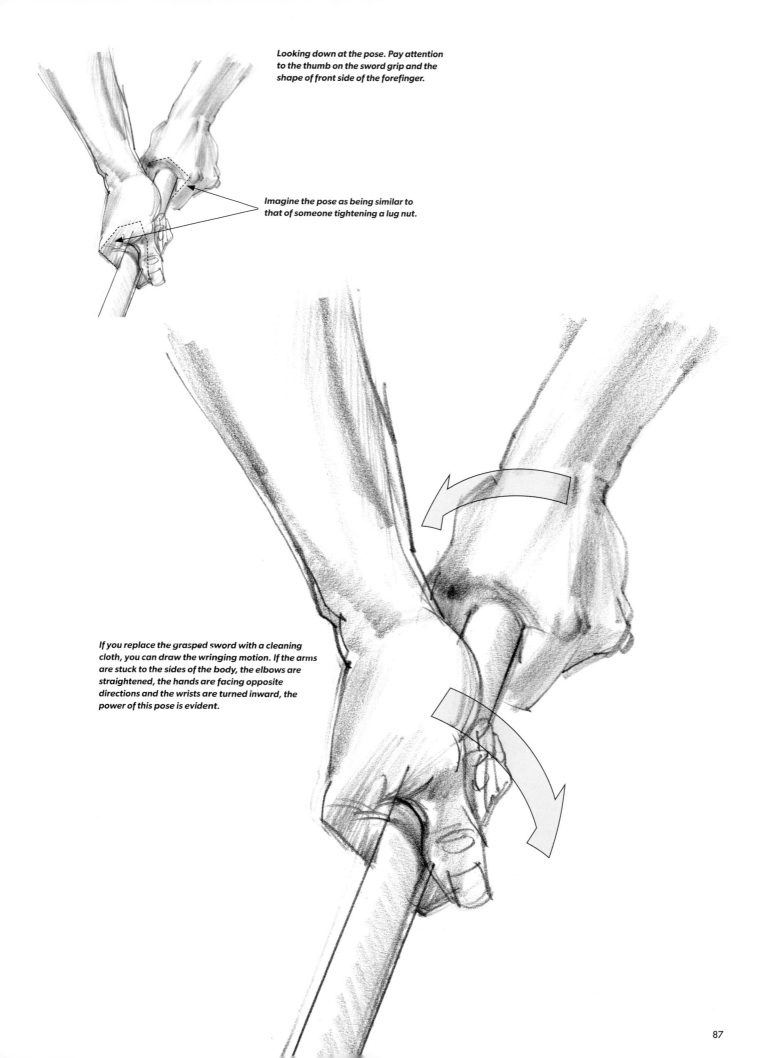

Looking down at the pose. Pay attention to the thumb on the sword grip and the shape of front side of the forefinger.

Imagine the pose as being similar to that of someone tightening a lug nut.

If you replace the grasped sword with a cleaning cloth, you can draw the wringing motion. If the arms are stuck to the sides of the body, the elbows are straightened, the hands are facing opposite directions and the wrists are turned inward, the power of this pose is evident.

The Various Shapes of Wringing Hands

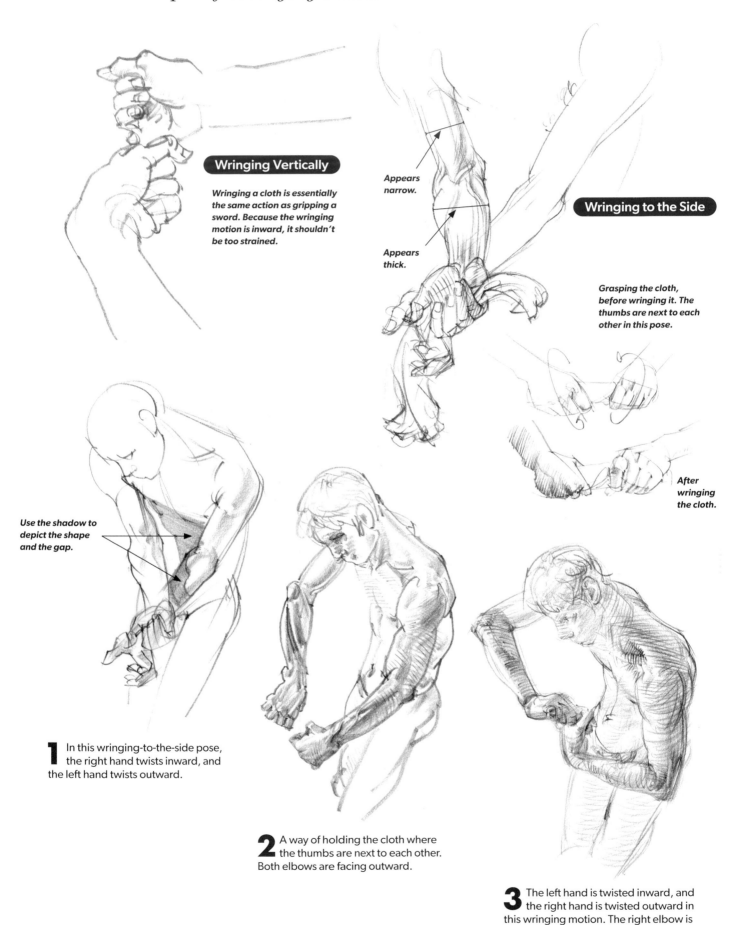

Wringing Vertically

Wringing a cloth is essentially the same action as gripping a sword. Because the wringing motion is inward, it shouldn't be too strained.

Appears narrow.

Appears thick.

Wringing to the Side

Grasping the cloth, before wringing it. The thumbs are next to each other in this pose.

After wringing the cloth.

Use the shadow to depict the shape and the gap.

1 In this wringing-to-the-side pose, the right hand twists inward, and the left hand twists outward.

2 A way of holding the cloth where the thumbs are next to each other. Both elbows are facing outward.

3 The left hand is twisted inward, and the right hand is twisted outward in this wringing motion. The right elbow is open and the left one is tightened.

Capturing the Form of Hugging Something with Both Arms

When something is pulled in close to the chest by the arms, the two bones in the forearm are lined up against each other naturally, instead of being twisted.

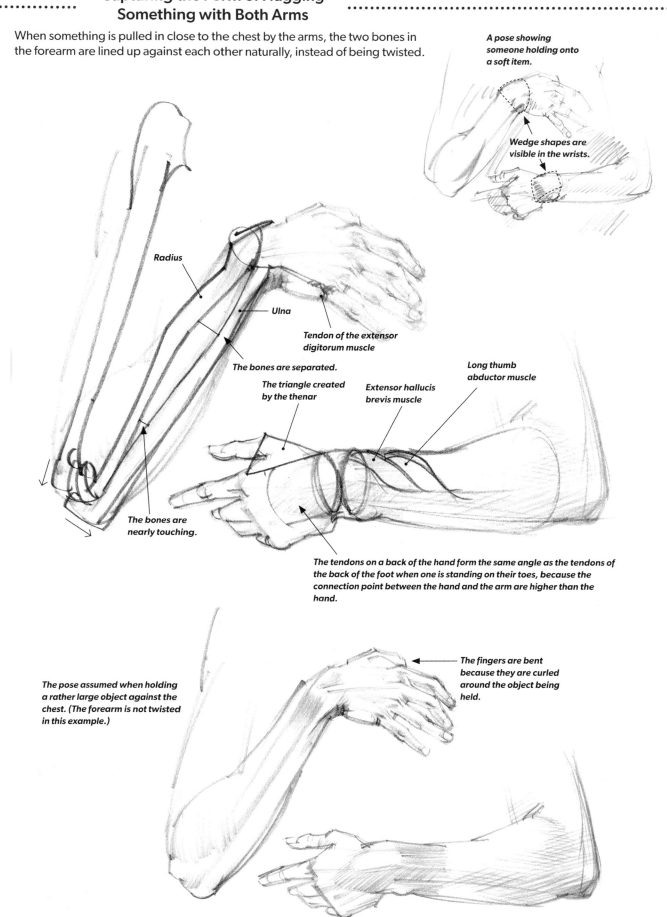

A pose showing someone holding onto a soft item.

Wedge shapes are visible in the wrists.

Radius

Ulna

Tendon of the extensor digitorum muscle

The bones are separated.

The triangle created by the thenar

Extensor hallucis brevis muscle

Long thumb abductor muscle

The bones are nearly touching.

The tendons on a back of the hand form the same angle as the tendons of the back of the foot when one is standing on their toes, because the connection point between the hand and the arm are higher than the hand.

The pose assumed when holding a rather large object against the chest. (The forearm is not twisted in this example.)

The fingers are bent because they are curled around the object being held.

Capturing Movements of the Lower Body and Legs

Focus on the hips and the legs, the large body parts below the waist. We'll start with a standing pose seen from the front, and move on to poses with straightened and bent legs.

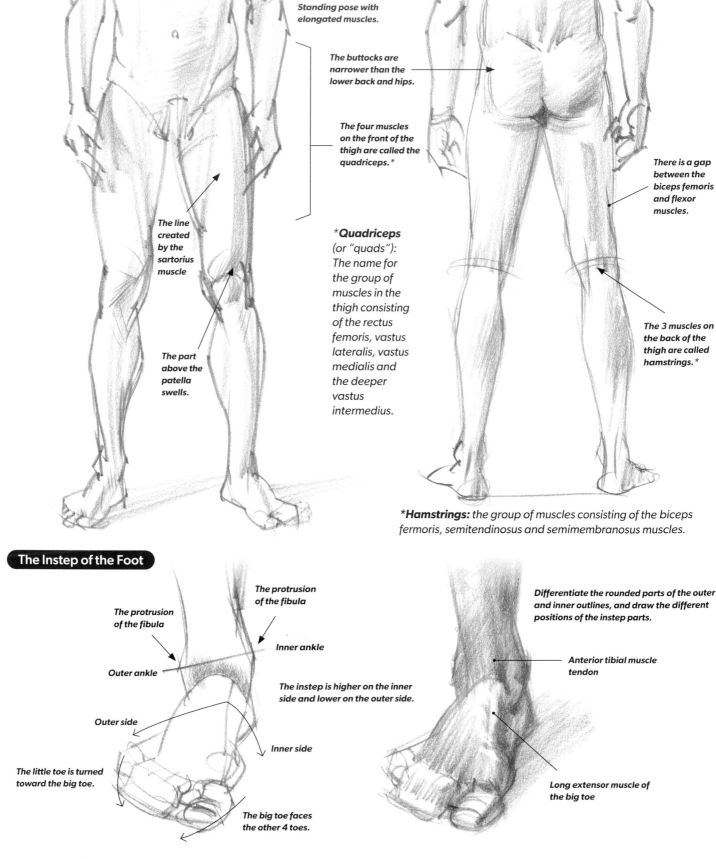

Standing pose with elongated muscles.

The buttocks are narrower than the lower back and hips.

The four muscles on the front of the thigh are called the quadriceps. *

The line created by the sartorius muscle

The part above the patella swells.

There is a gap between the biceps femoris and flexor muscles.

The 3 muscles on the back of the thigh are called hamstrings. *

***Quadriceps** (or "quads"): The name for the group of muscles in the thigh consisting of the rectus femoris, vastus lateralis, vastus medialis and the deeper vastus intermedius.*

***Hamstrings:** the group of muscles consisting of the biceps fermoris, semitendinosus and semimembranosus muscles.*

The Instep of the Foot

The protrusion of the fibula

The protrusion of the fibula

Inner ankle

Outer ankle

The instep is higher on the inner side and lower on the outer side.

Outer side

Inner side

The little toe is turned toward the big toe.

The big toe faces the other 4 toes.

Differentiate the rounded parts of the outer and inner outlines, and draw the different positions of the instep parts.

Anterior tibial muscle tendon

Long extensor muscle of the big toe

Observe the Movements of the Legs and Feet

Changes in the shape of the straightened knees

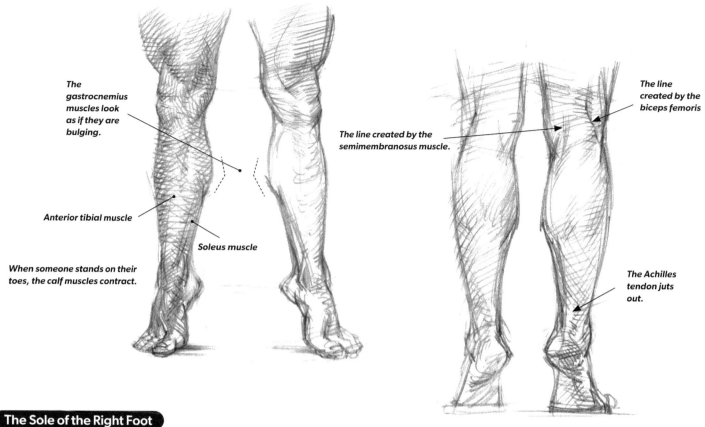

The gastrocnemius muscles look as if they are bulging.

Anterior tibial muscle

Soleus muscle

When someone stands on their toes, the calf muscles contract.

The line created by the semimembranosus muscle.

The line created by the biceps femoris

The Achilles tendon juts out.

The Sole of the Right Foot

The three padded parts are cushions!

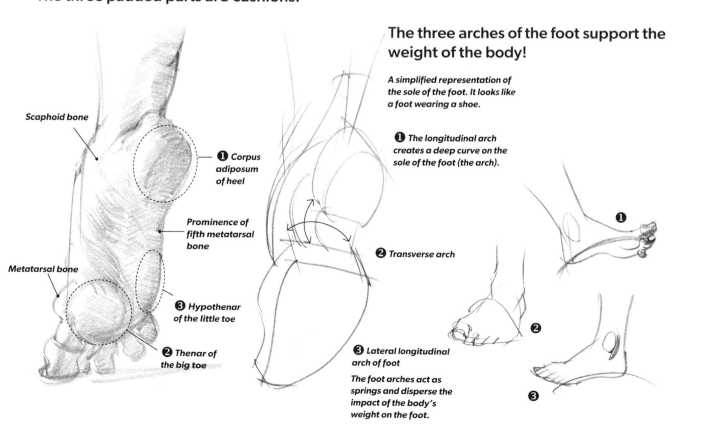

Scaphoid bone

Metatarsal bone

❶ Corpus adiposum of heel

Prominence of fifth metatarsal bone

❸ Hypothenar of the little toe

❷ Thenar of the big toe

The three arches of the foot support the weight of the body!

A simplified representation of the sole of the foot. It looks like a foot wearing a shoe.

❶ The longitudinal arch creates a deep curve on the sole of the foot (the arch).

❷ Transverse arch

❸ Lateral longitudinal arch of foot

The foot arches act as springs and disperse the impact of the body's weight on the foot.

The Changing Shapes of Bent Knees

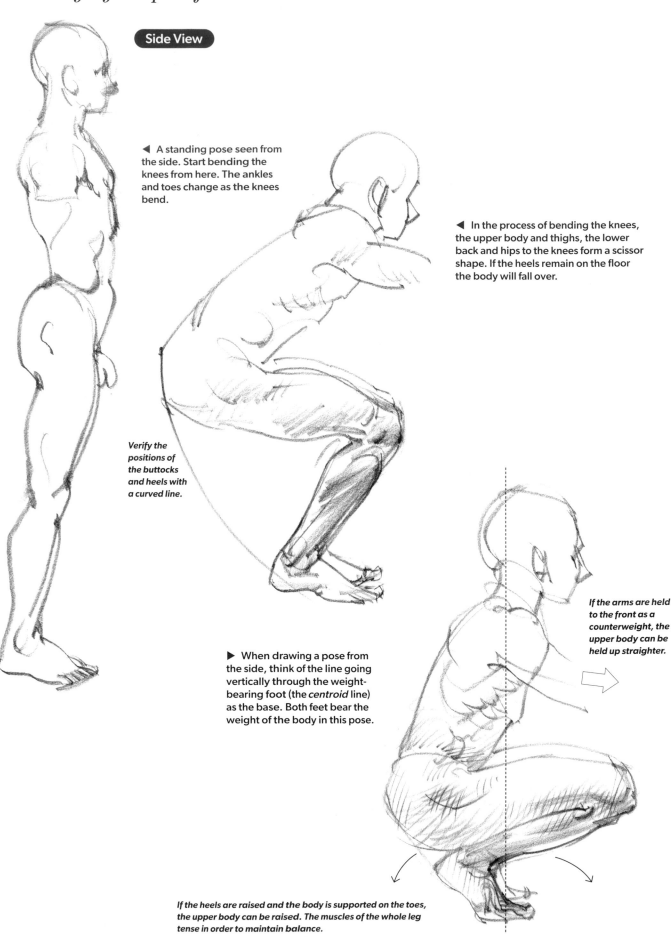

◀ A standing pose seen from the side. Start bending the knees from here. The ankles and toes change as the knees bend.

◀ In the process of bending the knees, the upper body and thighs, the lower back and hips to the knees form a scissor shape. If the heels remain on the floor the body will fall over.

Verify the positions of the buttocks and heels with a curved line.

▶ When drawing a pose from the side, think of the line going vertically through the weight-bearing foot (the *centroid* line) as the base. Both feet bear the weight of the body in this pose.

If the arms are held to the front as a counterweight, the upper body can be held up straighter.

If the heels are raised and the body is supported on the toes, the upper body can be raised. The muscles of the whole leg tense in order to maintain balance.

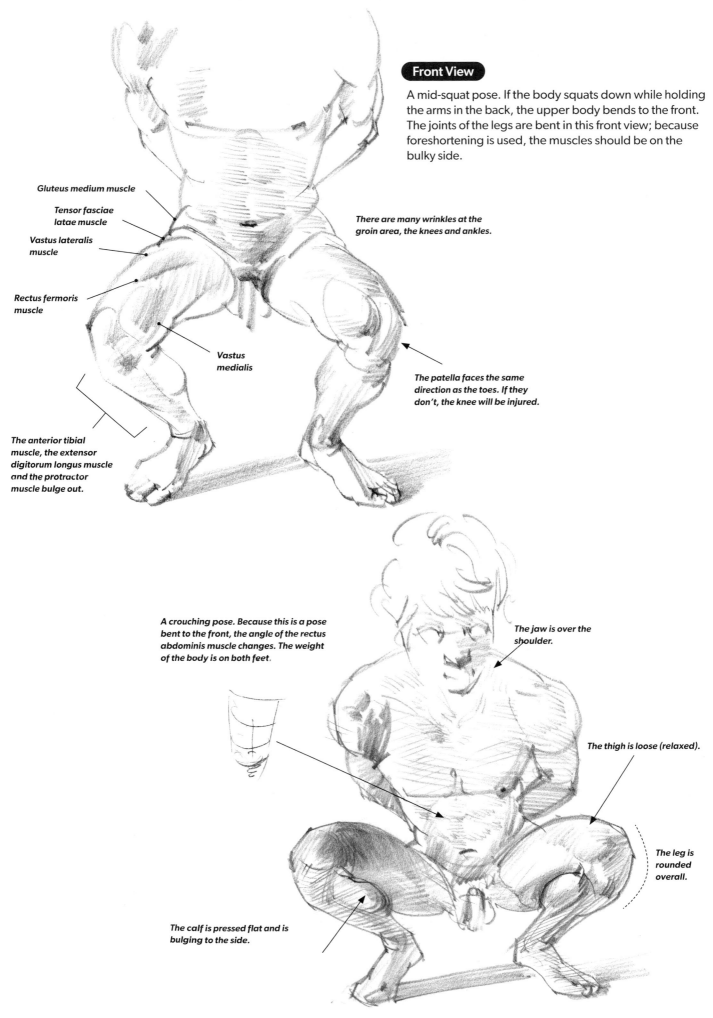

A mid-squat pose. If the body squats down while holding the arms in the back, the upper body bends to the front. The joints of the legs are bent in this front view; because foreshortening is used, the muscles should be on the bulky side.

Gluteus medium muscle

Tensor fasciae latae muscle

Vastus lateralis muscle

Rectus fermoris muscle

There are many wrinkles at the groin area, the knees and ankles.

Vastus medialis

The anterior tibial muscle, the extensor digitorum longus muscle and the protractor muscle bulge out.

The patella faces the same direction as the toes. If they don't, the knee will be injured.

A crouching pose. Because this is a pose bent to the front, the angle of the rectus abdominis muscle changes. The weight of the body is on both feet.

The jaw is over the shoulder.

The thigh is loose (relaxed).

The leg is rounded overall.

The calf is pressed flat and is bulging to the side.

An example of a pose where the weight
of the body is on the right foot,
supported by the right arm.

Show the bend of the
torso to the hip with
shading.

Show the roundness
of the knee with
shading.

If you depict the shadow on the floor, an
additional negative space is created, adding
more depth to the space shown in the drawing.

The arm is on top of the
leg. Draw the knee
slightly overlapping the
arm to clarify the
front-to-back
relationship between
the limbs.

b

The shape of the groin
marked "b" is relatively far
from the viewer. Draw it with
relatively few details in
order the emphasize the
depth of field in relation to
the knee.

a

In this example, the weight of
the body is on the left leg, and
also supported by the left arm.

The area marked "a" is
the bottom outline of the
buttocks and thighs.

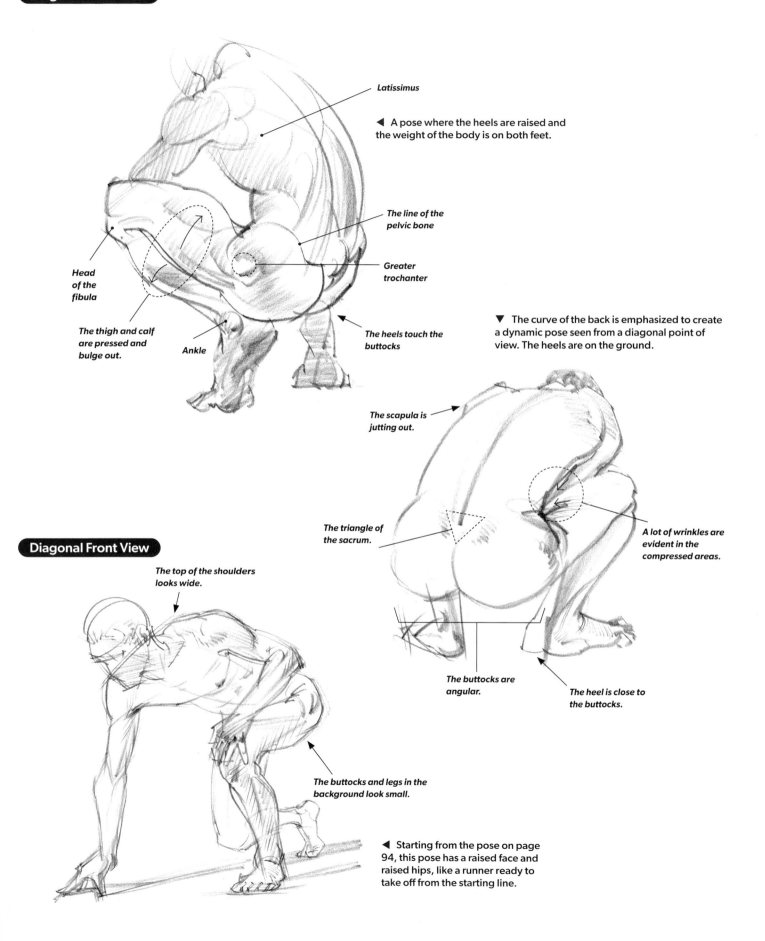

Latissimus

◀ A pose where the heels are raised and the weight of the body is on both feet.

The line of the pelvic bone

Greater trochanter

Head of the fibula

The thigh and calf are pressed and bulge out.

Ankle

The heels touch the buttocks

▼ The curve of the back is emphasized to create a dynamic pose seen from a diagonal point of view. The heels are on the ground.

The scapula is jutting out.

The triangle of the sacrum.

A lot of wrinkles are evident in the compressed areas.

Diagonal Front View

The top of the shoulders looks wide.

The buttocks are angular.

The heel is close to the buttocks.

The buttocks and legs in the background look small.

◀ Starting from the pose on page 94, this pose has a raised face and raised hips, like a runner ready to take off from the starting line.

A Pose with Strongly Bent Knees

Front View

◄ This is a *seiza* or formal sitting pose in Japan. In an actual seiza the knees are not so widely spread, but in the case of a male with a wide pelvis the posture is more stable if the knees are spread out.

Side View

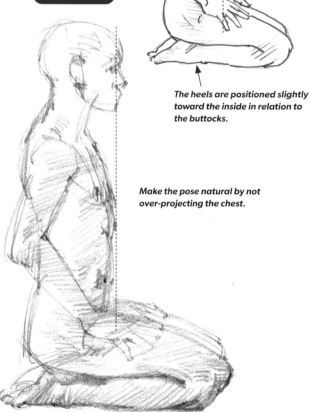

The head is inclined slightly toward the front.

The heels are positioned slightly toward the inside in relation to the buttocks.

Make the pose natural by not over-projecting the chest.

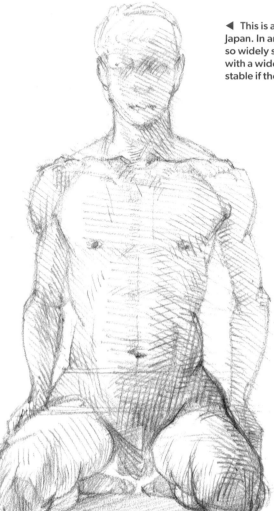

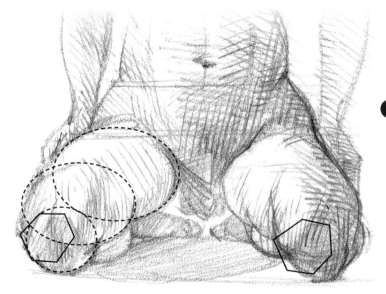

Characteristics of the Thighs Seen from the Front

1 *The thighs are flattened, and the muscles bulge.*

2 *The thighs come out to the foreground because of the layered ovals.*

3 *Think of the knees as being hexagonal in shape.*

4

Whole-body Movements: Standing, Walking, Sitting

Think about the continuity between body movements. Even if you are capturing a single pose, the motion in that pose is an indicator of the movement that will follow it in many cases. If you consider the related poses when drawing the body in a dynamic configuration, you can better capture realistic characteristics in your drawing. Examine what everyday activities like standing, walking and sitting look like as you practice drawing them.

Drawing Variations of a Standing Pose

In order to give a standing pose more dynamism than a ramrod-straight "attention" pose, think of the way a person's weight is naturally shifted as you draw.

Shifting the Weight from One Side to Another

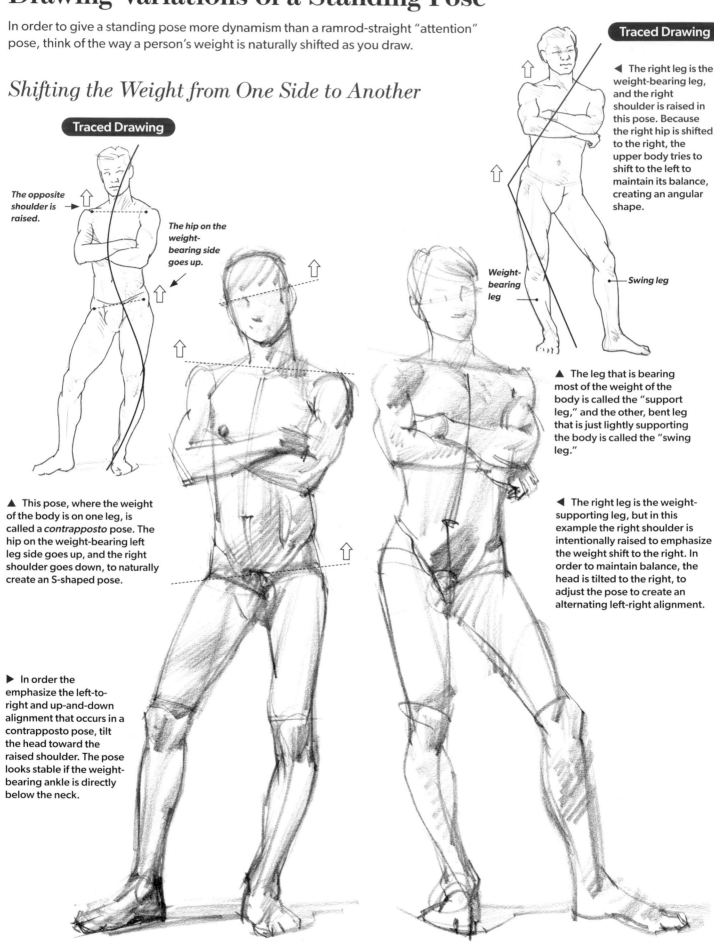

Traced Drawing

The opposite shoulder is raised.

The hip on the weight-bearing side goes up.

Traced Drawing

◀ The right leg is the weight-bearing leg, and the right shoulder is raised in this pose. Because the right hip is shifted to the right, the upper body tries to shift to the left to maintain its balance, creating an angular shape.

Weight-bearing leg

Swing leg

▲ This pose, where the weight of the body is on one leg, is called a *contrapposto* pose. The hip on the weight-bearing left leg side goes up, and the right shoulder goes down, to naturally create an S-shaped pose.

▲ The leg that is bearing most of the weight of the body is called the "support leg," and the other, bent leg that is just lightly supporting the body is called the "swing leg."

▶ In order the emphasize the left-to-right and up-and-down alignment that occurs in a contrapposto pose, tilt the head toward the raised shoulder. The pose looks stable if the weight-bearing ankle is directly below the neck.

◀ The right leg is the weight-supporting leg, but in this example the right shoulder is intentionally raised to emphasize the weight shift to the right. In order to maintain balance, the head is tilted to the right, to adjust the pose to create an alternating left-right alignment.

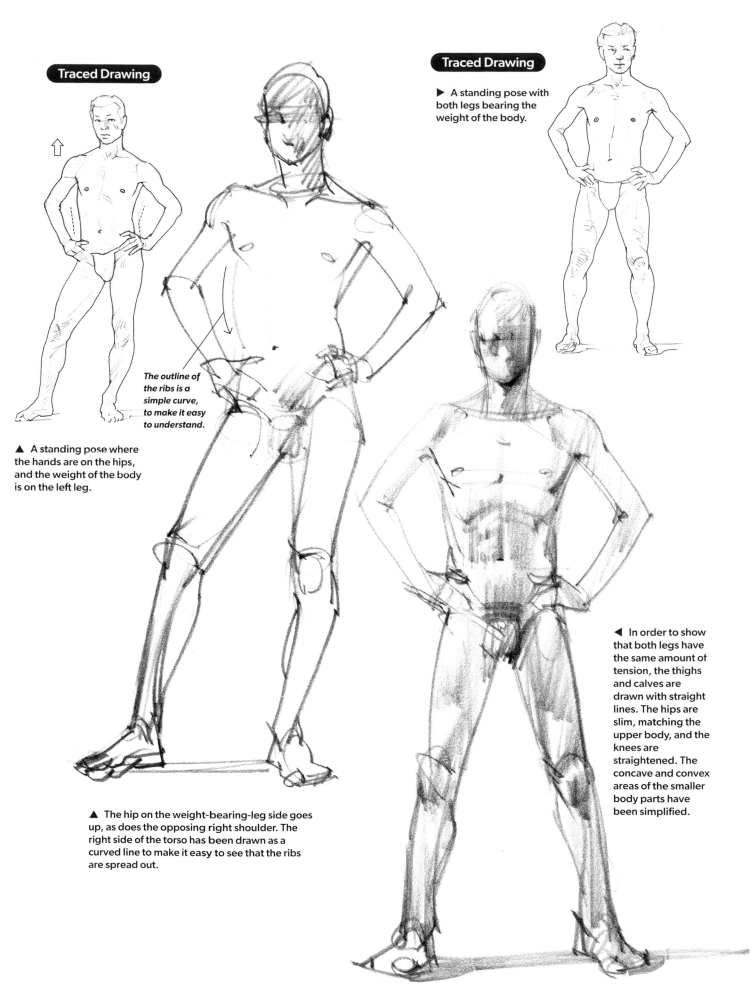

▶ A standing pose with both legs bearing the weight of the body.

The outline of the ribs is a simple curve, to make it easy to understand.

▲ A standing pose where the hands are on the hips, and the weight of the body is on the left leg.

▲ The hip on the weight-bearing-leg side goes up, as does the opposing right shoulder. The right side of the torso has been drawn as a curved line to make it easy to see that the ribs are spread out.

◀ In order to show that both legs have the same amount of tension, the thighs and calves are drawn with straight lines. The hips are slim, matching the upper body, and the knees are straightened. The concave and convex areas of the smaller body parts have been simplified.

99

Moving from a Standing Pose to a Squatting Pose (Front View)

We'll draw the continuous movement from a standing pose to a squatting pose, bending the knees in the process. Please also refer to the section *"Capturing Movements of the Lower Body and Legs"* on page 90. In the drawing here, the figure is made a little thinner, with more definition around the hips and legs.

Please also refer to the section *"Capturing Movements of the Lower Body and Legs"* on page 90.

Traced Drawings

1 The upper part of the body is left out in order to focus on the motion of the hips downward.

2 In the reference photo the lower legs look compressed and short.

Front View

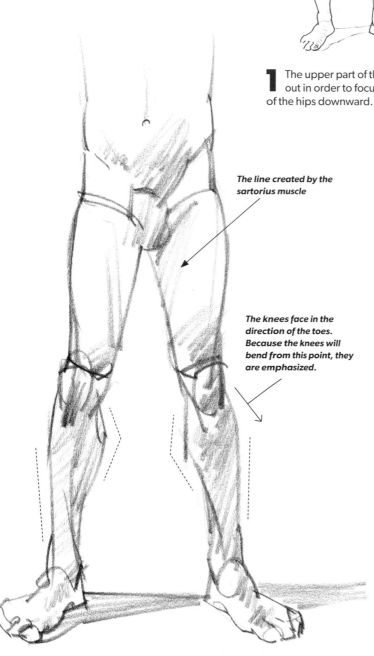

The line created by the sartorius muscle

The knees face in the direction of the toes. Because the knees will bend from this point, they are emphasized.

1 Draw the outer line of the leg below the knee as a straight line, and draw the swell of the gastrocnemius muscle on the inside.

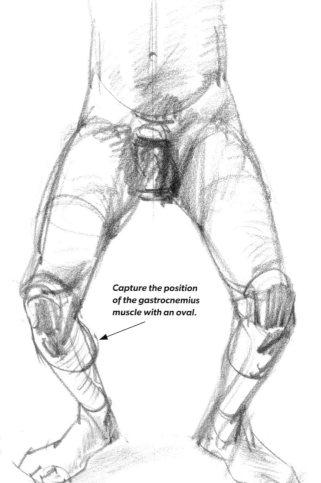

Capture the position of the gastrocnemius muscle with an oval.

2 To emphasize the protrusion of the knees, draw the structure with cylinders and ovals, and adjust the lower half of the legs to slightly exaggerate their size.

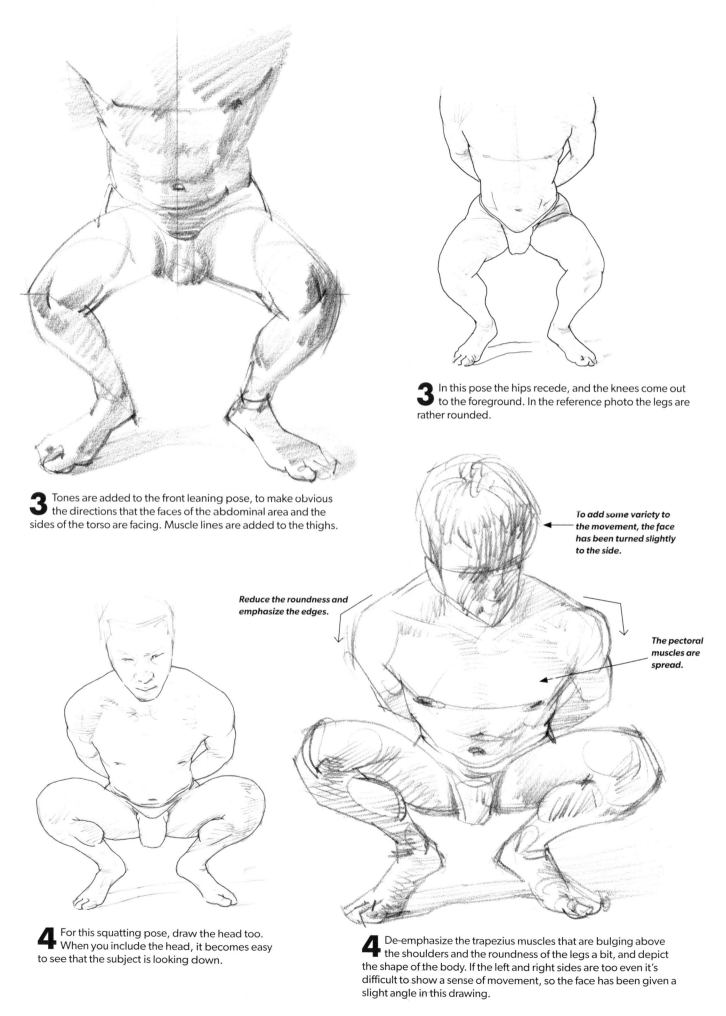

3 Tones are added to the front leaning pose, to make obvious the directions that the faces of the abdominal area and the sides of the torso are facing. Muscle lines are added to the thighs.

3 In this pose the hips recede, and the knees come out to the foreground. In the reference photo the legs are rather rounded.

To add some variety to the movement, the face has been turned slightly to the side.

Reduce the roundness and emphasize the edges.

The pectoral muscles are spread.

4 For this squatting pose, draw the head too. When you include the head, it becomes easy to see that the subject is looking down.

4 De-emphasize the trapezius muscles that are bulging above the shoulders and the roundness of the legs a bit, and depict the shape of the body. If the left and right sides are too even it's difficult to show a sense of movement, so the face has been given a slight angle in this drawing.

From a Standing Pose to a Squatting Pose (Back View)

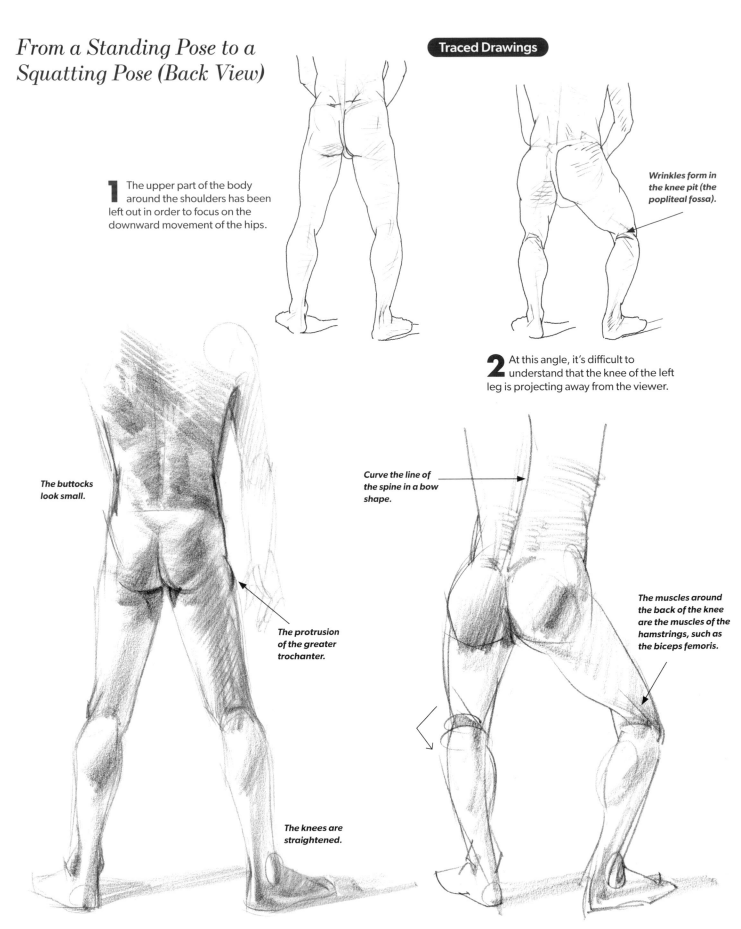

1 The upper part of the body around the shoulders has been left out in order to focus on the downward movement of the hips.

Wrinkles form in the knee pit (the popliteal fossa).

2 At this angle, it's difficult to understand that the knee of the left leg is projecting away from the viewer.

The buttocks look small.

The protrusion of the greater trochanter.

The knees are straightened.

Curve the line of the spine in a bow shape.

The muscles around the back of the knee are the muscles of the hamstrings, such as the biceps femoris.

1 Make the waist narrower than the width of the back. The light coming from above makes highlights on the body, which makes the shapes of the hips and lower back and the roundness of the buttocks easy to see.

2 Depict the shapes of the hips and back with a few taut lines. The construction of the left knee is seen as a cylinder to make it protrude to the front of the figure.

3 This is a mid-squat pose with the buttocks sticking out to the back, so the hips look large.

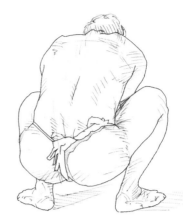

4 A squatting pose. The hip joints and knees are bent deeply to lower the hips.

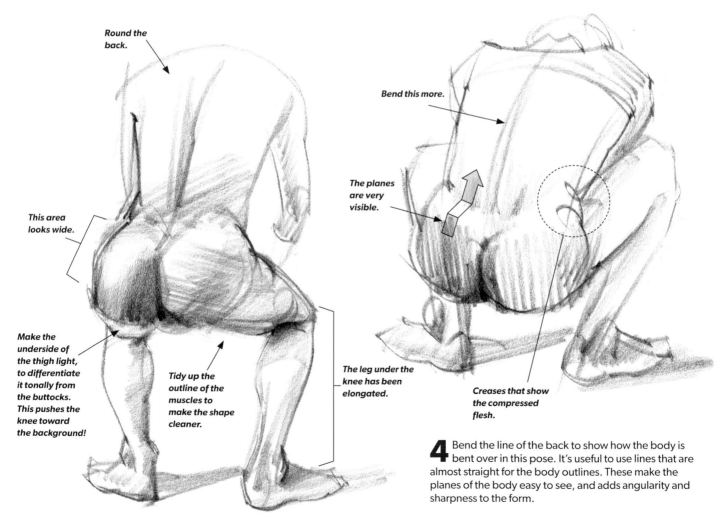

Round the back.

This area looks wide.

Make the underside of the thigh light, to differentiate it tonally from the buttocks. This pushes the knee toward the background!

Tidy up the outline of the muscles to make the shape cleaner.

The leg under the knee has been elongated.

3 When the hips are lowered, the shape of the buttocks changes. The right knee, which is projecting toward the background, is drawn small.

Bend this more.

The planes are very visible.

Creases that show the compressed flesh.

4 Bend the line of the back to show how the body is bent over in this pose. It's useful to use lines that are almost straight for the body outlines. These make the planes of the body easy to see, and adds angularity and sharpness to the form.

Transitioning from Standing to Walking (Seen from the Diagonal Front)

When a human starts to walk, the upper and lower bodies are twisted. The hip on the side of the raised leg goes up a bit, and the body attempts to move forward with the weight supported on one leg.

Traced Drawings

1 One leg goes out to the front, and the arms spread to both sides in this movement.

2 The left leg lands on the ground, and the right leg is in the process of kicking off the ground.

The upper and lower bodies have a twisting movement.

The midline changes subtly because of the twisting movement.

The right hand comes out to the front.

The front leg goes up in the air. The toes are pulled up.

The back leg lifts up. The heel is raised here.

The left foot lands on the ground.

1 The left leg is about to land on the ground from the heel in this pose. The right leg is drawn a bit to the rear so that the knee is visible.

2 Express the transfer of power from the front of the torso to the right leg with simple lines.

Transitioning from Standing to Walking (Seen from the Diagonal Back)

Traced Drawings

1 The left leg is raised high in this pose. The movement has been exaggerated to show the act of walking more easily. The pose looks stiff.

2 This is the number 2 pose on page 102 drawn from the back.

The left arm is pulled to the back.

Elongated

Shortened

Leaving a gap between the legs makes their shapes look cleaner.

Lifts up

1 The right legs is bent slightly so that the body doesn't fall over backward to demonstrate the movement. The left and right outlines of the body have been differentiated with shortened and elongated outlines.

2 Rough in the left leg in the background using cylinders, and verify the position of the knee.

Transitioning from Standing to Walking
(Seen from the Diagonal Back—continued)

Traced Drawings

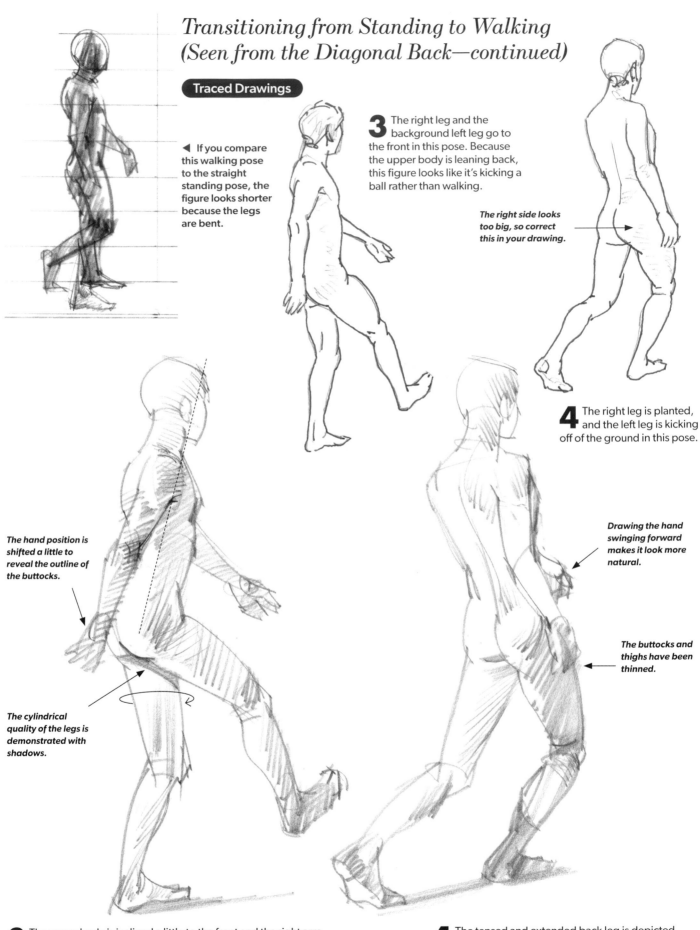

◄ If you compare this walking pose to the straight standing pose, the figure looks shorter because the legs are bent.

3 The right leg and the background left leg go to the front in this pose. Because the upper body is leaning back, this figure looks like it's kicking a ball rather than walking.

The right side looks too big, so correct this in your drawing.

4 The right leg is planted, and the left leg is kicking off of the ground in this pose.

The hand position is shifted a little to reveal the outline of the buttocks.

The cylindrical quality of the legs is demonstrated with shadows.

Drawing the hand swinging forward makes it look more natural.

The buttocks and thighs have been thinned.

3 The upper body is inclined a little to the front and the right arm is stretched diagonally to the side, to make it easier to see that it's projecting toward the viewer.

4 The tensed and extended back leg is depicted as a simple shape with just a few lines.

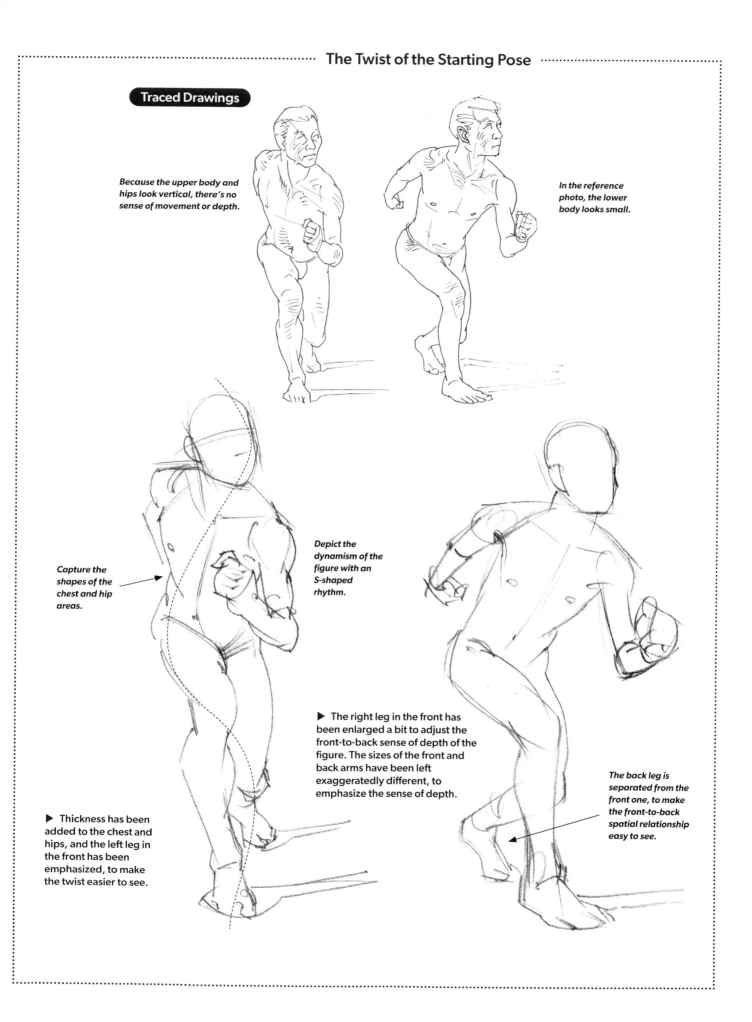

Traced Drawings

Because the upper body and hips look vertical, there's no sense of movement or depth.

In the reference photo, the lower body looks small.

Capture the shapes of the chest and hip areas.

Depict the dynamism of the figure with an S-shaped rhythm.

▶ Thickness has been added to the chest and hips, and the left leg in the front has been emphasized, to make the twist easier to see.

▶ The right leg in the front has been enlarged a bit to adjust the front-to-back sense of depth of the figure. The sizes of the front and back arms have been left exaggeratedly different, to emphasize the sense of depth.

The back leg is separated from the front one, to make the front-to-back spatial relationship easy to see.

Taking a Drink While Standing (Front View)

The figure stands with the weight on one leg and drinks from a bottle in this pose.

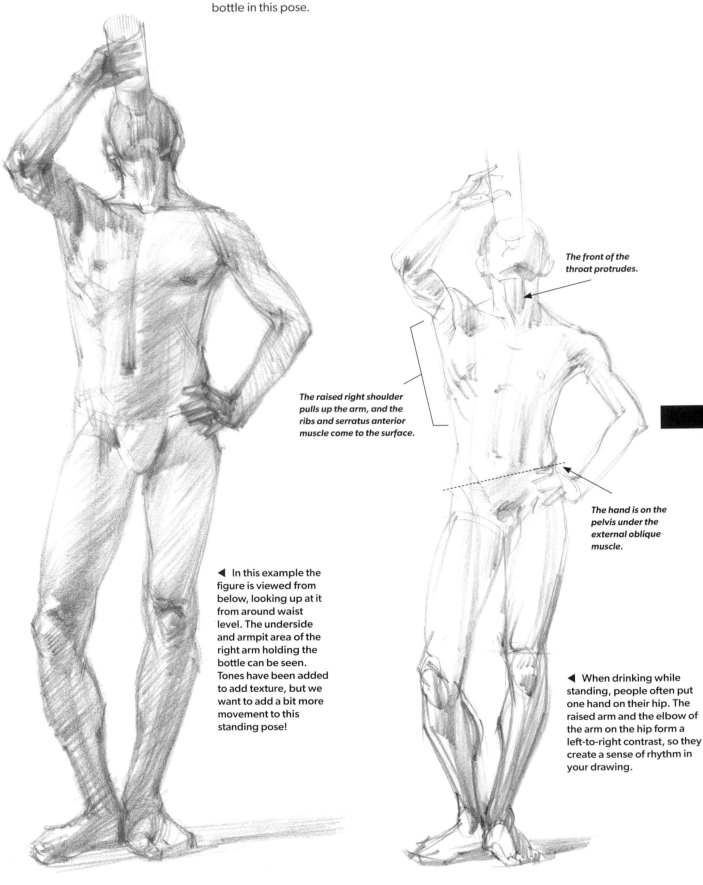

The front of the throat protrudes.

The raised right shoulder pulls up the arm, and the ribs and serratus anterior muscle come to the surface.

The hand is on the pelvis under the external oblique muscle.

◀ In this example the figure is viewed from below, looking up at it from around waist level. The underside and armpit area of the right arm holding the bottle can be seen. Tones have been added to add texture, but we want to add a bit more movement to this standing pose!

◀ When drinking while standing, people often put one hand on their hip. The raised arm and the elbow of the arm on the hip form a left-to-right contrast, so they create a sense of rhythm in your drawing.

Analyze the Shapes to Give the Pose More Movement!

◀ Exaggerate the left and right outlines. By doing so, you can clearly see the movement of the body and the different directions they take.

▶ The pose in this roughly traced drawing of a reference photo has no movement, and looks stiff.

The midline forms a gentle S-shaped curve!

If you capture the shape of the outline of the body starting with the shapes of the negative space behind the figure, the shape becomes more accurate.

The outside of the floating leg is a simple clean line, and the inside has convex and concave areas.

The median line is straight.

◀ *The outside of the supporting leg has convex and concave areas, and the inside is a simple line.*

Extend the midline all the way down to the feet.

The S-shaped flow rising from the weight-supporting left leg to the hips and then to the right shoulder becomes clearer, and the pose looks natural.

◀ An example where the pose is rather stiff.

Taking a Drink While Standing (Diagonal Front View)

Capture the same drinking-while-standing pose from a different angle. We'll draw the motion of putting the bottle on the mouth, and the raised arm movement.

Traced Drawing

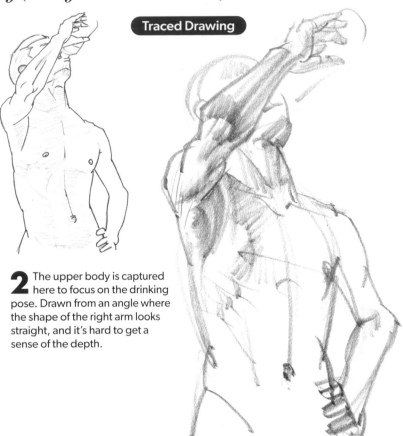

1 A pose showing a figure putting a bottle to its lips. This is the weight-on-one-leg standing pose that we described on pages 108–109, seen from the diagonal front.

2 The upper body is captured here to focus on the drinking pose. Drawn from an angle where the shape of the right arm looks straight, and it's hard to get a sense of the depth.

2 An example of adding tones to depict the bent elbow of the raised arm. The mouth area is shown to make it easy to see this is a drinking movement.

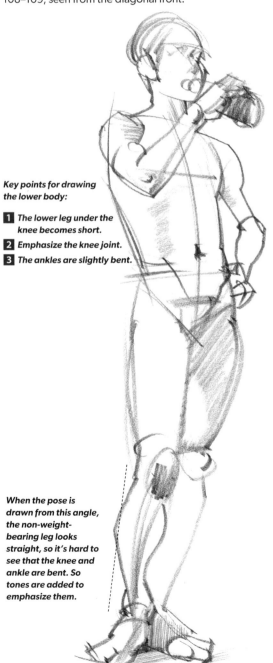

Key points for drawing the lower body:

1 *The lower leg under the knee becomes short.*

2 *Emphasize the knee joint.*

3 *The ankles are slightly bent.*

When the pose is drawn from this angle, the non-weight-bearing leg looks straight, so it's hard to see that the knee and ankle are bent. So tones are added to emphasize them.

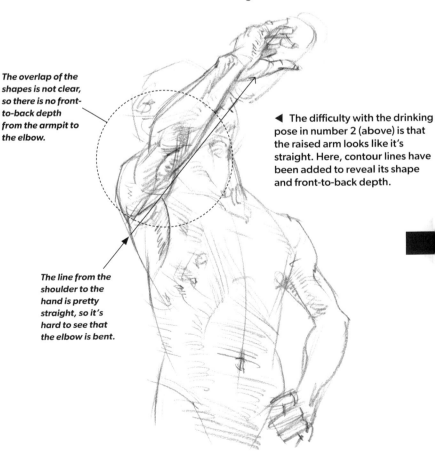

The overlap of the shapes is not clear, so there is no front-to-back depth from the armpit to the elbow.

The line from the shoulder to the hand is pretty straight, so it's hard to see that the elbow is bent.

◄ The difficulty with the drinking pose in number 2 (above) is that the raised arm looks like it's straight. Here, contour lines have been added to reveal its shape and front-to-back depth.

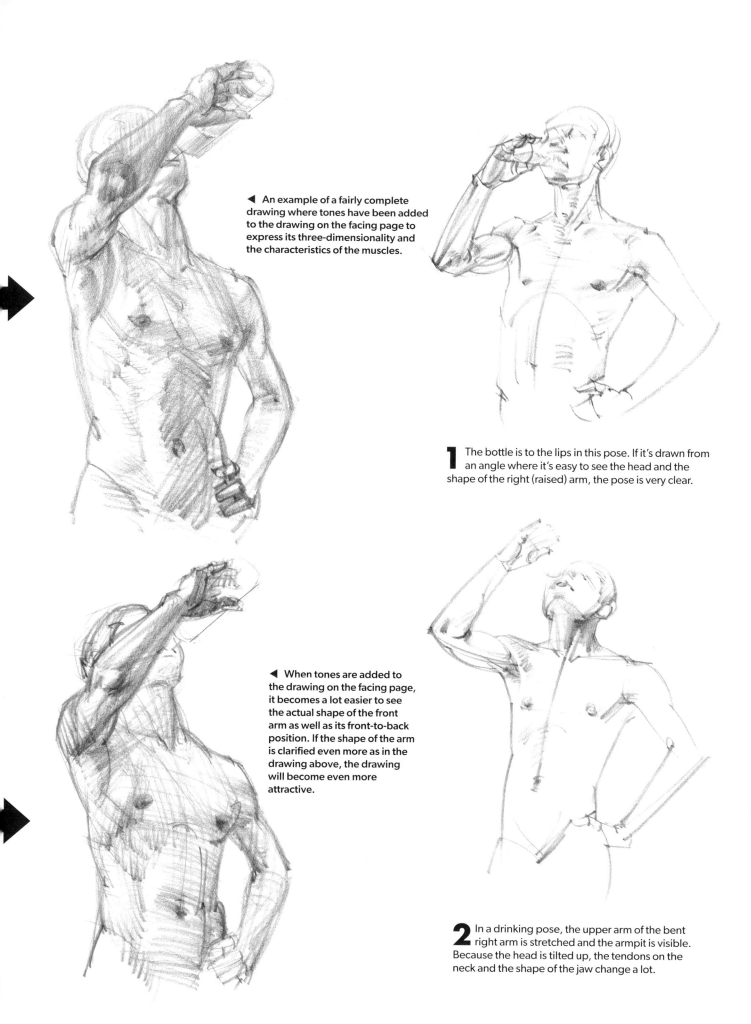

◀ An example of a fairly complete drawing where tones have been added to the drawing on the facing page to express its three-dimensionality and the characteristics of the muscles.

1 The bottle is to the lips in this pose. If it's drawn from an angle where it's easy to see the head and the shape of the right (raised) arm, the pose is very clear.

◀ When tones are added to the drawing on the facing page, it becomes a lot easier to see the actual shape of the front arm as well as its front-to-back position. If the shape of the arm is clarified even more as in the drawing above, the drawing will become even more attractive.

2 In a drinking pose, the upper arm of the bent right arm is stretched and the armpit is visible. Because the head is tilted up, the tendons on the neck and the shape of the jaw change a lot.

Drawing Variations of a Sitting Pose

In a sitting pose, use cylinders to construct the hidden parts such as the hips and the buttocks that are in contact with the seat surface. Refer to the section "Using Cylindrical Shapes for a Seated Pose" on page 40.

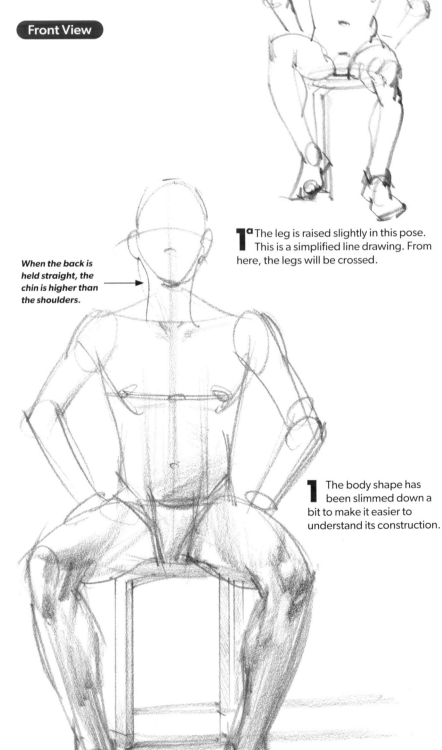

Traced Drawing

Crossing the Legs

Front View

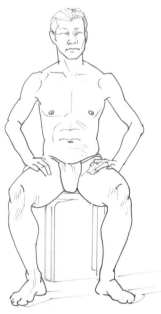

1 The thighs coming out to the foreground look short, so verify the ratio of the legs and the positions of the knees.

When the back is held straight, the chin is higher than the shoulders.

1ᵃ The leg is raised slightly in this pose. This is a simplified line drawing. From here, the legs will be crossed.

1 The body shape has been slimmed down a bit to make it easier to understand its construction.

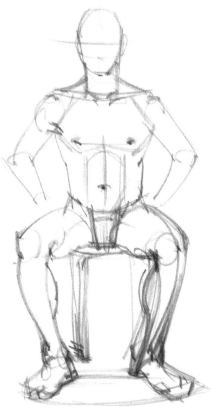

▲ An example of a drawing where a muscular upper body has been depicted, using reference material as the base.

In order to bring the knee to the front, be sure to show the shape of the groin area!

2 The left foot has been raised to knee level in this pose.

2ᵃ The right foot has been placed on top of the left thigh in this pose. Change the positions of the legs as you draw.

When the buttocks are in contact with the seat, they becomes flattened. Explore the shape of the groin area.

2 The arms and feet are abbreviated, and the shapes of the hips and buttocks are refined at this stage.

◄ Tilt the upper body in the opposite direction from the raised right leg, and connect the upper body with the curve created by the lowered left leg with an S-shaped flow.

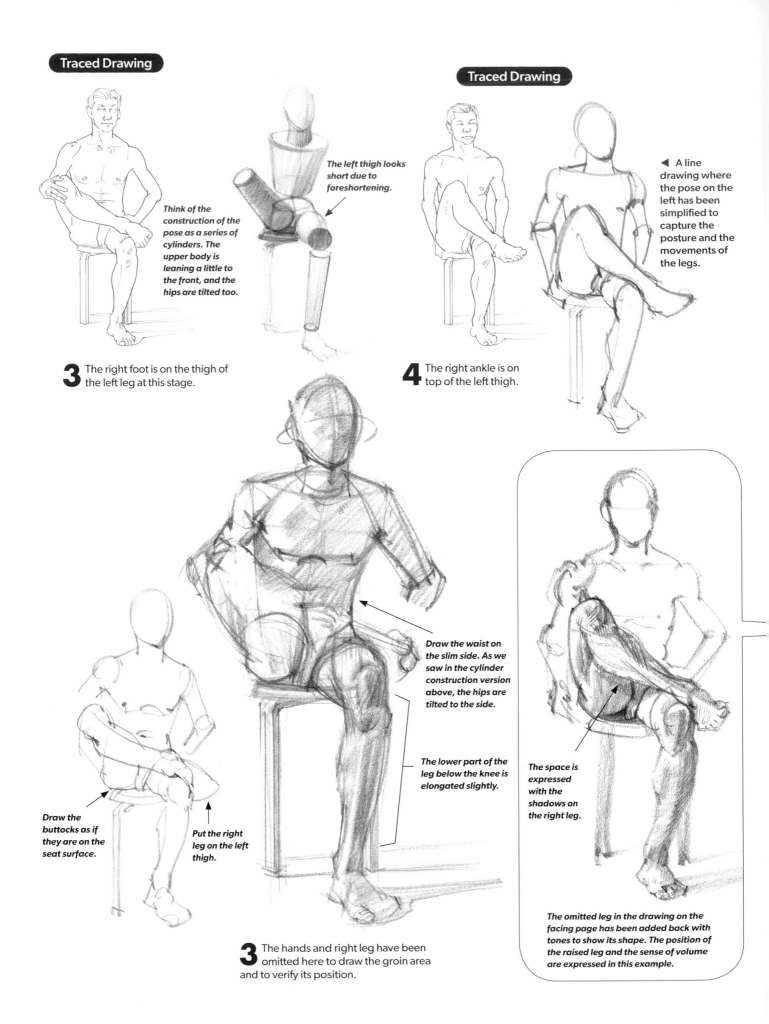

Think of the construction of the pose as a series of cylinders. The upper body is leaning a little to the front, and the hips are tilted too.

The left thigh looks short due to foreshortening.

3 The right foot is on the thigh of the left leg at this stage.

◄ A line drawing where the pose on the left has been simplified to capture the posture and the movements of the legs.

4 The right ankle is on top of the left thigh.

Draw the buttocks as if they are on the seat surface.

Put the right leg on the left thigh.

Draw the waist on the slim side. As we saw in the cylinder construction version above, the hips are tilted to the side.

The lower part of the leg below the knee is elongated slightly.

The space is expressed with the shadows on the right leg.

3 The hands and right leg have been omitted here to draw the groin area and to verify its position.

The omitted leg in the drawing on the facing page has been added back with tones to show its shape. The position of the raised leg and the sense of volume are expressed in this example.

114

Drawing the Flattened Thigh

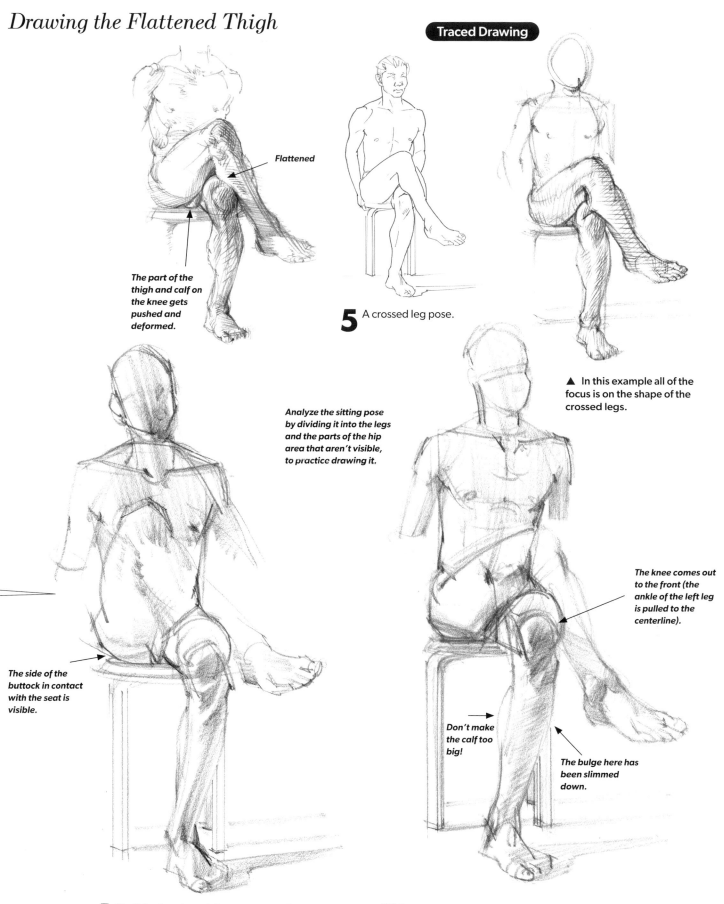

Flattened

The part of the thigh and calf on the knee gets pushed and deformed.

5 A crossed leg pose.

▲ In this example all of the focus is on the shape of the crossed legs.

Analyze the sitting pose by dividing it into the legs and the parts of the hip area that aren't visible, to practice drawing it.

The side of the buttock in contact with the seat is visible.

The knee comes out to the front (the ankle of the left leg is pulled to the centerline).

Don't make the calf too big!

The bulge here has been slimmed down.

4 Omit the hands and the lower part of the right leg, to verify the shape of the groin area once more.

5 Don't forget to capture the shape of left leg, which is supporting the weight of the crossed right leg. If you draw the difficult-to-see buttocks and hips when you're creating the rough guidelines for the figure, the sitting posture becomes more stable.

Crossing the Legs (Diagonal Front to Side Views)

Draw a sequence of poses where the left leg is lifted, then crossed over. If the figure is viewed from a diagonal vantage point, the seated position of the upper body and the tilt of the hips are easier to see.

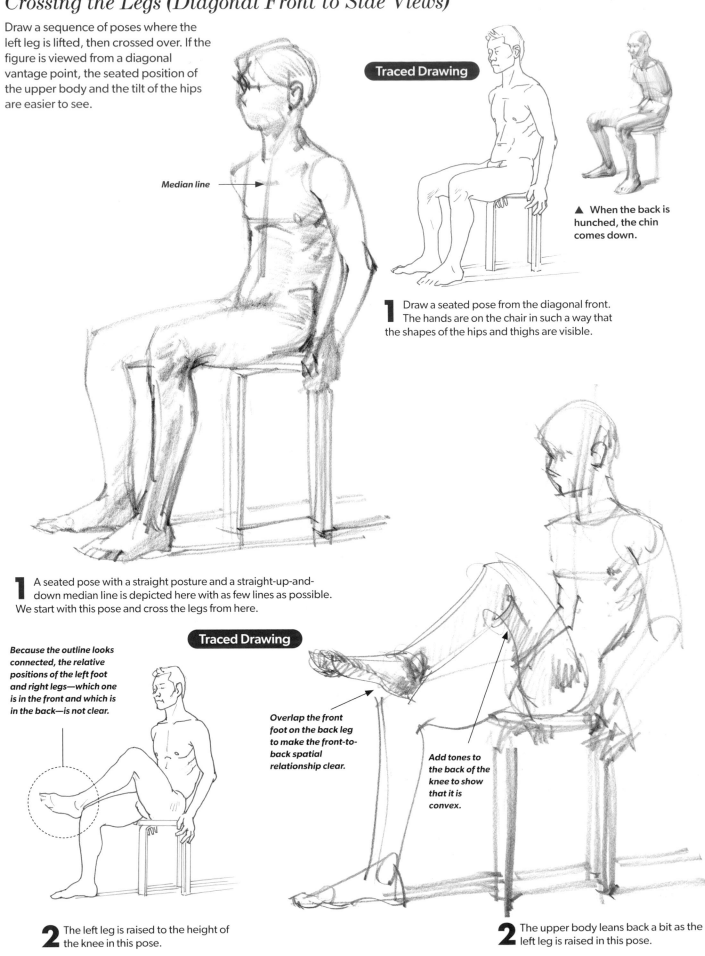

Median line

Traced Drawing

▲ When the back is hunched, the chin comes down.

1 Draw a seated pose from the diagonal front. The hands are on the chair in such a way that the shapes of the hips and thighs are visible.

1 A seated pose with a straight posture and a straight-up-and-down median line is depicted here with as few lines as possible. We start with this pose and cross the legs from here.

Traced Drawing

Because the outline looks connected, the relative positions of the left foot and right legs—which one is in the front and which is in the back—is not clear.

Overlap the front foot on the back leg to make the front-to-back spatial relationship clear.

Add tones to the back of the knee to show that it is convex.

2 The left leg is raised to the height of the knee in this pose.

2 The upper body leans back a bit as the left leg is raised in this pose.

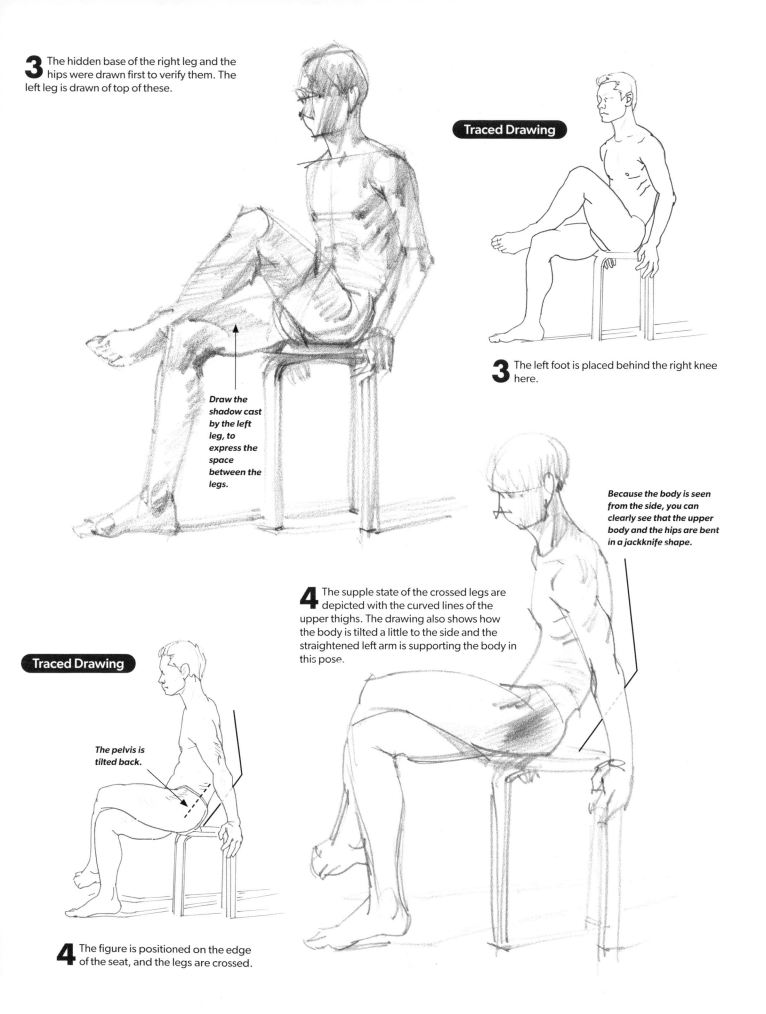

3 The hidden base of the right leg and the hips were drawn first to verify them. The left leg is drawn of top of these.

Draw the shadow cast by the left leg, to express the space between the legs.

Traced Drawing

3 The left foot is placed behind the right knee here.

Because the body is seen from the side, you can clearly see that the upper body and the hips are bent in a jackknife shape.

4 The supple state of the crossed legs are depicted with the curved lines of the upper thighs. The drawing also shows how the body is tilted a little to the side and the straightened left arm is supporting the body in this pose.

Traced Drawing

The pelvis is tilted back.

4 The figure is positioned on the edge of the seat, and the legs are crossed.

117

Getting Up to a Kneeling Position from the Sitting "Seiza" Position (Side and Diagonal Views)

From the "seiza" pose, one of the formal sitting positions in Japanese culture, we will draw the movement of the knees gradually straightening to sit up.

Traced Drawing

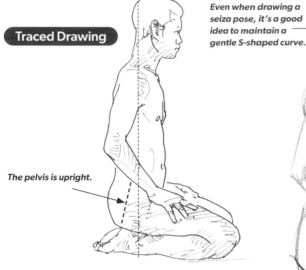

The pelvis is upright.

1 A seiza sitting pose seen from the side. The head is slightly tilted to the front, and the posture is straight.

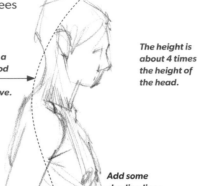

Even when drawing a seiza pose, it's a good idea to maintain a gentle S-shaped curve.

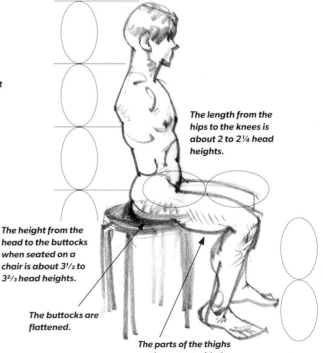

Add some shading lines to the front of the chest to express three-dimensionality.

1 A sitting pose with the knees together captured with as few lines as possible. The back is straight and the pelvis is upright in this position.

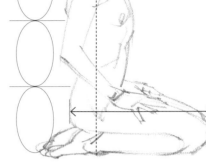

The height is about 4 times the height of the head.

The proportions from the hips to the knees is the same as when sitting on a chair.

Proportions of the Body When Seated on a Chair

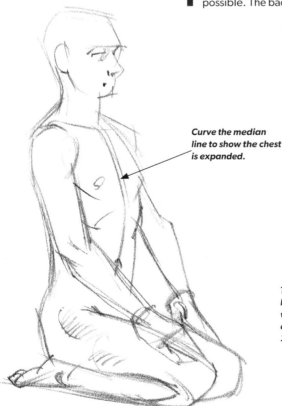

Curve the median line to show the chest is expanded.

▲ An example of a drawing of the seiza pose viewed from a diagonal point of view. Because the front of the chest and the tops of the knees are very visible, it's easy to draw three-dimensionally without having to add very many shading cues.

The length from the hips to the knees is about 2 to 2¼ head heights.

The height from the head to the buttocks when seated on a chair is about 3½ to 3⅔ head heights.

The buttocks are flattened.

The parts of the thighs not in contact with the seat sag a bit.

In the drawings in this book, the legs have been adjusted to make them on the longer side.

The height from the knees down is about 2 head heights.

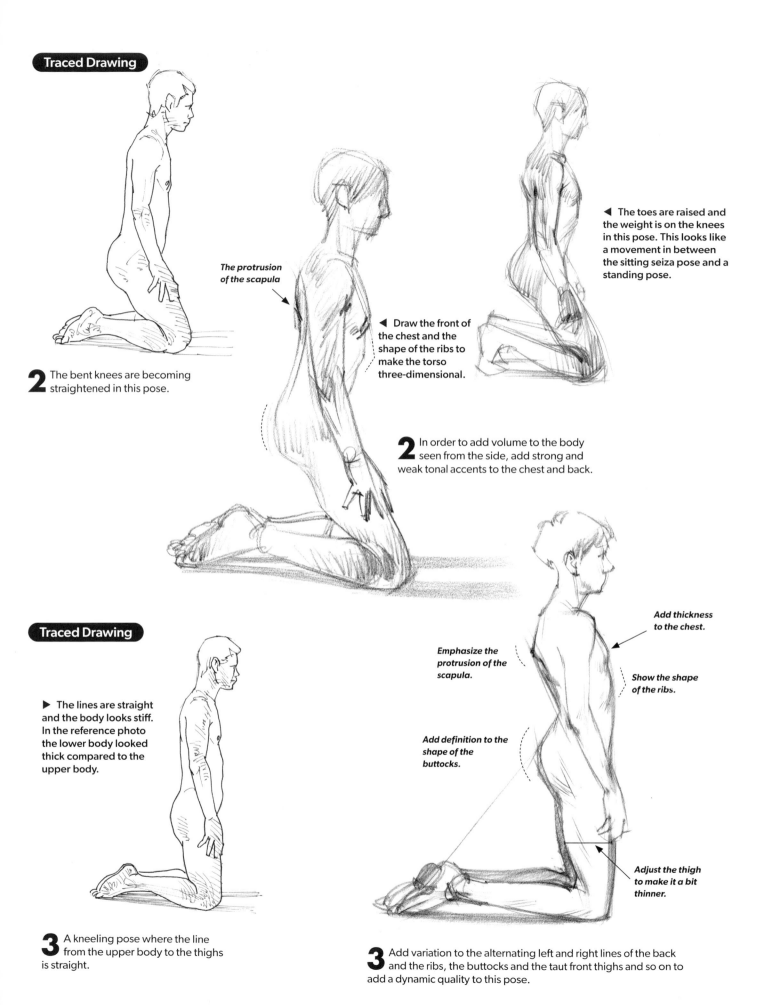

◀ The toes are raised and the weight is on the knees in this pose. This looks like a movement in between the sitting seiza pose and a standing pose.

The protrusion of the scapula

◀ Draw the front of the chest and the shape of the ribs to make the torso three-dimensional.

2 The bent knees are becoming straightened in this pose.

2 In order to add volume to the body seen from the side, add strong and weak tonal accents to the chest and back.

Add thickness to the chest.

Emphasize the protrusion of the scapula.

Show the shape of the ribs.

Add definition to the shape of the buttocks.

Traced Drawing

▶ The lines are straight and the body looks stiff. In the reference photo the lower body looked thick compared to the upper body.

Adjust the thigh to make it a bit thinner.

3 A kneeling pose where the line from the upper body to the thighs is straight.

3 Add variation to the alternating left and right lines of the back and the ribs, the buttocks and the taut front thighs and so on to add a dynamic quality to this pose.

Getting Up to a Kneeling Position from the Sitting "Seiza" Position (Front View)

If you observe the seiza sitting position from the front, the thighs look quite short. Add contour lines along the shape of the legs to give them volume. Refer to page 96, "A Pose with Strongly Bent Knees," to draw the shapes of legs that come out to the front.

Traced Drawings

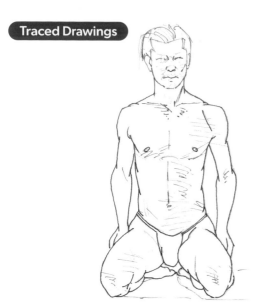

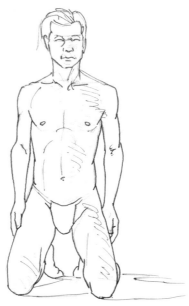

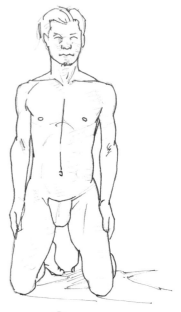

1 The belly swells a bit because it's in contact with the thighs.

2 When the body goes up on the knees, the torso becomes thinner.

3

The key points for drawing bent legs

1 *A series of oval shapes make the thighs come out to the foreground.*

2 *The thighs are flattened and the upper muscles bulge out.*

3 *The knees are hexagon shaped.*

1 2 3

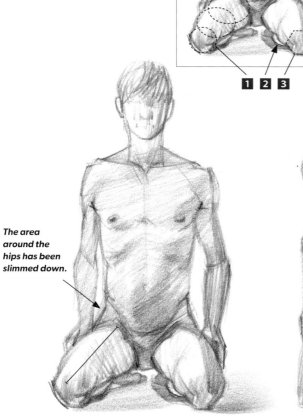

The area around the hips has been slimmed down.

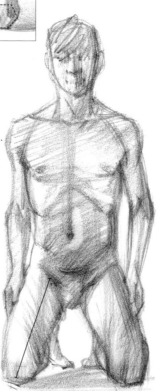

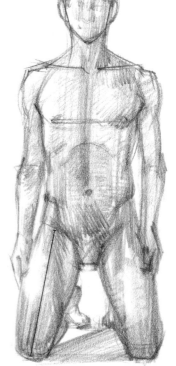

1 The more the knees are bent, the shorter the thighs look.

2

3

Variations of Sitting-to-standing Transitional Movements

Use the everyday movements we've been looking at in this chapter—sitting to standing; sitting in a chair; and coming up from a seiza sitting position on the floor up to a kneeling position—to draw variations, such as standing up from a low stool.

Making a Figure Stand Up (Diagonal View)

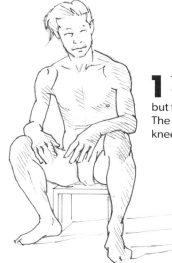

1 The chair in the sitting pose on page 112 is about 18 inches (45 cm) high, but this low stool is about half that height. The thigh is bent from the groin, and the knees come up to the height of the waist.

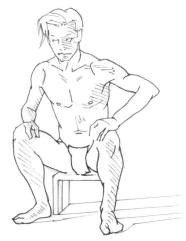

2 The hands on the knees have tensed, in preparation for standing up.

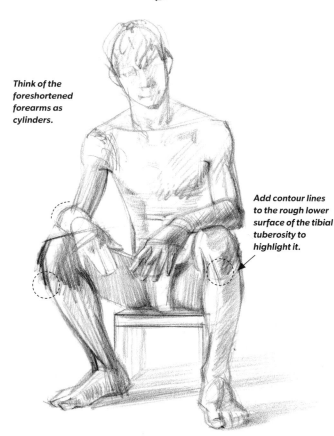

Think of the foreshortened forearms as cylinders.

Add contour lines to the rough lower surface of the tibial tuberosity to highlight it.

1 A relaxed sitting pose. As with the squatting pose on page 101, the upper body is leaning slightly forward.

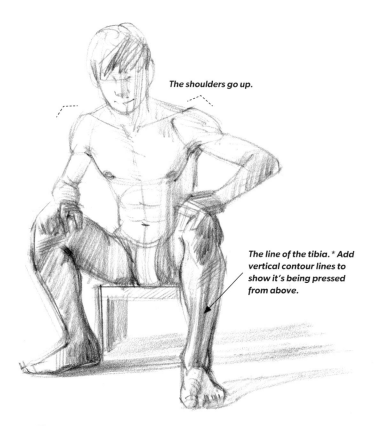

The shoulders go up.

The line of the tibia. Add vertical contour lines to show it's being pressed from above.*

3 The upper body leans a little to the front, and the left elbow is pushed out strongly to the side, to emphasize that it is tensing for action. Vertical contour lines are added to the lower legs too, to show that they are becoming tensed.

**The tibial tubercle is the flat upper surface of the tibia (the shin bone).*

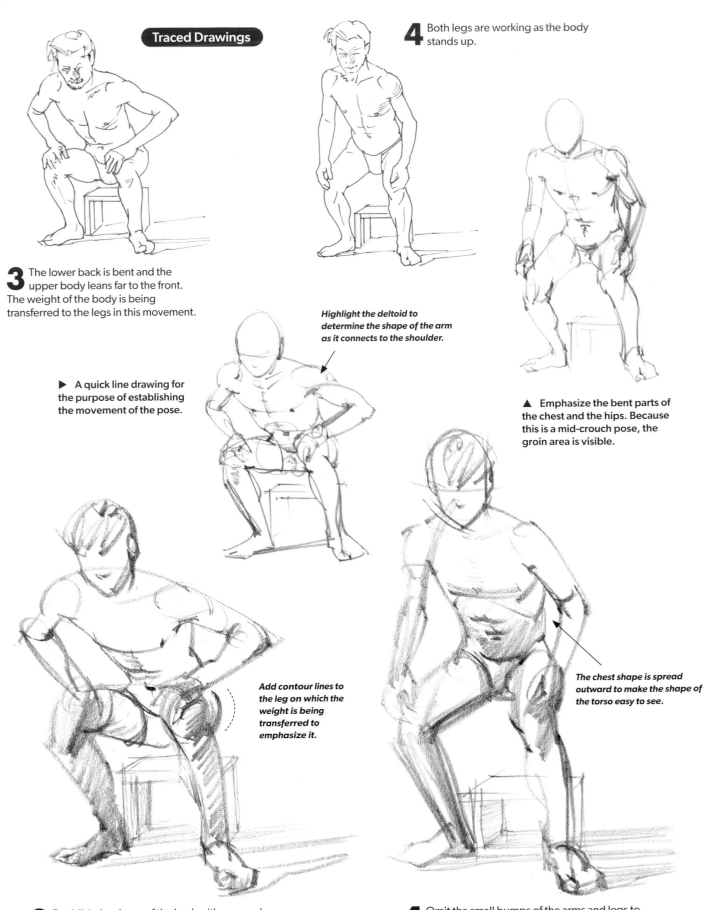

4 Both legs are working as the body stands up.

3 The lower back is bent and the upper body leans far to the front. The weight of the body is being transferred to the legs in this movement.

Highlight the deltoid to determine the shape of the arm as it connects to the shoulder.

▶ A quick line drawing for the purpose of establishing the movement of the pose.

▲ Emphasize the bent parts of the chest and the hips. Because this is a mid-crouch pose, the groin area is visible.

Add contour lines to the leg on which the weight is being transferred to emphasize it.

The chest shape is spread outward to make the shape of the torso easy to see.

3 Establish the shape of the back with a curved line that connects from the right shoulder to the left shoulder, to help lend a dynamic quality to the inclined upper body.

4 Omit the small bumps of the arms and legs to place the emphasis on the simply communicating the action that's taking place.

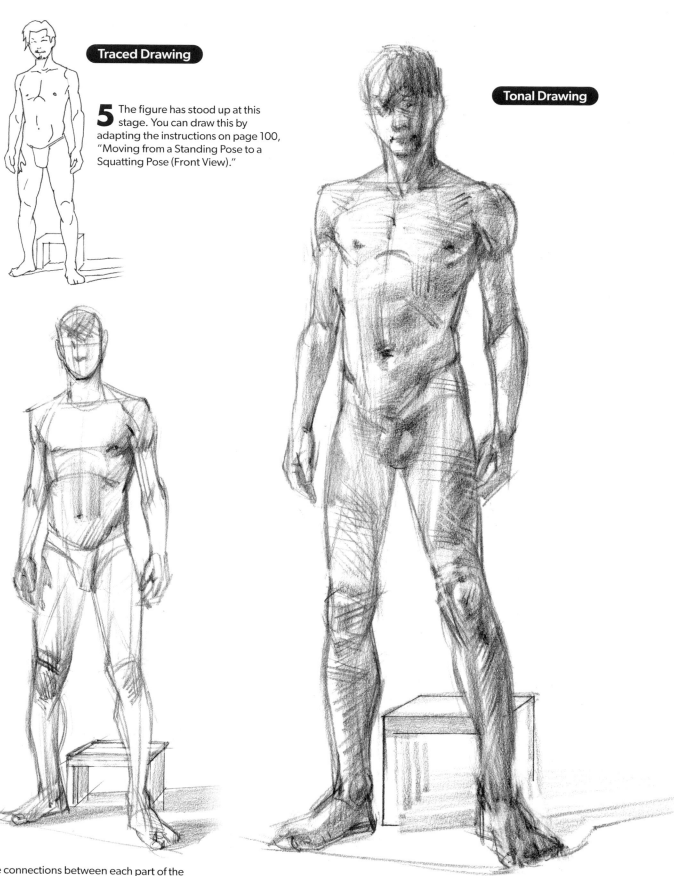

Traced Drawing

5 The figure has stood up at this stage. You can draw this by adapting the instructions on page 100, "Moving from a Standing Pose to a Squatting Pose (Front View)."

Tonal Drawing

5 The connections between each part of the body are drawn with lines that are as long as possible, so that the construction of the body can be easily seen in this standing pose.

▲ An example of a drawing with tones and details added. The sense of volume and the front-to-back spatial relationships between each part are easy to see, making this a drawing with a strong presence.

Making a Figure Stand Up
(Three-quarters View)

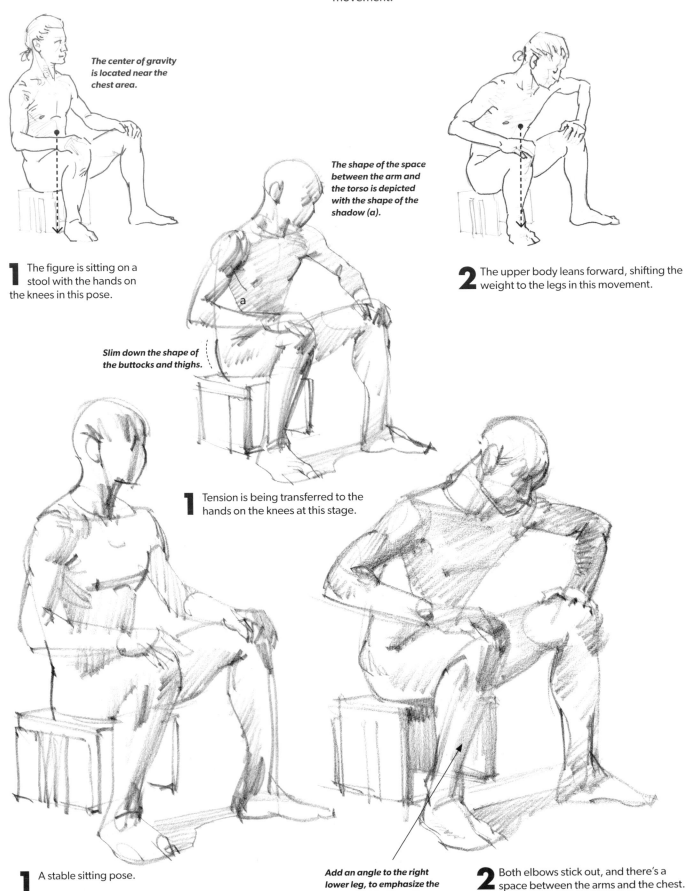

When viewed from a diagonal vantage point, it's easy to see the transfer of weight and how the legs move to be under the center of gravity in the sitting-to-standing movement.

The center of gravity is located near the chest area.

1 The figure is sitting on a stool with the hands on the knees in this pose.

The shape of the space between the arm and the torso is depicted with the shape of the shadow (a).

2 The upper body leans forward, shifting the weight to the legs in this movement.

Slim down the shape of the buttocks and thighs.

1 Tension is being transferred to the hands on the knees at this stage.

1 A stable sitting pose.

Add an angle to the right lower leg, to emphasize the movement that transfers tension to it.

2 Both elbows stick out, and there's a space between the arms and the chest.

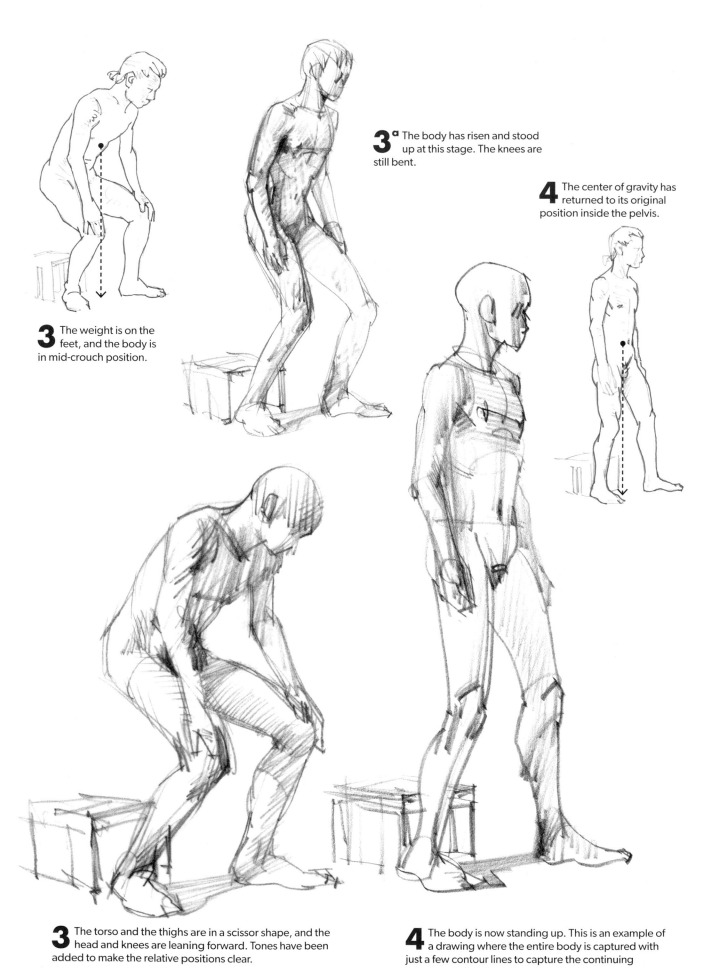

3ᵃ The body has risen and stood up at this stage. The knees are still bent.

4 The center of gravity has returned to its original position inside the pelvis.

3 The weight is on the feet, and the body is in mid-crouch position.

3 The torso and the thighs are in a scissor shape, and the head and knees are leaning forward. Tones have been added to make the relative positions clear.

4 The body is now standing up. This is an example of a drawing where the entire body is captured with just a few contour lines to capture the continuing movement. Small details are omitted to present a clear view of the entire body in motion.

Vary the Wrinkles on Clothes

When drawing a clothed figure, the expression of the wrinkles on the clothes is essential. Drawing the wrinkles makes it easier to see the body's flow of movement. Examples of the wrinkles seen on clothing with large arm and leg movements are shown in the next chapter, on page 170.

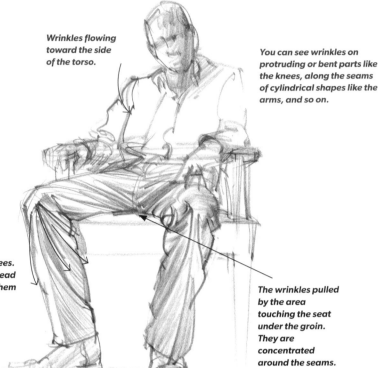

Wrinkles flowing toward the side of the torso.

You can see wrinkles on protruding or bent parts like the knees, along the seams of cylindrical shapes like the arms, and so on.

A Deeply Seated Pose

There are wrinkles pulled by the knees. The wrinkles from the kneecaps spread out and become looser toward the hem of the pants.

The wrinkles pulled by the area touching the seat under the groin. They are concentrated around the seams.

Clothing Wrinkles in a Relaxed Pose

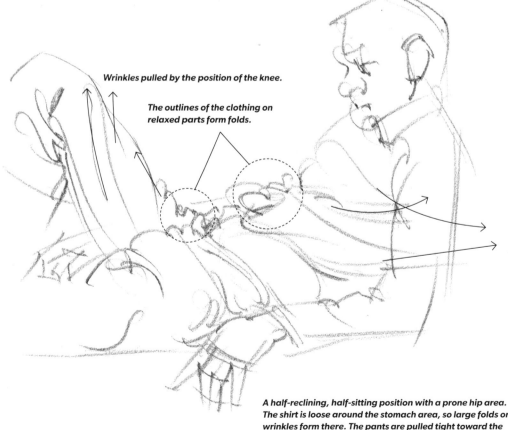

Wrinkles pulled by the position of the knee.

The outlines of the clothing on relaxed parts form folds.

Because the back is against a wall, the garment is pinned there, causing folds to form as the body and clothing are affected by gravity and tension.

A half-reclining, half-sitting position with a prone hip area. The shirt is loose around the stomach area, so large folds or wrinkles form there. The pants are pulled tight toward the knee, so thin wrinkles form there.

5

Dynamically Moving Poses—Adaptations and Expressions

In this chapter we will draw lively movements or theatrical expressions where the arms and legs have exaggerated motions. A dynamic movement is formed when the body is tilted or twisted to the front and back or to the sides. Here, we introduce example drawings of the low-center-of-gravity movements and dance-like body positions of a model with exceptional physical ability.

Capturing Throwing Movements

Before starting a major motion, the body often assumes a pose where the hips are dropped. This is a position that allows for a smooth transition to the next movement. Start by drawing the preliminary and ending poses, and then tackle the continuous movements in between.

Preparatory Movements and the Follow Through

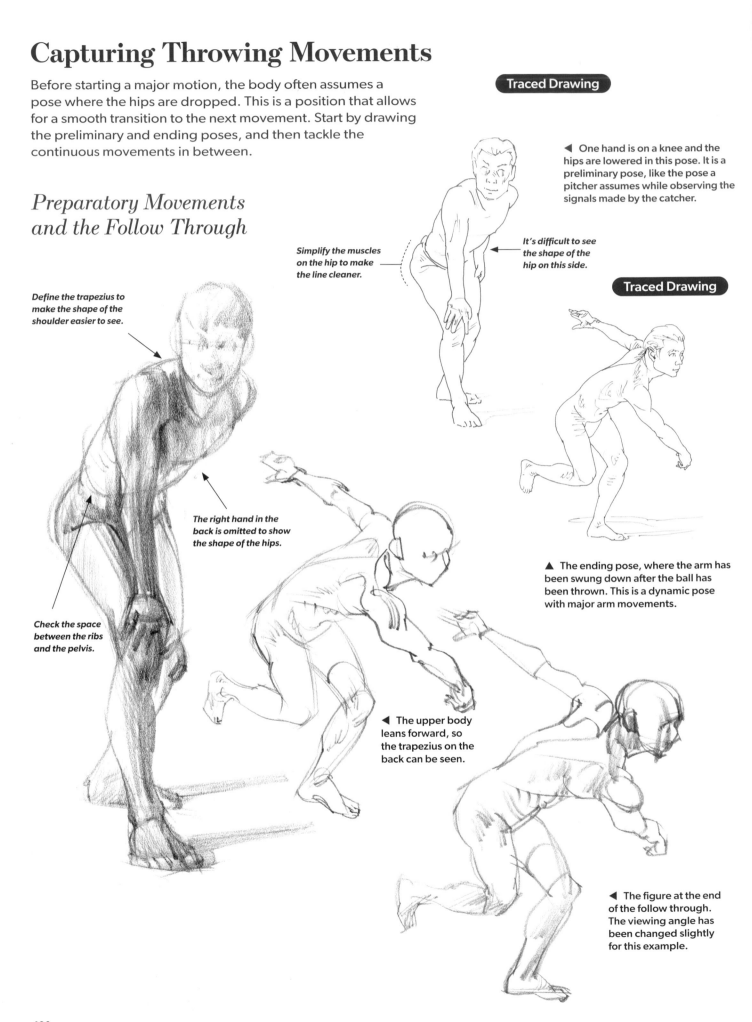

Traced Drawing

◀ One hand is on a knee and the hips are lowered in this pose. It is a preliminary pose, like the pose a pitcher assumes while observing the signals made by the catcher.

Simplify the muscles on the hip to make the line cleaner.

It's difficult to see the shape of the hip on this side.

Traced Drawing

Define the trapezius to make the shape of the shoulder easier to see.

The right hand in the back is omitted to show the shape of the hips.

Check the space between the ribs and the pelvis.

▲ The ending pose, where the arm has been swung down after the ball has been thrown. This is a dynamic pose with major arm movements.

◀ The upper body leans forward, so the trapezius on the back can be seen.

◀ The figure at the end of the follow through. The viewing angle has been changed slightly for this example.

Traced Drawing

If the head is depicted a little wider, the sense of depth is enhanced.

The hips in the back are wide and look too big.

The head has been enlarged to show the top of it.

The first drawing made based on a reference photo.

Make Corrections!

Use the shadow of the shoulder to show that there is a space between the torso and the hips.

Put in a crease between the torso and the hips that is hidden by the arm, to show the bent shape.

The drawing should have light-to-dark shading to communicate the different planes to the viewer.

If the hand is drawn as if it's wrapped around the knee, the underlying shape of the knee is expressed even though it's hidden.

Pare away some of the bulge of the calf, to show the bend of the knee.

The pose seen from the front. It's difficult to see the front-to-back depth from this angle.

This drawing shows the weight of the body as it flows down from the shoulders, through the trunk and limbs, all the way to the balls of the feet.

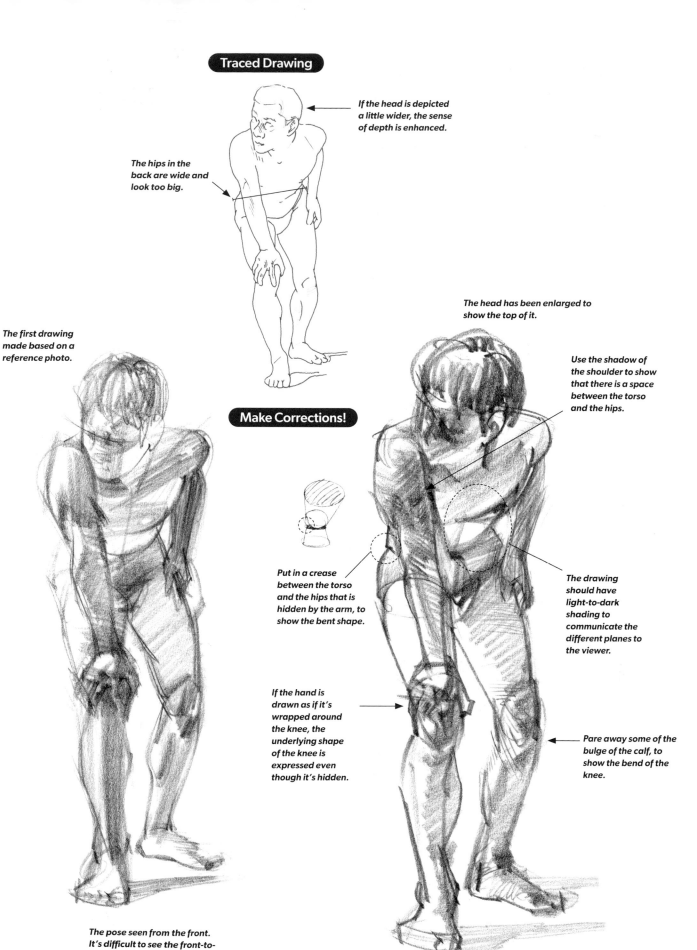

Drawing a Simulated Throwing Gesture

This is a pose that simulates throwing a small, light object or a long spear. There is no run-up, and it is drawn so that the swing of the arms and the transition from the back to the front can be seen.

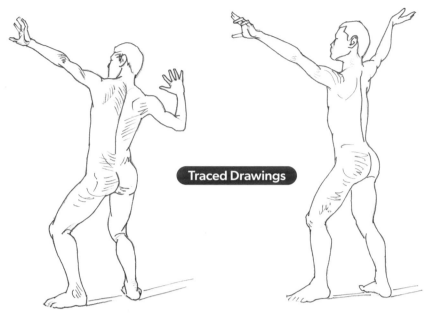

Traced Drawings

1 In the preparatory movement, the arm is pulled to the back.

2 The straight lines of the left arm in the traced drawing are converted to curved lines in this drawing.

Throwing with the Right Hand

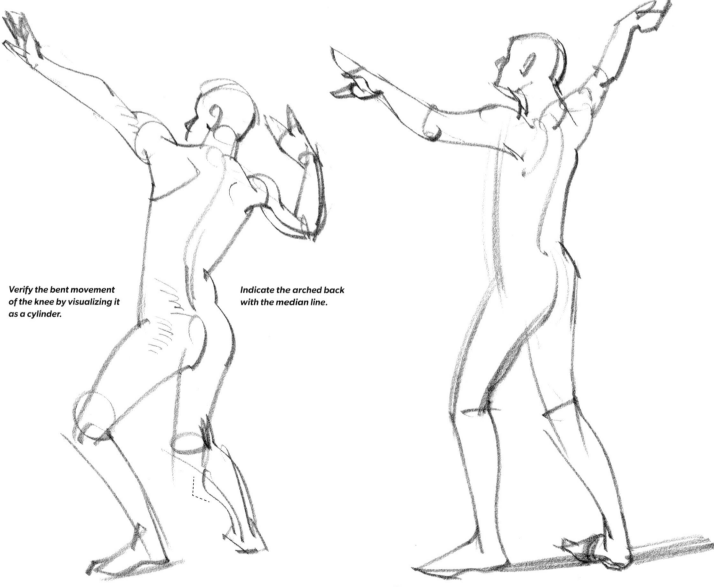

Verify the bent movement of the knee by visualizing it as a cylinder.

Indicate the arched back with the median line.

1 The upper body is arched to the rear, and the hips are lowered to gather strength.

2 Straighten the knees, and indicate the transfer of power gathered in the hips to the arm swing.

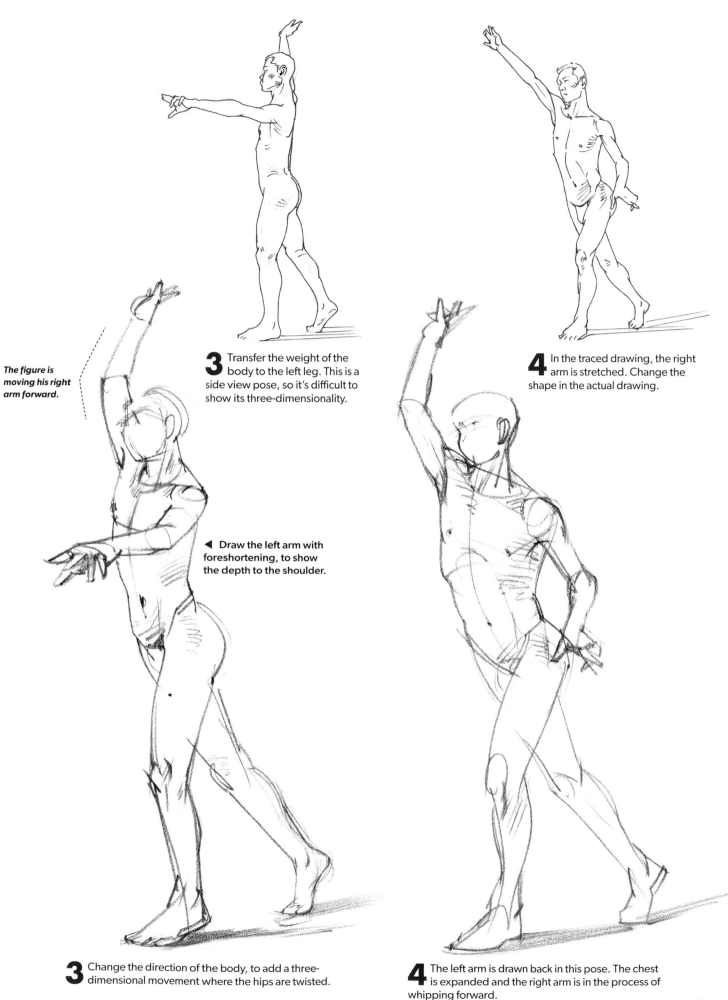

The figure is moving his right arm forward.

3 Transfer the weight of the body to the left leg. This is a side view pose, so it's difficult to show its three-dimensionality.

◄ Draw the left arm with foreshortening, to show the depth to the shoulder.

4 In the traced drawing, the right arm is stretched. Change the shape in the actual drawing.

3 Change the direction of the body, to add a three-dimensional movement where the hips are twisted.

4 The left arm is drawn back in this pose. The chest is expanded and the right arm is in the process of whipping forward.

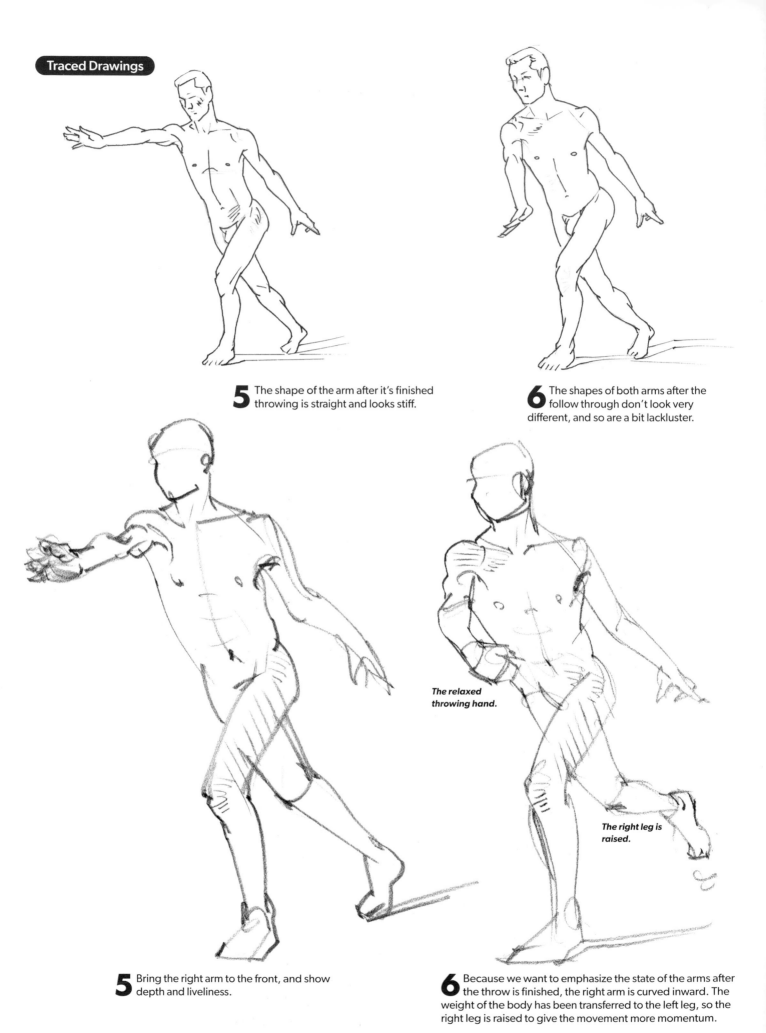

5 The shape of the arm after it's finished throwing is straight and looks stiff.

6 The shapes of both arms after the follow through don't look very different, and so are a bit lackluster.

The relaxed throwing hand.

The right leg is raised.

5 Bring the right arm to the front, and show depth and liveliness.

6 Because we want to emphasize the state of the arms after the throw is finished, the right arm is curved inward. The weight of the body has been transferred to the left leg, so the right leg is raised to give the movement more momentum.

Throwing with the Left Hand

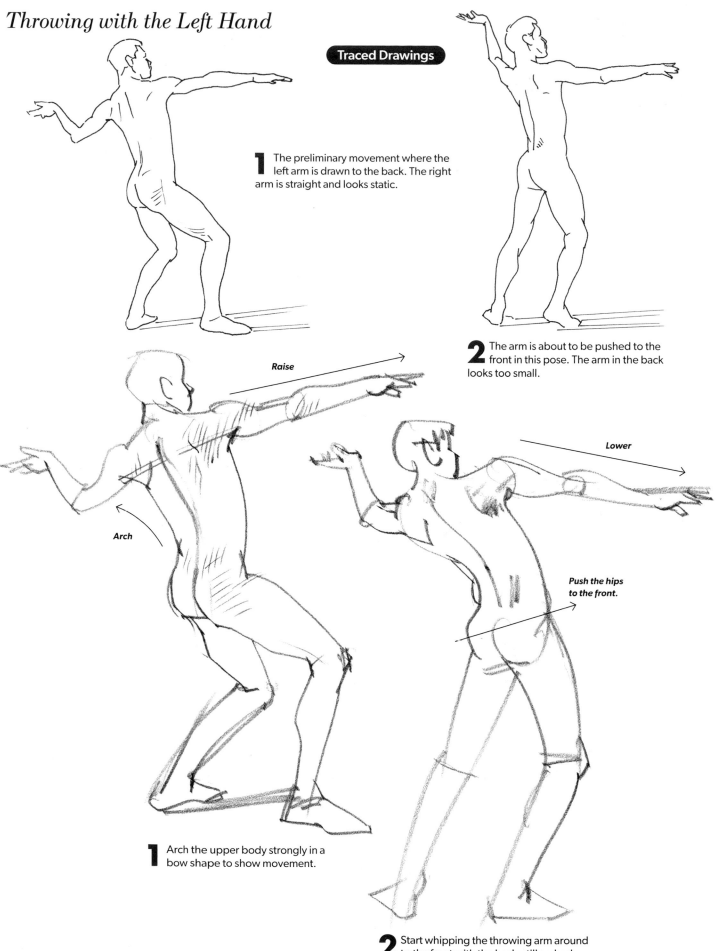

1 The preliminary movement where the left arm is drawn to the back. The right arm is straight and looks static.

2 The arm is about to be pushed to the front in this pose. The arm in the back looks too small.

Raise

Arch

Lower

Push the hips to the front.

1 Arch the upper body strongly in a bow shape to show movement.

2 Start whipping the throwing arm around to the front with the body still arched. Straighten the knees and transfer the gathered power to the front.

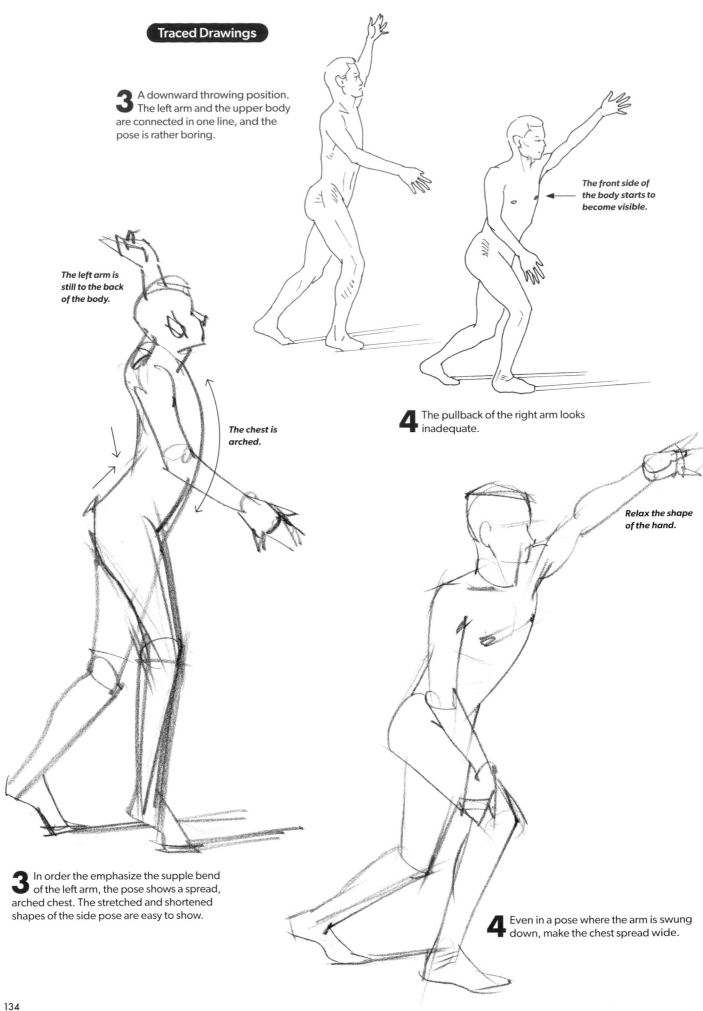

Traced Drawings

3 A downward throwing position. The left arm and the upper body are connected in one line, and the pose is rather boring.

The front side of the body starts to become visible.

The left arm is still to the back of the body.

The chest is arched.

4 The pullback of the right arm looks inadequate.

Relax the shape of the hand.

3 In order the emphasize the supple bend of the left arm, the pose shows a spread, arched chest. The stretched and shortened shapes of the side pose are easy to show.

4 Even in a pose where the arm is swung down, make the chest spread wide.

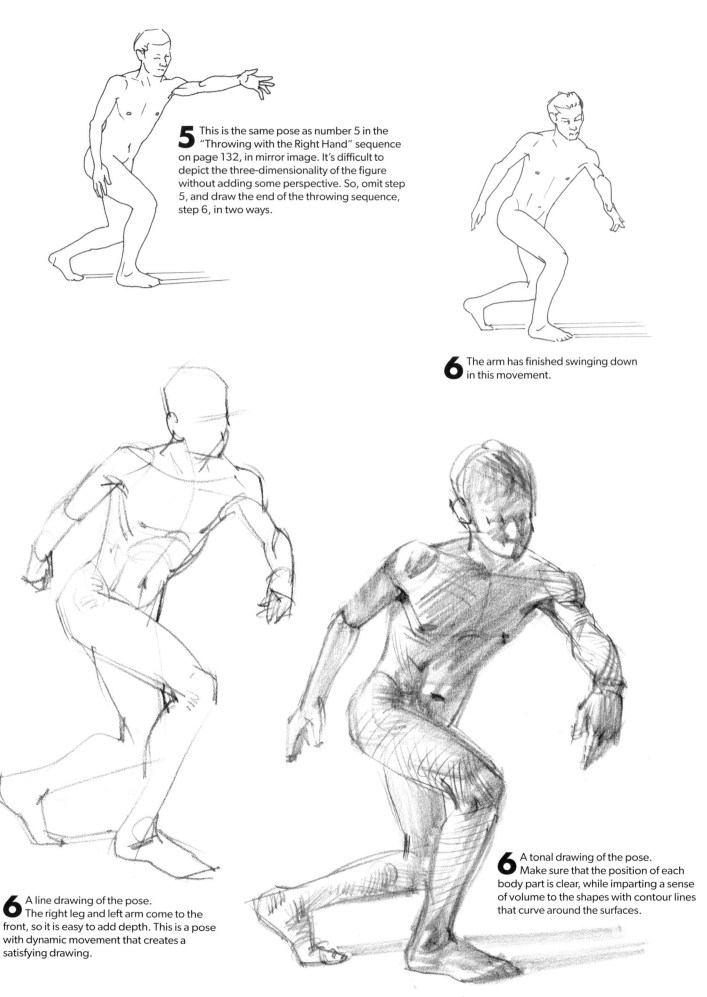

5 This is the same pose as number 5 in the "Throwing with the Right Hand" sequence on page 132, in mirror image. It's difficult to depict the three-dimensionality of the figure without adding some perspective. So, omit step 5, and draw the end of the throwing sequence, step 6, in two ways.

6 The arm has finished swinging down in this movement.

6 A line drawing of the pose. The right leg and left arm come to the front, so it is easy to add depth. This is a pose with dynamic movement that creates a satisfying drawing.

6 A tonal drawing of the pose. Make sure that the position of each body part is clear, while imparting a sense of volume to the shapes with contour lines that curve around the surfaces.

Capturing the Movement of Bending Over

Draw the motion of the body bending to the front. From poses where the hips are at a high level while the arm is stretched out, or where the legs are bent and the hips are at a low level, try capturing a movement that displays a sense of depth from the torso to the hips.

Bending Over to Pick Something Up

Traced Drawing

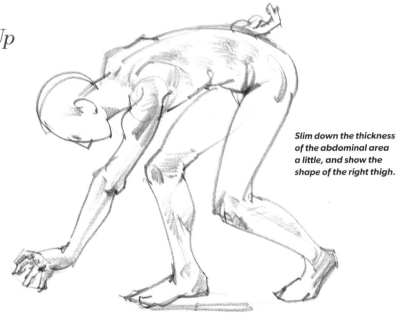

Slim down the thickness of the abdominal area a little, and show the shape of the right thigh.

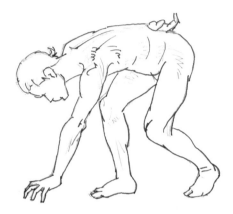

1 The weight of the body is on the right leg and the left arm is stretched in this pose. The hip area looks thick compared to the upper body.

1 Round the back even more, to exaggerate the act of bending down.

a. The pectoral muscles are emphasized.

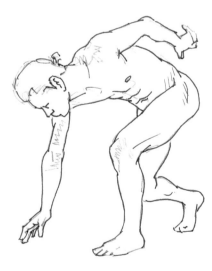

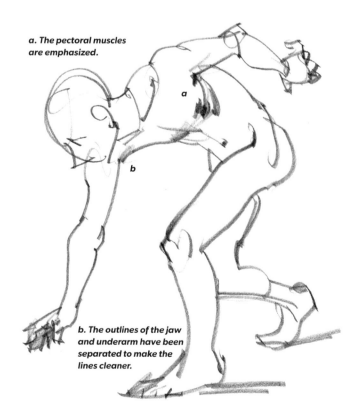

b. The outlines of the jaw and underarm have been separated to make the lines cleaner.

2 The weight of the body is on the left leg, and the hips are slightly twisted as the right hand stretches out in this pose. The outlines of the jaw and underarm area are on top of each other and are distracting.

2 There is a twist from the upper body to the hips in this nuanced, lyrical pose. The outline created by the arms and legs is attractive too.

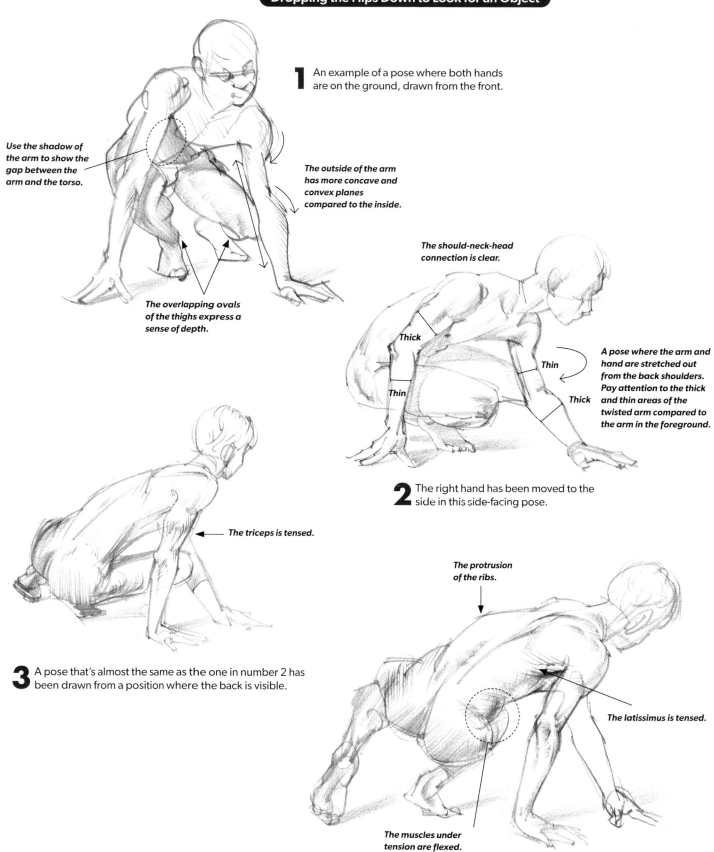

1 An example of a pose where both hands are on the ground, drawn from the front.

Use the shadow of the arm to show the gap between the arm and the torso.

The outside of the arm has more concave and convex planes compared to the inside.

The overlapping ovals of the thighs express a sense of depth.

The should-neck-head connection is clear.

Thick

Thin

Thin

Thick

A pose where the arm and hand are stretched out from the back shoulders. Pay attention to the thick and thin areas of the twisted arm compared to the arm in the foreground.

2 The right hand has been moved to the side in this side-facing pose.

The triceps is tensed.

3 A pose that's almost the same as the one in number 2 has been drawn from a position where the back is visible.

The protrusion of the ribs.

The latissimus is tensed.

The muscles under tension are flexed.

4 The left leg is drawn to the back, and the hips are raised in this movement. This pose is not only seen in a situation where someone is looking for something on the ground, but also one in which someone is in the process of standing up.

137

Moving Forward from a Bent Pose

This is a weighty movement that is similar to a sumo wrestler lunging toward his opponent at the start of a match, or the crouching start of a runner. Capture the force of this movement, which is like that of the standing start.

Traced Drawing

It's hard to understand the shape of the leg.

The spatial relationship of the left hand is not clear.

1 A pose that looks like the figure is about to make a tackle.

Starting from a Low Position

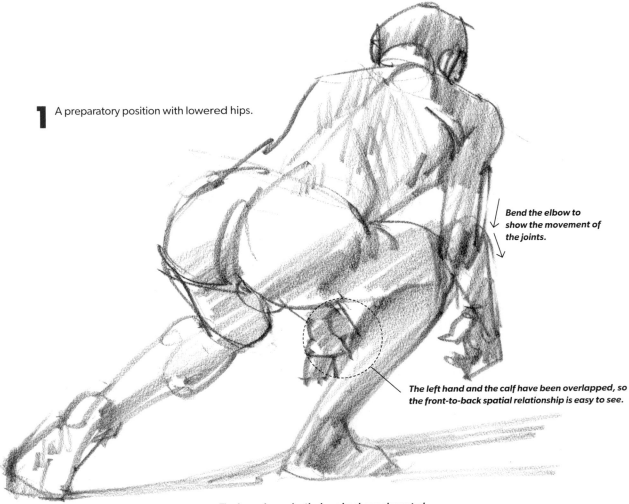

1 A preparatory position with lowered hips.

Bend the elbow to show the movement of the joints.

The left hand and the calf have been overlapped, so the front-to-back spatial relationship is easy to see.

The lower leg under the knee has been elongated.

140

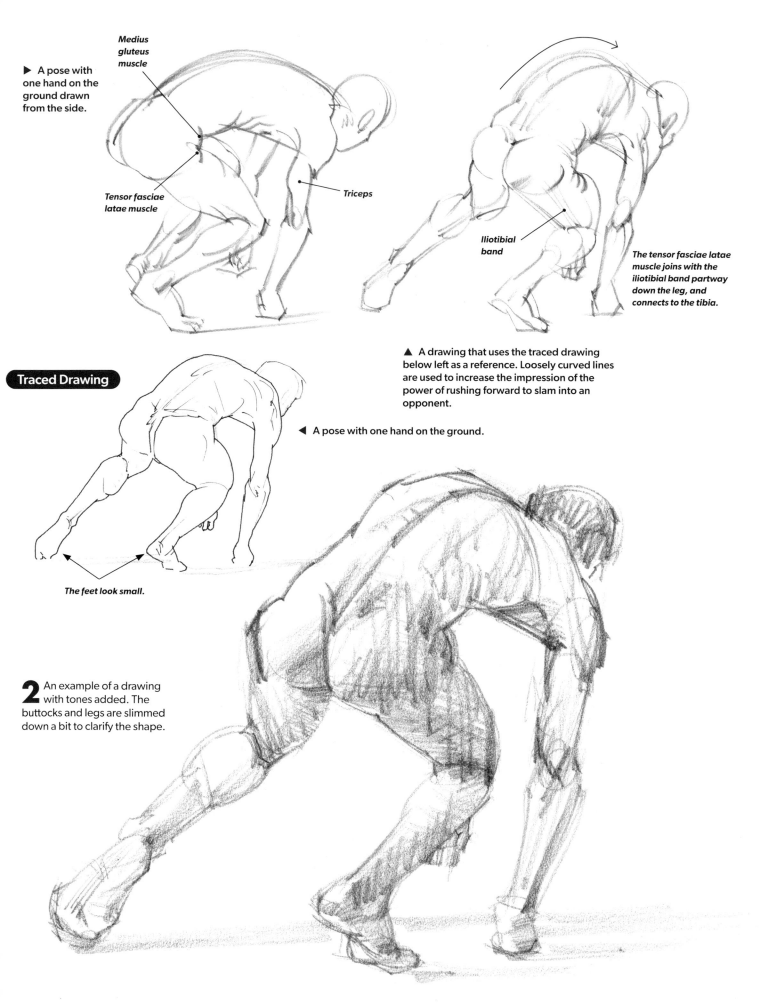

► A pose with one hand on the ground drawn from the side.

Medius gluteus muscle

Tensor fasciae latae muscle

Triceps

Iliotibial band

The tensor fasciae latae muscle joins with the iliotibial band partway down the leg, and connects to the tibia.

▲ A drawing that uses the traced drawing below left as a reference. Loosely curved lines are used to increase the impression of the power of rushing forward to slam into an opponent.

Traced Drawing

◄ A pose with one hand on the ground.

The feet look small.

2 An example of a drawing with tones added. The buttocks and legs are slimmed down a bit to clarify the shape.

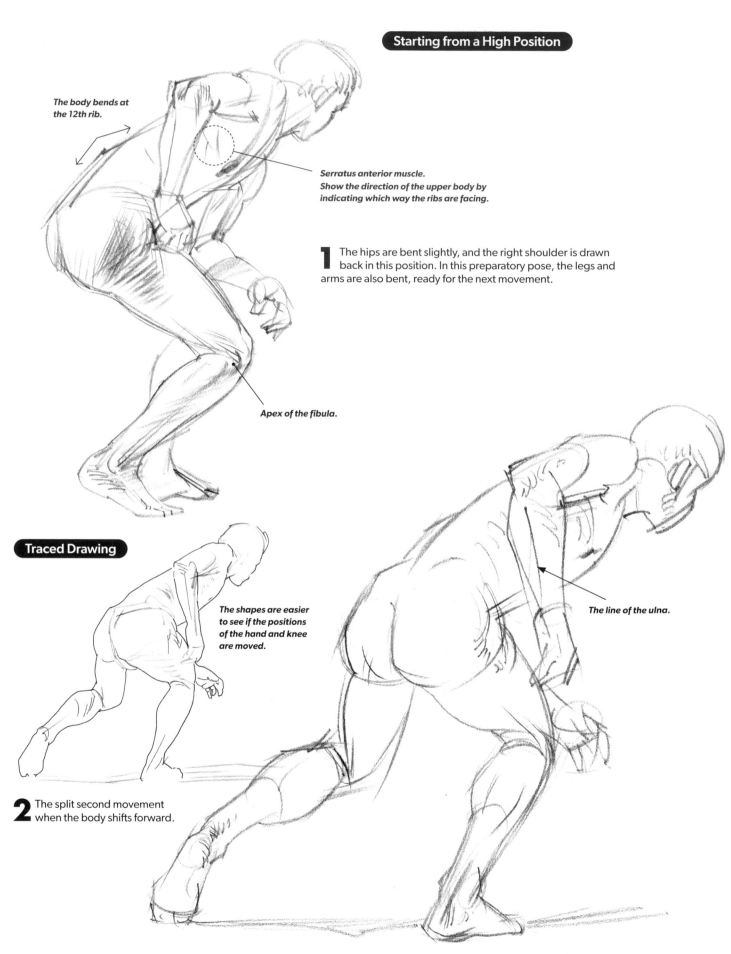

The body bends at the 12th rib.

Serratus anterior muscle.
Show the direction of the upper body by indicating which way the ribs are facing.

1 The hips are bent slightly, and the right shoulder is drawn back in this position. In this preparatory pose, the legs and arms are also bent, ready for the next movement.

Apex of the fibula.

Traced Drawing

The shapes are easier to see if the positions of the hand and knee are moved.

The line of the ulna.

2 The split second movement when the body shifts forward.

2 A pose right after pushing off. The feet are hitting the ground hard, so capture the movement of the legs and hips. The buttocks, thighs and head have been made a bit smaller.

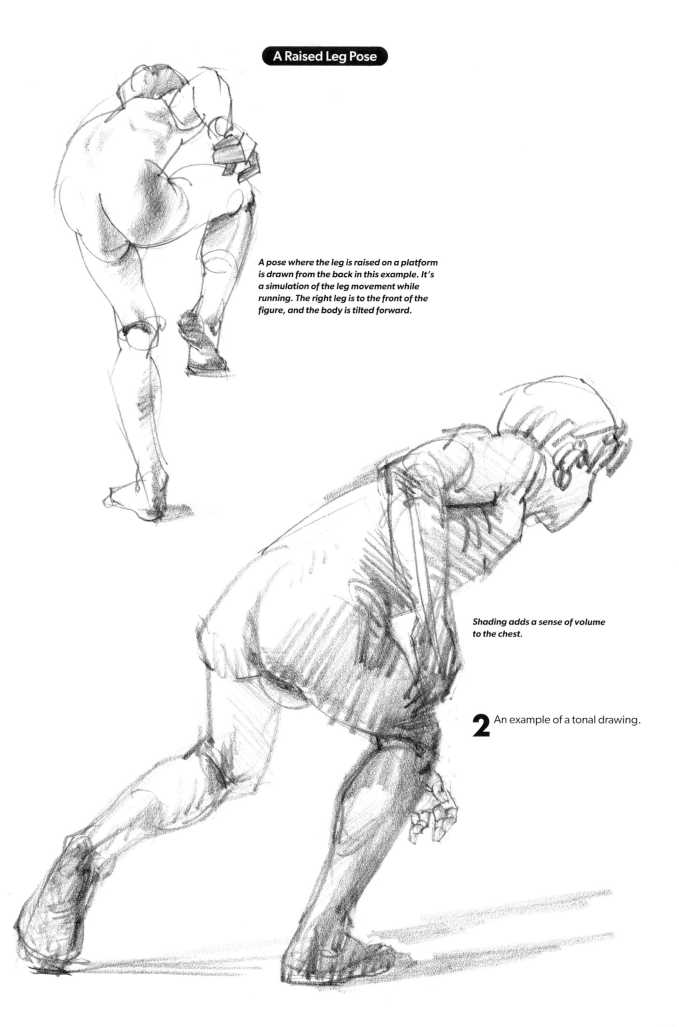

A pose where the leg is raised on a platform is drawn from the back in this example. It's a simulation of the leg movement while running. The right leg is to the front of the figure, and the body is tilted forward.

Shading adds a sense of volume to the chest.

2 An example of a tonal drawing.

A Raised Leg Pose

Shifting the Body Weight in Mid-crouch

Traced Drawing

1 The body is lowered halfway with the legs opened, and the weight of the body is shifted to one leg in this action. This pose is often seen when a baseball player is trying to steal a base, or when a tennis player is getting ready for the serve—it allows the body to move quickly to the front or back, left or right.

◀ In this example, the focus is on the twist of the back.

▶ An example of a drawing with tonal indicators of depth added.

1 The weight of the body is on the left leg in this pose. The line connecting the median line of the back to the right leg shows the flexibility of the body.

1 The focus here is on visually communicating how the figure appears three-dimensional, with the legs and hips in the foreground and the head in the background. The weight and presence of the body are clearly expressed.

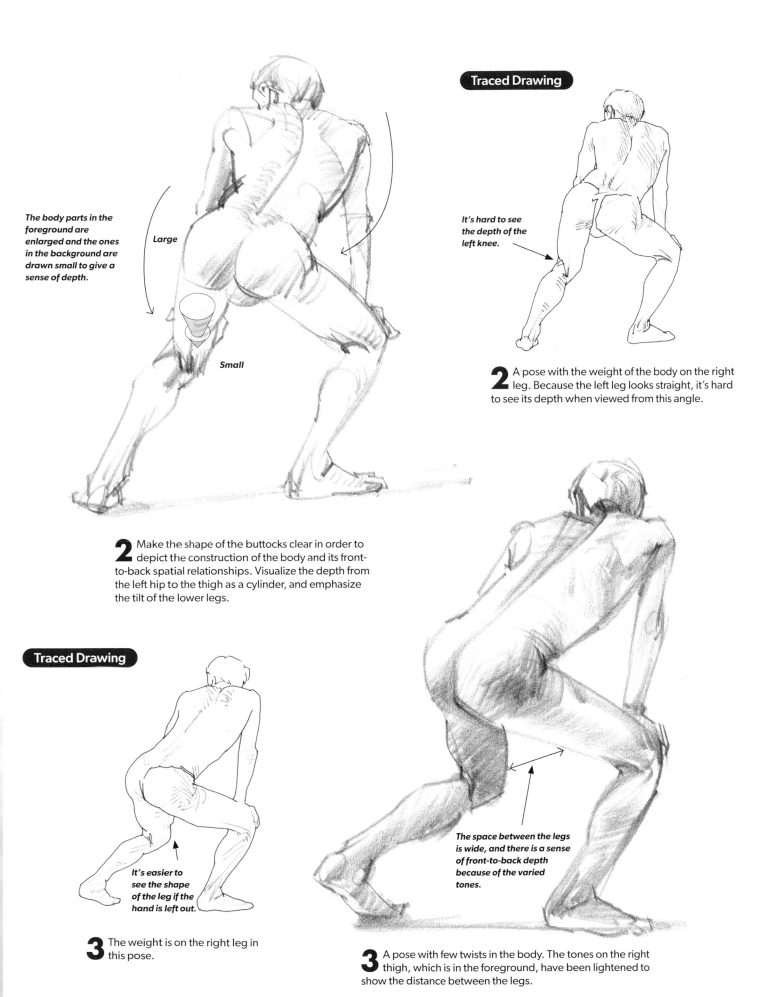

The body parts in the foreground are enlarged and the ones in the background are drawn small to give a sense of depth.

Large

Small

Traced Drawing

It's hard to see the depth of the left knee.

2 A pose with the weight of the body on the right leg. Because the left leg looks straight, it's hard to see its depth when viewed from this angle.

2 Make the shape of the buttocks clear in order to depict the construction of the body and its front-to-back spatial relationships. Visualize the depth from the left hip to the thigh as a cylinder, and emphasize the tilt of the lower legs.

Traced Drawing

It's easier to see the shape of the leg if the hand is left out.

3 The weight is on the right leg in this pose.

The space between the legs is wide, and there is a sense of front-to-back depth because of the varied tones.

3 A pose with few twists in the body. The tones on the right thigh, which is in the foreground, have been lightened to show the distance between the legs.

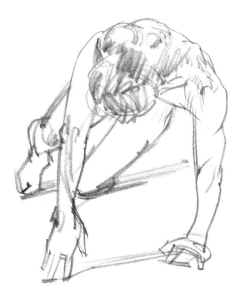

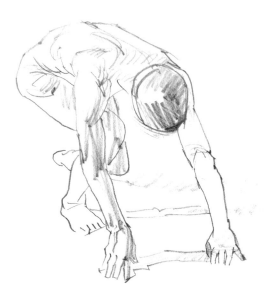

5 The tension of the weight-bearing left arm is visible, but the shape of the head is not clear. We'll better define the front-to-back spatial relationships in the drawing below.

6 In this example, tones are added to the traced lines, to clarify the front-to-back spatial relationships.

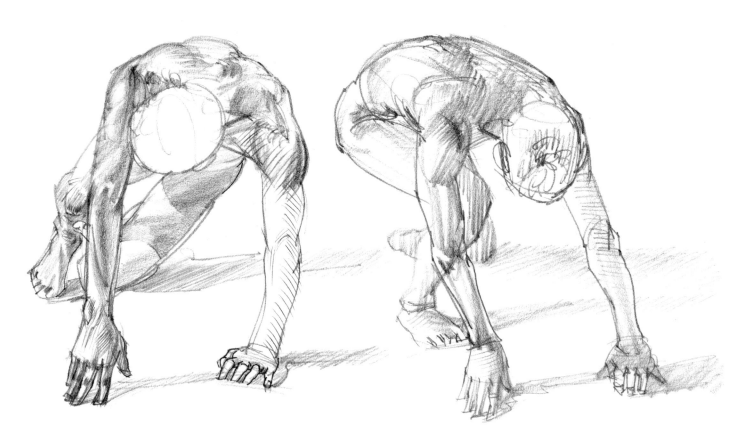

5 The shape of the head is simplified, and the construction of the body is rebuilt in this drawing. The straightened right arm and the weight-bearing left arm are differentiated. The foot is on the ground, as the figure starts to stand up.

6 The weight of the body is shifted to the right leg, and the figure has started to get up. The left leg is on its knee, and both hands are planted on the ground. The roundness of the back is emphasized, and the connection between it and the outstretched left arm is highlighted.

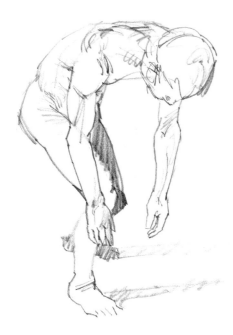

8 The arms are in the front, and the figure has essentially finished rising to a standing position.

7 The arms are limp, and the upper body is still bent over. The weight of the body is on the right leg in this pose.

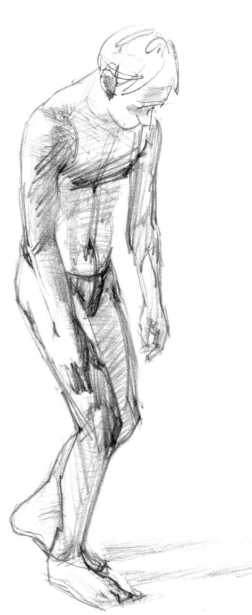

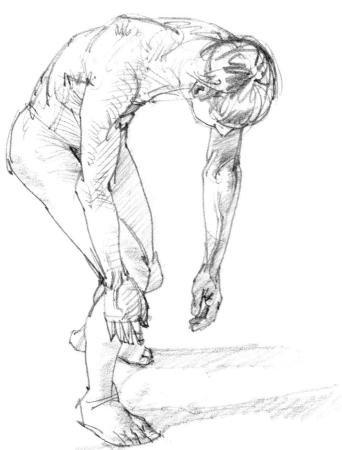

7 The hands leave the ground as the figure stands up. The veins visible on the slackened arms are drawn too. The hip part mostly hidden by the arm in the foreground is important when establishing the body's construction, so draw it carefully.

8 The figure is standing, although somewhat slumped. The knees and hips are bent in this relaxed pose.

Capturing Bent and Inclined Poses

Traced Drawing

Draw movements where the body is bent, arched or tilted to the side, diagonally or to the back. Forward-bending poses are seen a lot in everyday life, but because controlled bent or arched poses in other directions require great effort, they appear very dynamic.

Drawing a Kicking Pose

As an example of a kicking pose, here we capture a high kicking pose where the leg is raised up before kicking at a high level. The upper body arches back in order to raise the leg high (see page 50).

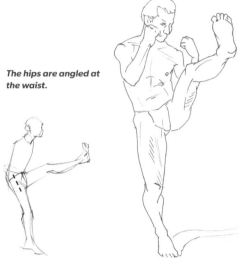

The hips are angled at the waist.

▲ A pose where the leg is kicked to the front. The weight-bearing right leg is bent slightly, and the hips are pushed forward as the left leg kicks out.

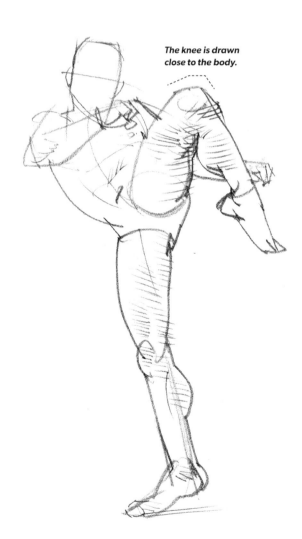

The knee is drawn close to the body.

1 In order to make the pose more dynamic, the movement is changed to one where the hips are moved to the side as the leg kicks around. The upper body is tilted back as the shoulders are raised.

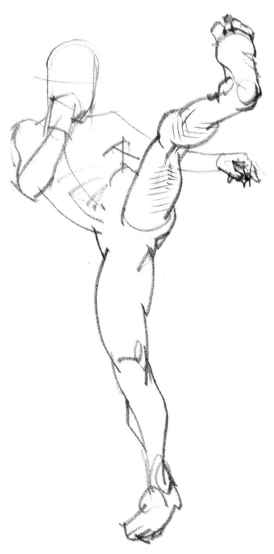

2 The knee of the left leg is straightened.

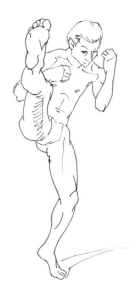

▲ The right leg is kicked out in this pose.

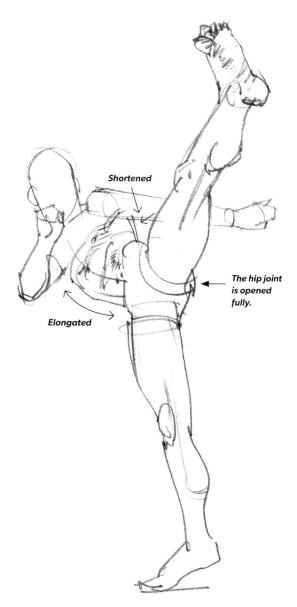

Shortened

Elongated

The hip joint is opened fully.

3 The upper body tilts back even more, to kick the leg up very high.

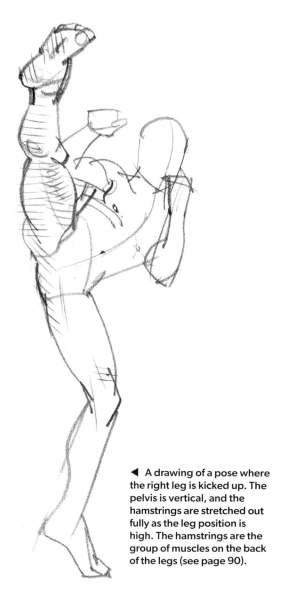

◀ A drawing of a pose where the right leg is kicked up. The pelvis is vertical, and the hamstrings are stretched out fully as the leg position is high. The hamstrings are the group of muscles on the back of the legs (see page 90).

Sideways-bending Poses

Use the Negative Spaces to Define the Outline of the Body!

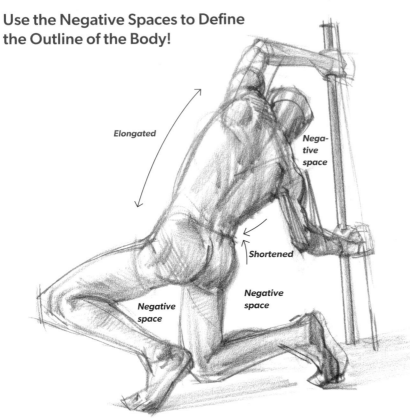

Elongated

Negative space

Shortened

Negative space

Negative space

1 It's a good idea to capture the shapes and sizes of the background (the negative spaces) to nail down the shape of the figure while you draw the pose. In this first sketch, the knees were rather chunky.

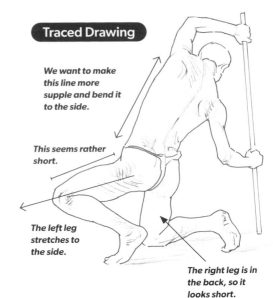

We want to make this line more supple and bend it to the side.

This seems rather short.

The left leg stretches to the side.

The right leg is in the back, so it looks short.

1 A pole is being struck to the ground, and the figure is bent to the side while it kneels in this pose.

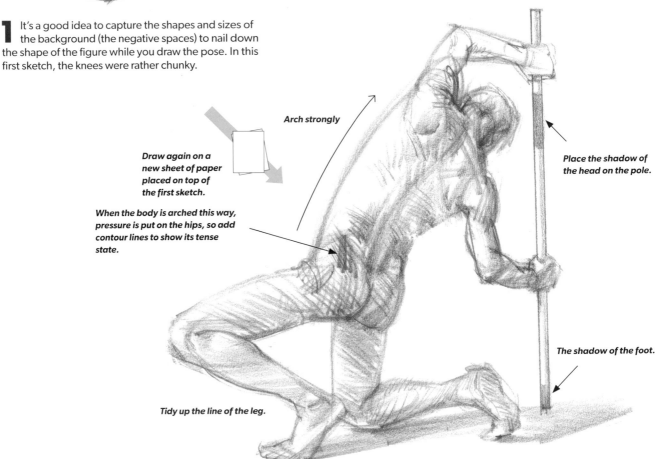

Arch strongly

Draw again on a new sheet of paper placed on top of the first sketch.

When the body is arched this way, pressure is put on the hips, so add contour lines to show its tense state.

Place the shadow of the head on the pole.

The shadow of the foot.

Tidy up the line of the leg.

1 The second drawing. The sides of the torso and the median line are more curved, to emphasize the arching movement of the upper body.

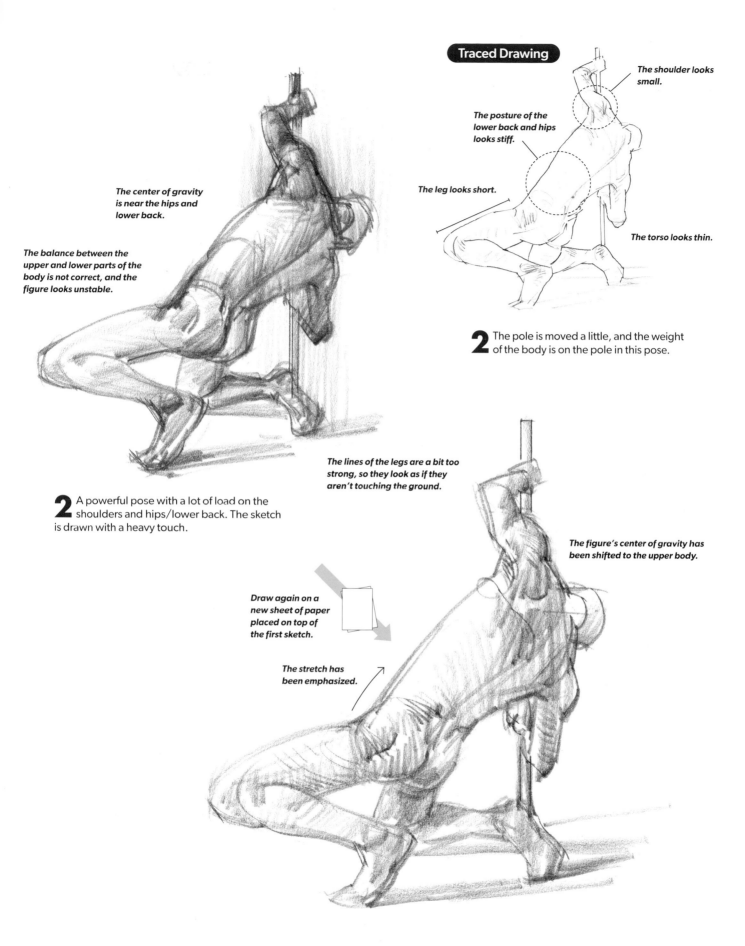

The center of gravity
is near the hips and
lower back.

The balance between the
upper and lower parts of the
body is not correct, and the
figure looks unstable.

2 A powerful pose with a lot of load on the
shoulders and hips/lower back. The sketch
is drawn with a heavy touch.

The shoulder looks
small.

The posture of the
lower back and hips
looks stiff.

The leg looks short.

The torso looks thin.

2 The pole is moved a little, and the weight
of the body is on the pole in this pose.

The lines of the legs are a bit too
strong, so they look as if they
aren't touching the ground.

Draw again on a
new sheet of paper
placed on top of
the first sketch.

The stretch has
been emphasized.

The figure's center of gravity has
been shifted to the upper body.

2 The second drawing. In this example, the pose has
been adjusted so the upper body is supporting the
lower body, to balance them out.

Back-arching Poses

Draw some poses that bend or arch the back. The strongly arched poses are drawn from the front.

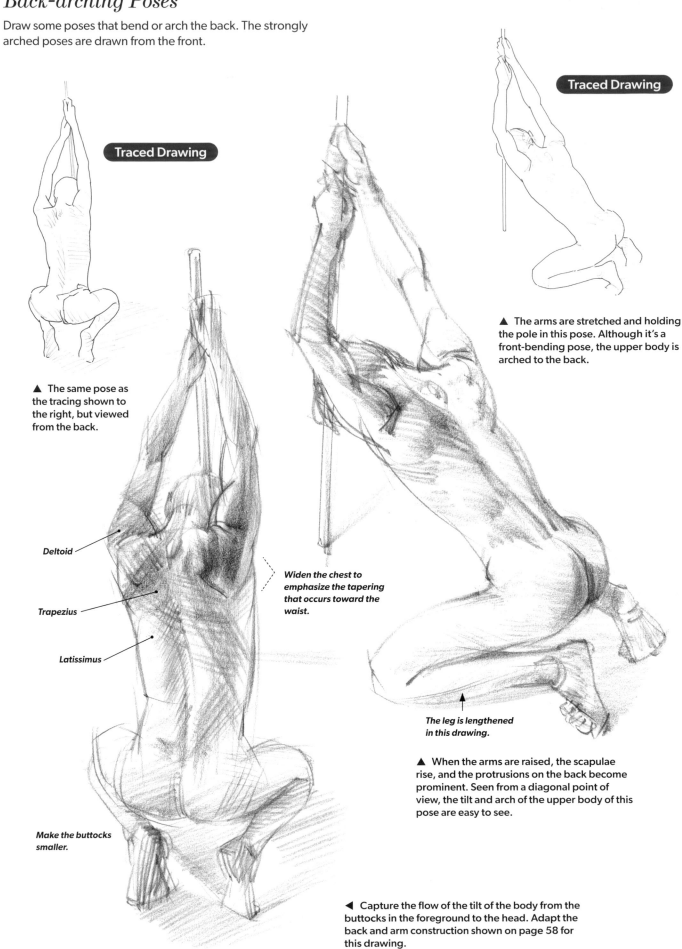

Traced Drawing

Traced Drawing

▲ The same pose as the tracing shown to the right, but viewed from the back.

Deltoid

Trapezius

Latissimus

Widen the chest to emphasize the tapering that occurs toward the waist.

Make the buttocks smaller.

▲ The arms are stretched and holding the pole in this pose. Although it's a front-bending pose, the upper body is arched to the back.

The leg is lengthened in this drawing.

▲ When the arms are raised, the scapulae rise, and the protrusions on the back become prominent. Seen from a diagonal point of view, the tilt and arch of the upper body of this pose are easy to see.

◀ Capture the flow of the tilt of the body from the buttocks in the foreground to the head. Adapt the back and arm construction shown on page 58 for this drawing.

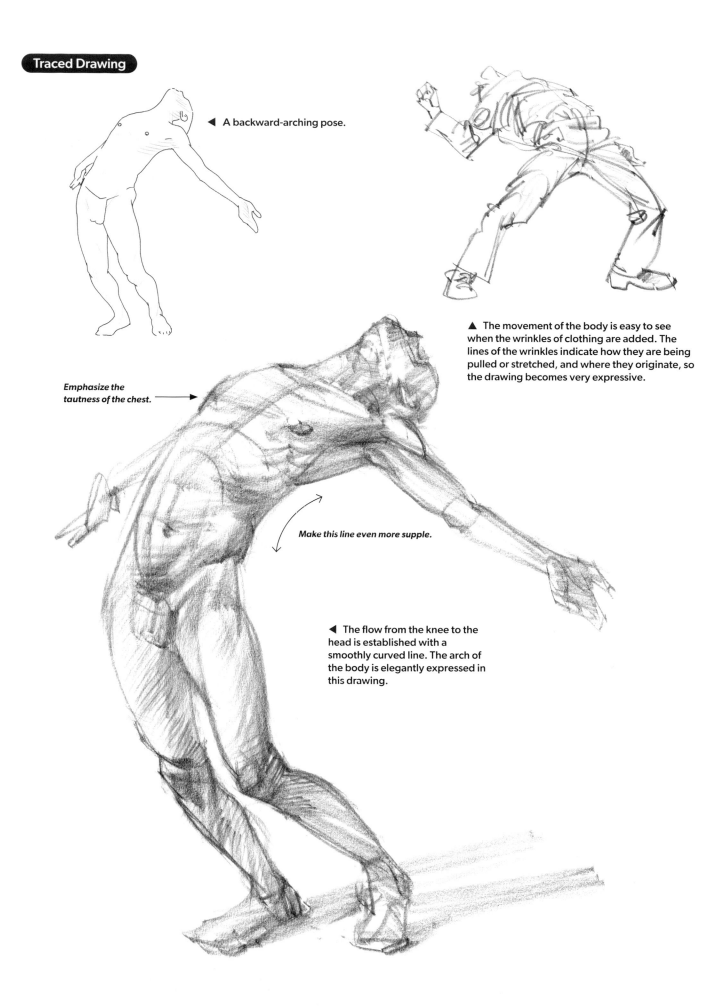

◀ A backward-arching pose.

▲ The movement of the body is easy to see when the wrinkles of clothing are added. The lines of the wrinkles indicate how they are being pulled or stretched, and where they originate, so the drawing becomes very expressive.

Emphasize the tautness of the chest.

Make this line even more supple.

◀ The flow from the knee to the head is established with a smoothly curved line. The arch of the body is elegantly expressed in this drawing.

Side-bending and Back-bending Poses

Draw the posture of the figure on one knee as the upper body bends to the side or arches back.

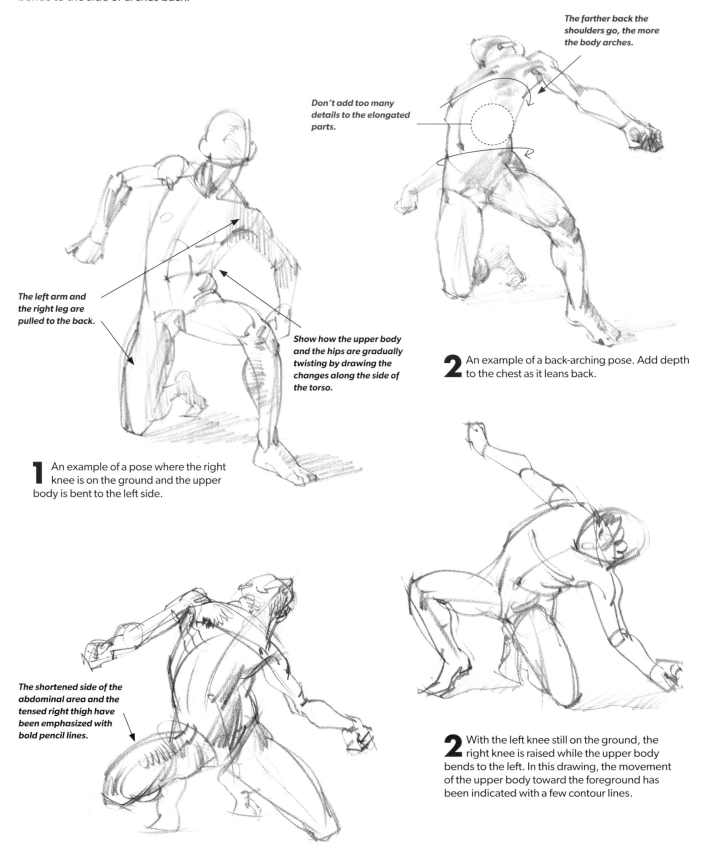

The farther back the shoulders go, the more the body arches.

Don't add too many details to the elongated parts.

The left arm and the right leg are pulled to the back.

Show how the upper body and the hips are gradually twisting by drawing the changes along the side of the torso.

1 An example of a pose where the right knee is on the ground and the upper body is bent to the left side.

2 An example of a back-arching pose. Add depth to the chest as it leans back.

The shortened side of the abdominal area and the tensed right thigh have been emphasized with bold pencil lines.

1 The left knee is on the ground, the right leg is deeply bent, and the upper body is arched to the back left in this pose. In this drawing, the depth of the pose from the chest on up has been indicated with shading.

2 With the left knee still on the ground, the right knee is raised while the upper body bends to the left. In this drawing, the movement of the upper body toward the foreground has been indicated with a few contour lines.

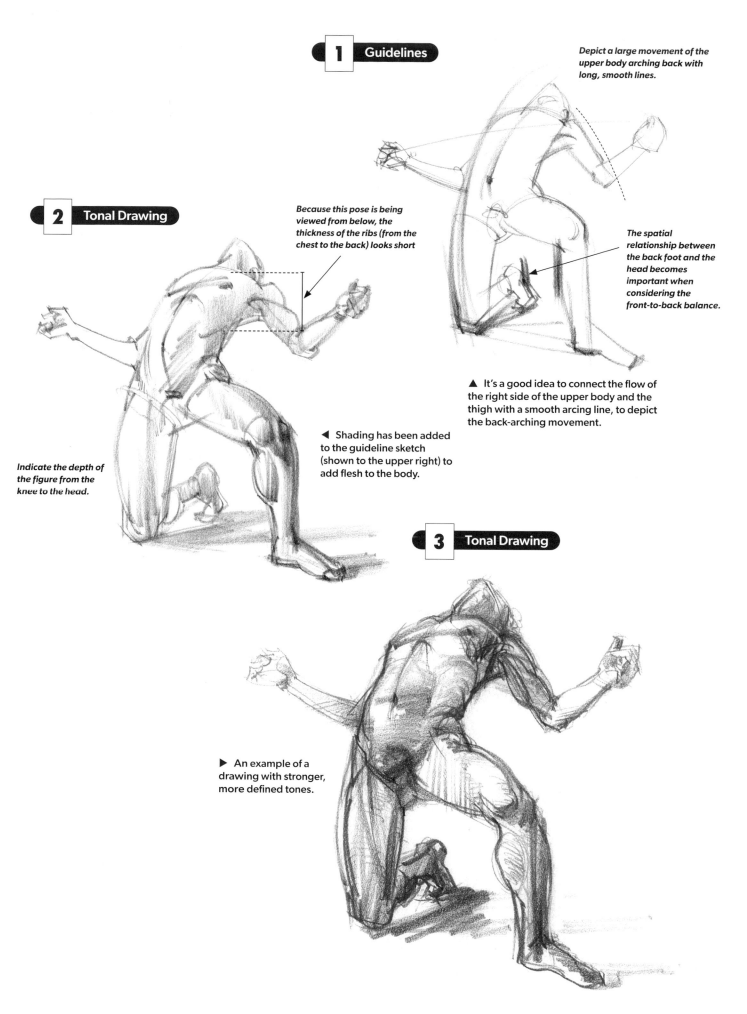

1 Guidelines

Depict a large movement of the upper body arching back with long, smooth lines.

The spatial relationship between the back foot and the head becomes important when considering the front-to-back balance.

▲ It's a good idea to connect the flow of the right side of the upper body and the thigh with a smooth arcing line, to depict the back-arching movement.

2 Tonal Drawing

Because this pose is being viewed from below, the thickness of the ribs (from the chest to the back) looks short

◀ Shading has been added to the guideline sketch (shown to the upper right) to add flesh to the body.

Indicate the depth of the figure from the knee to the head.

3 Tonal Drawing

▶ An example of a drawing with stronger, more defined tones.

Capturing Movements of Pushing Poses

Draw of the action of lifting objects to support them, or pushing against a wall or a post.

Drawing a Figure Holding Up an Object

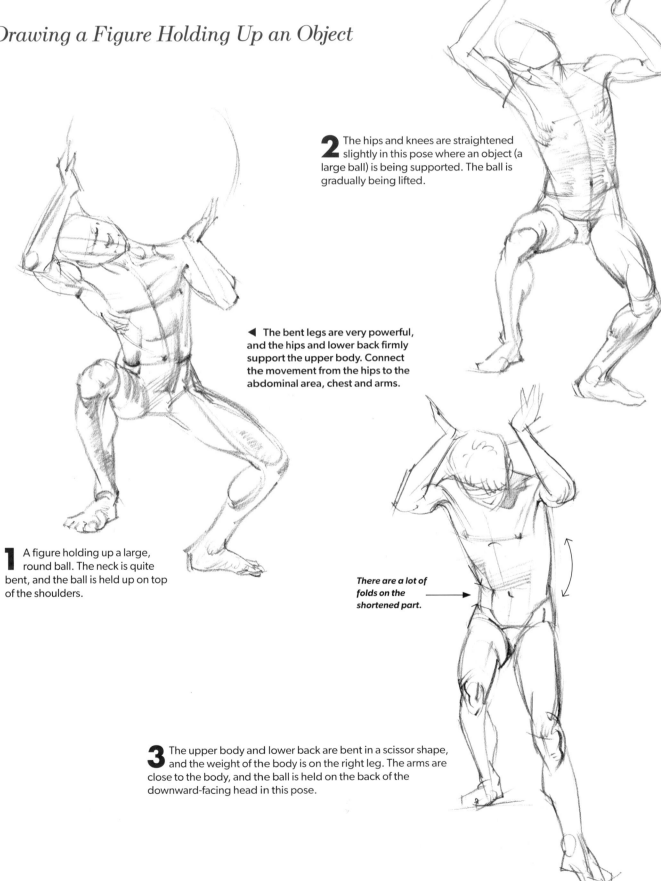

2 The hips and knees are straightened slightly in this pose where an object (a large ball) is being supported. The ball is gradually being lifted.

◀ The bent legs are very powerful, and the hips and lower back firmly support the upper body. Connect the movement from the hips to the abdominal area, chest and arms.

1 A figure holding up a large, round ball. The neck is quite bent, and the ball is held up on top of the shoulders.

There are a lot of folds on the shortened part.

3 The upper body and lower back are bent in a scissor shape, and the weight of the body is on the right leg. The arms are close to the body, and the ball is held on the back of the downward-facing head in this pose.

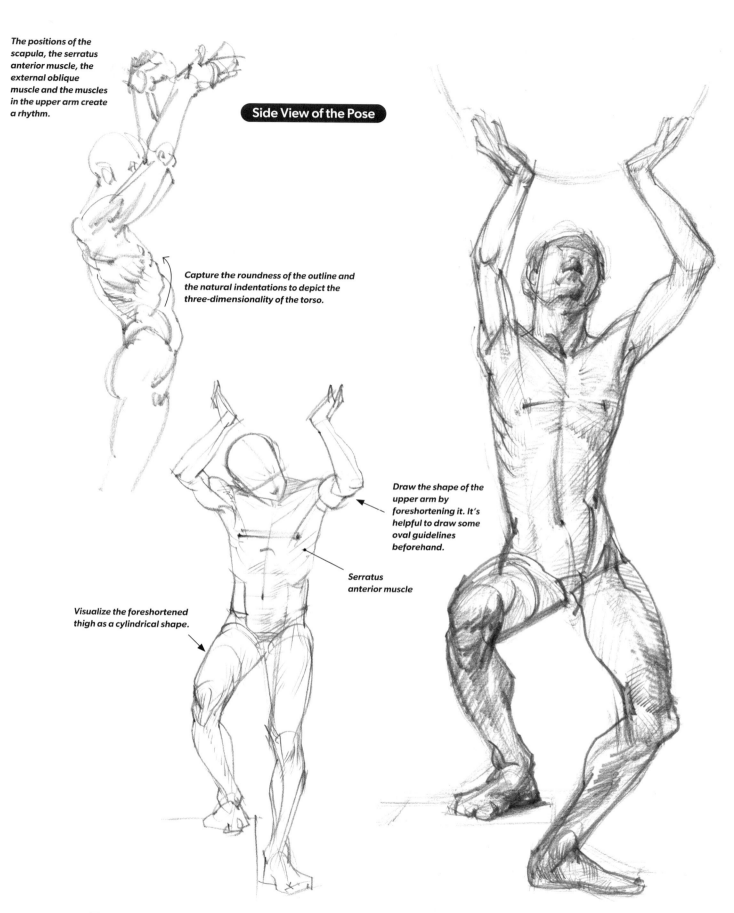

The positions of the scapula, the serratus anterior muscle, the external oblique muscle and the muscles in the upper arm create a rhythm.

Side View of the Pose

Capture the roundness of the outline and the natural indentations to depict the three-dimensionality of the torso.

Draw the shape of the upper arm by foreshortening it. It's helpful to draw some oval guidelines beforehand.

Serratus anterior muscle

Visualize the foreshortened thigh as a cylindrical shape.

4 The upper body is stretched and the underarm areas can be seen in this pose. The elbows are higher than the shoulders, and the chest area is pulled up too, so the serratus anterior muscle stands out.

5 The ball is held up high in this pose. Shading has been added to the drawing. The weight-bearing right leg is bent with the knee coming out to the foreground to give this pose a powerful appearance.

Pressing on an Object

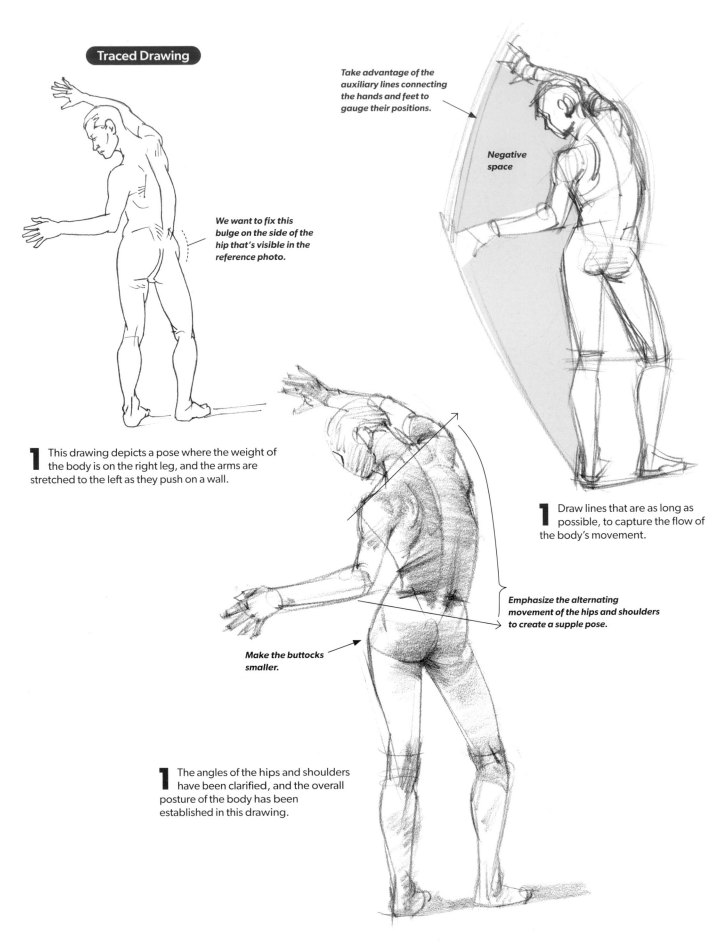

Traced Drawing

We want to fix this bulge on the side of the hip that's visible in the reference photo.

Take advantage of the auxiliary lines connecting the hands and feet to gauge their positions.

Negative space

1 This drawing depicts a pose where the weight of the body is on the right leg, and the arms are stretched to the left as they push on a wall.

1 Draw lines that are as long as possible, to capture the flow of the body's movement.

Emphasize the alternating movement of the hips and shoulders to create a supple pose.

Make the buttocks smaller.

1 The angles of the hips and shoulders have been clarified, and the overall posture of the body has been established in this drawing.

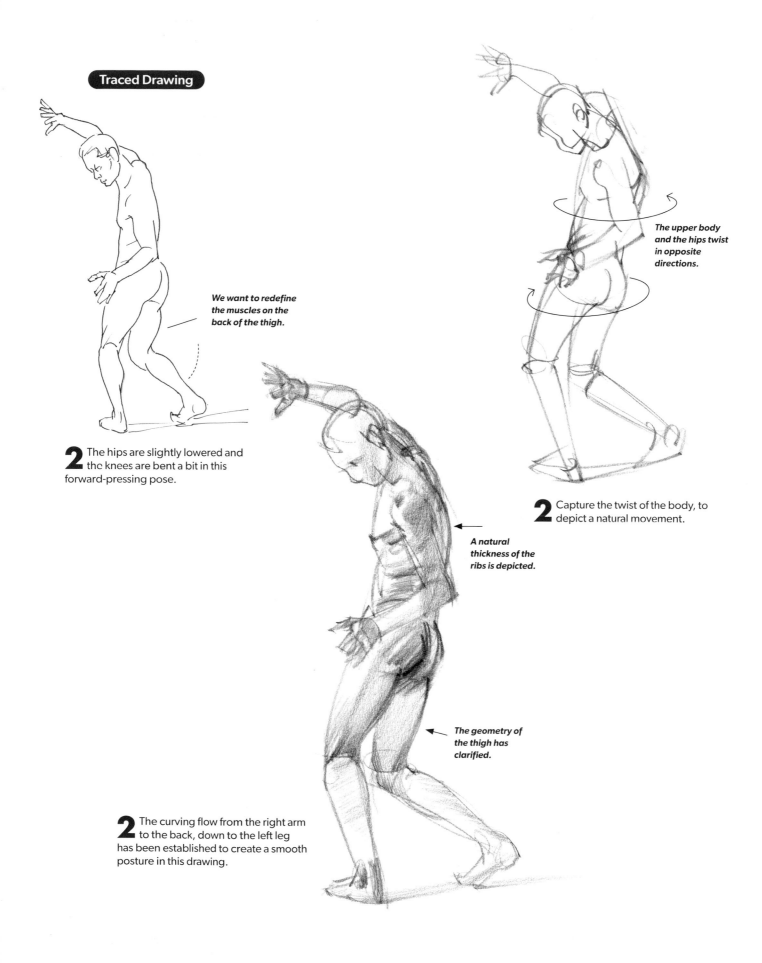

Traced Drawing

We want to redefine the muscles on the back of the thigh.

2 The hips are slightly lowered and the knees are bent a bit in this forward-pressing pose.

The upper body and the hips twist in opposite directions.

2 Capture the twist of the body, to depict a natural movement.

A natural thickness of the ribs is depicted.

The geometry of the thigh has clarified.

2 The curving flow from the right arm to the back, down to the left leg has been established to create a smooth posture in this drawing.

Capturing Free-dancing Movements

Draw some poses where the body is moving around as if it's dancing. The "mid-squat" pose where the hips are partly lowered is difficult to maintain unless the body has strong muscles. Adapt the various poses you have drawn so far, to capture the supple movements that are created when the arms and legs are moved with grace.

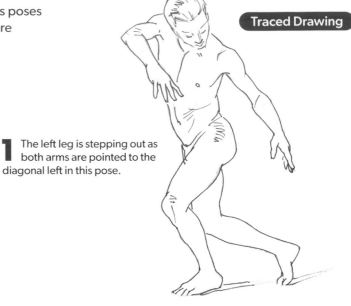

Traced Drawing

1 The left leg is stepping out as both arms are pointed to the diagonal left in this pose.

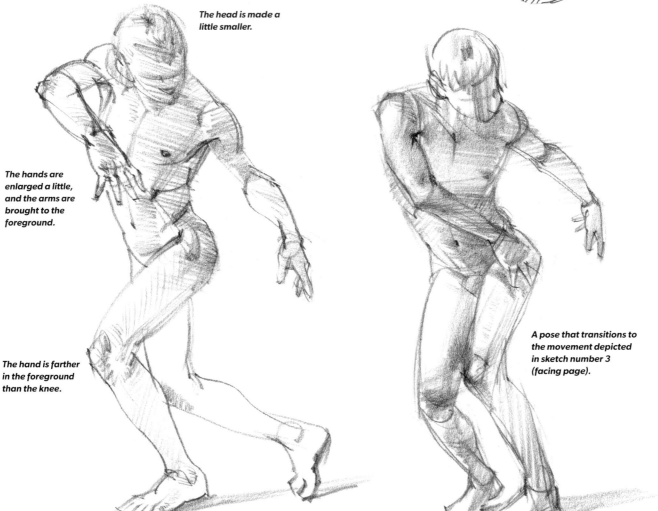

The head is made a little smaller.

The hands are enlarged a little, and the arms are brought to the foreground.

The hand is farther in the foreground than the knee.

A pose that transitions to the movement depicted in sketch number 3 (facing page).

1 Think of the front-to-back spatial relationship between the arms and legs, and capture the twist of the chest and hips.

2 This pose doesn't exist as a reference photo, but it's a drawing of a pose that is imagined to fit approximately between poses 1 and 3.

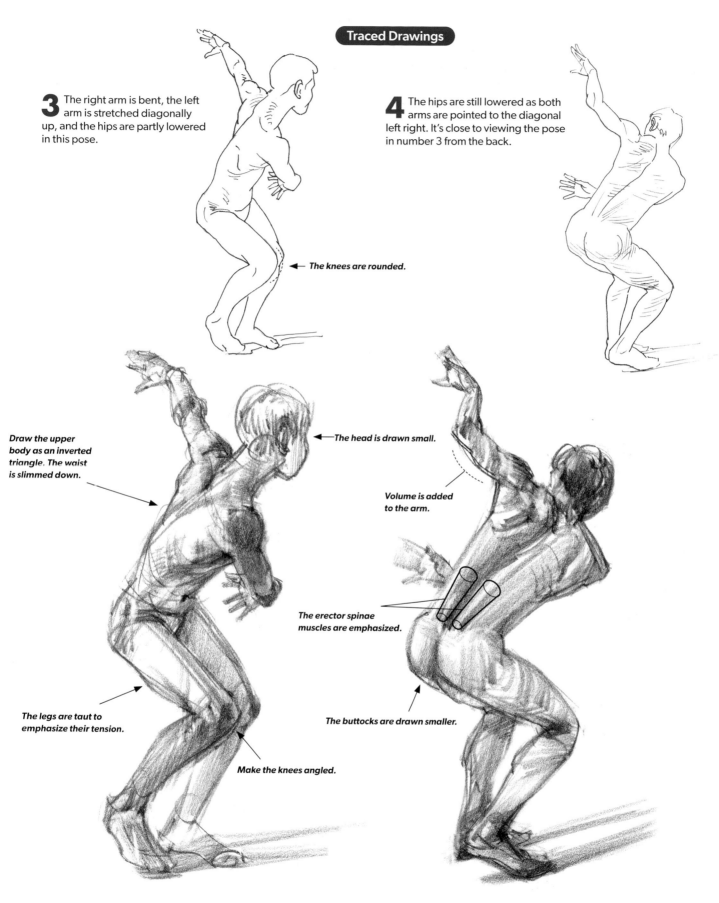

3 The right arm is bent, the left arm is stretched diagonally up, and the hips are partly lowered in this pose.

← *The knees are rounded.*

4 The hips are still lowered as both arms are pointed to the diagonal left right. It's close to viewing the pose in number 3 from the back.

Draw the upper body as an inverted triangle. The waist is slimmed down.

← *The head is drawn small.*

Volume is added to the arm.

The erector spinae muscles are emphasized.

The legs are taut to emphasize their tension.

The buttocks are drawn smaller.

Make the knees angled.

3 The shape of the back is depicted and the waist is slimmed down, in order to make the twisting movement of the body more obvious.

4 A tensed, mid-squat pose. From here the hips and lower back will be gradually lowered.

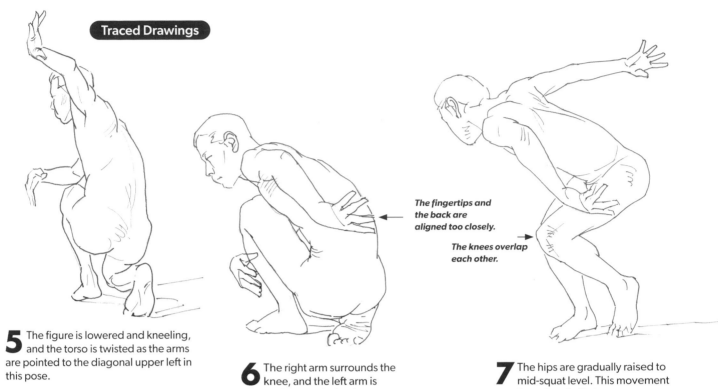

The fingertips and the back are aligned too closely.

The knees overlap each other.

5 The figure is lowered and kneeling, and the torso is twisted as the arms are pointed to the diagonal upper left in this pose.

6 The right arm surrounds the knee, and the left arm is swung down to the back.

7 The hips are gradually raised to mid-squat level. This movement requires a lot of effort.

Bulk up the arm a bit.

Emphasize the shoulders a bit, and tie them in to the shape of the back.

Make the chest thick.

Thicken the arm.

Make the hand come out farther than the outline of the back, to make the front-to-back spatial relationship clear.

The buttocks are reduced.

The thigh has been slimmed down.

Make the foot in the foreground big!

5 In the example above, the flow from the left arm to the shape of the back has been clarified, and tones have been added to the shaded side.

6 This pose, where the hips are fully lowered and the body is hunched down, is a preparatory movement for springing upward.

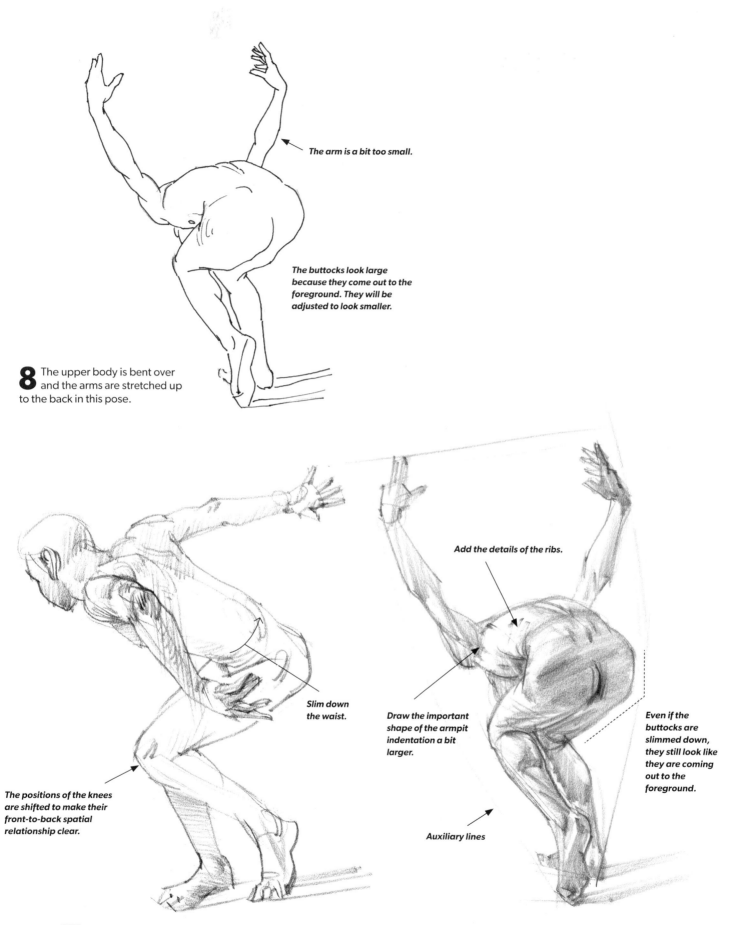

The arm is a bit too small.

The buttocks look large because they come out to the foreground. They will be adjusted to look smaller.

8 The upper body is bent over and the arms are stretched up to the back in this pose.

Slim down the waist.

The positions of the knees are shifted to make their front-to-back spatial relationship clear.

Add the details of the ribs.

Draw the important shape of the armpit indentation a bit larger.

Even if the buttocks are slimmed down, they still look like they are coming out to the foreground.

Auxiliary lines

7 The head in the background is made small, and the elbow in the foreground is made large to create a sense of depth.

8 When drawing a physically challenging pose (one you don't see in everyday situations), it's useful to draw auxiliary guidelines to establish the shapes and positions.

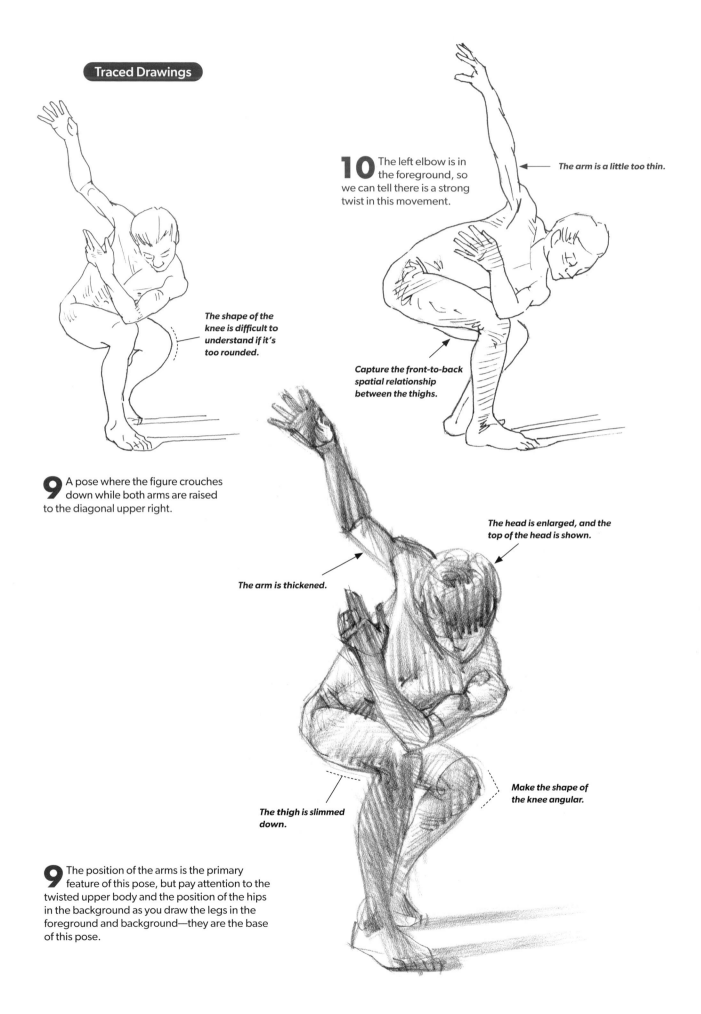

10 The left elbow is in the foreground, so we can tell there is a strong twist in this movement.

The arm is a little too thin.

Capture the front-to-back spatial relationship between the thighs.

The shape of the knee is difficult to understand if it's too rounded.

9 A pose where the figure crouches down while both arms are raised to the diagonal upper right.

The head is enlarged, and the top of the head is shown.

The arm is thickened.

Make the shape of the knee angular.

The thigh is slimmed down.

9 The position of the arms is the primary feature of this pose, but pay attention to the twisted upper body and the position of the hips in the background as you draw the legs in the foreground and background—they are the base of this pose.

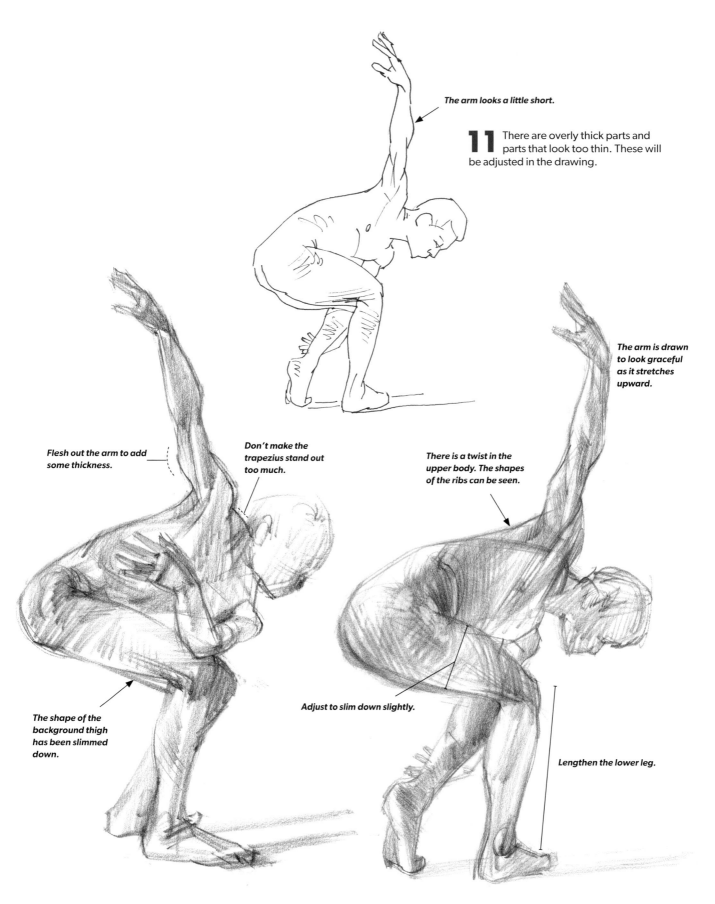

The arm looks a little short.

11 There are overly thick parts and parts that look too thin. These will be adjusted in the drawing.

The arm is drawn to look graceful as it stretches upward.

Flesh out the arm to add some thickness.

Don't make the trapezius stand out too much.

There is a twist in the upper body. The shapes of the ribs can be seen.

The shape of the background thigh has been slimmed down.

Adjust to slim down slightly.

Lengthen the lower leg.

10 The figure changes direction as it remains in a crouching pose in this drawing.

11 A tensed shape with one arm raised up. The right arm and left leg create an arc in this beautiful pose.

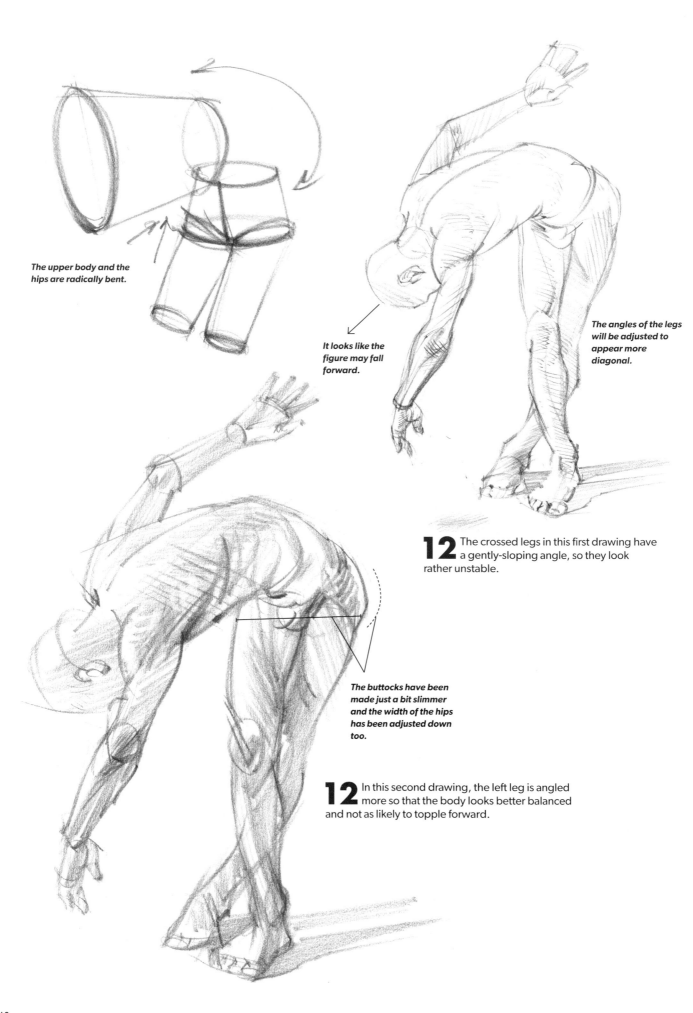

The upper body and the hips are radically bent.

It looks like the figure may fall forward.

The angles of the legs will be adjusted to appear more diagonal.

12 The crossed legs in this first drawing have a gently-sloping angle, so they look rather unstable.

The buttocks have been made just a bit slimmer and the width of the hips has been adjusted down too.

12 In this second drawing, the left leg is angled more so that the body looks better balanced and not as likely to topple forward.

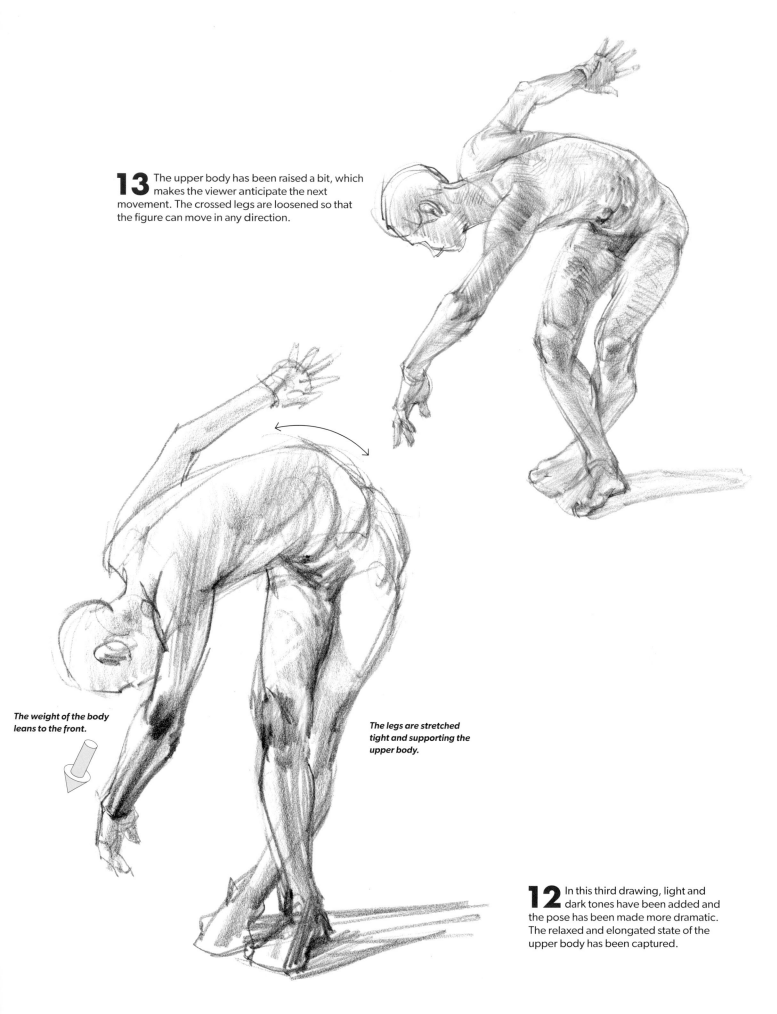

13 The upper body has been raised a bit, which makes the viewer anticipate the next movement. The crossed legs are loosened so that the figure can move in any direction.

The weight of the body leans to the front.

The legs are stretched tight and supporting the upper body.

12 In this third drawing, light and dark tones have been added and the pose has been made more dramatic. The relaxed and elongated state of the upper body has been captured.

Representing Motion-generated Wrinkles on Clothing

For this section, dancer Taketeru Kudo agreed to be my reference model. Mr. Kudo is an expressive interpretive dancer. In order to compare my drawings to the original photos, I have shown several traced drawings.

Although I have featured many poses that illustrate the basic movements and range of motion of the human body, from page 162 onward the drawings are all of Mr. Kudo posing freely. And from this page forward, I feature clothed poses. When you draw the wrinkles and folds of the clothes that are formed by the pose, it becomes easier to understand the direction the body is moving, as well as the shape of the body within the clothes.

To see the unique quality of the movements of this dancer on stage, refer to the photos and videos of Mr. Kudo on his web site: kudo-taketeru.com. The site also has information about his performances and workshops, so if you visit Japan you can personally experience how a professional dancer uses his body with skill!

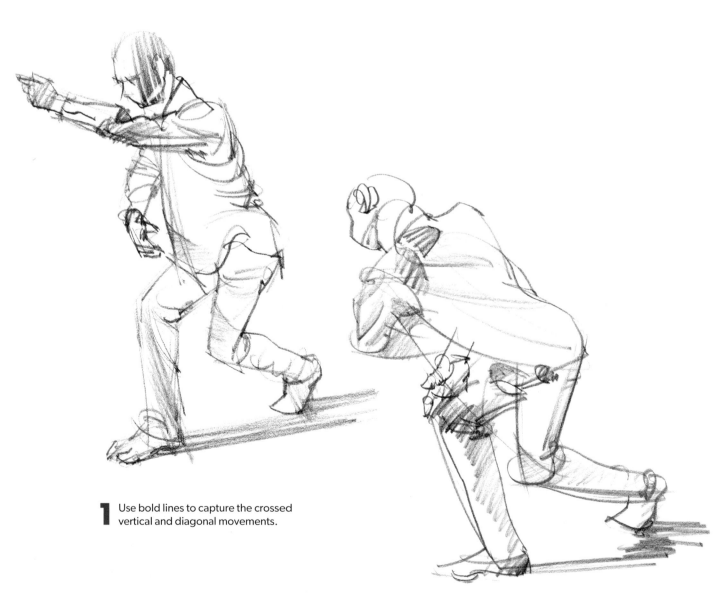

1 Use bold lines to capture the crossed vertical and diagonal movements.

2 The parts of the body that are actually hidden by the clothes are depicted as though the they can be seen through the clothes.

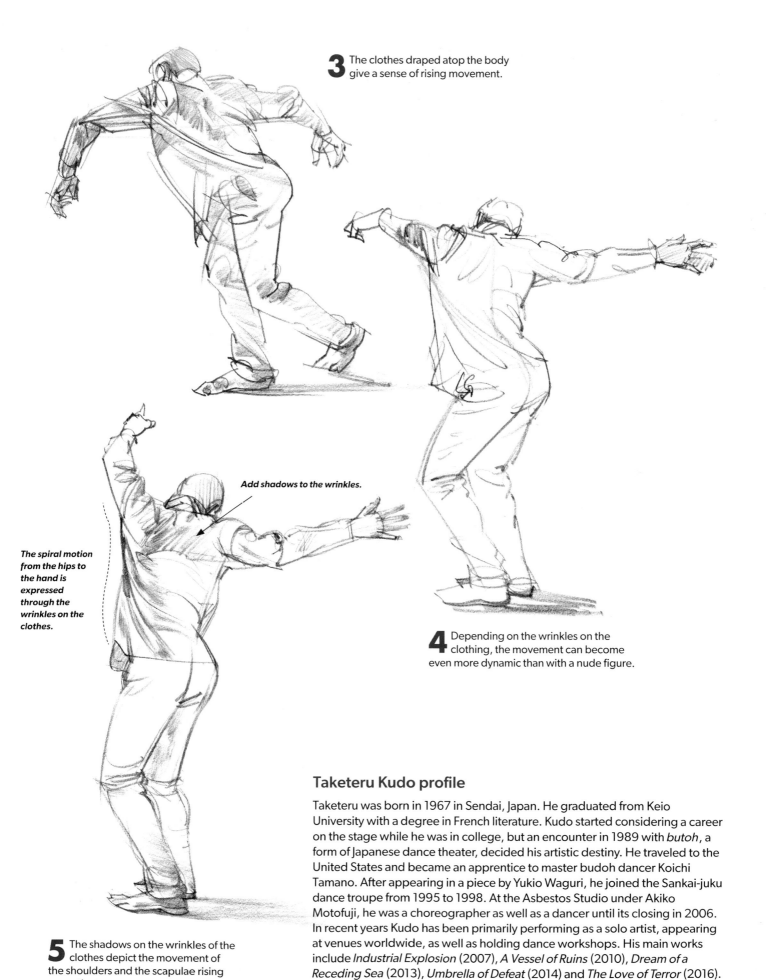

3 The clothes draped atop the body give a sense of rising movement.

The spiral motion from the hips to the hand is expressed through the wrinkles on the clothes.

Add shadows to the wrinkles.

4 Depending on the wrinkles on the clothing, the movement can become even more dynamic than with a nude figure.

5 The shadows on the wrinkles of the clothes depict the movement of the shoulders and the scapulae rising up on the torso.

Taketeru Kudo profile

Taketeru was born in 1967 in Sendai, Japan. He graduated from Keio University with a degree in French literature. Kudo started considering a career on the stage while he was in college, but an encounter in 1989 with *butoh*, a form of Japanese dance theater, decided his artistic destiny. He traveled to the United States and became an apprentice to master budoh dancer Koichi Tamano. After appearing in a piece by Yukio Waguri, he joined the Sankai-juku dance troupe from 1995 to 1998. At the Asbestos Studio under Akiko Motofuji, he was a choreographer as well as a dancer until its closing in 2006. In recent years Kudo has been primarily performing as a solo artist, appearing at venues worldwide, as well as holding dance workshops. His main works include *Industrial Explosion* (2007), *A Vessel of Ruins* (2010), *Dream of a Receding Sea* (2013), *Umbrella of Defeat* (2014) and *The Love of Terror* (2016).

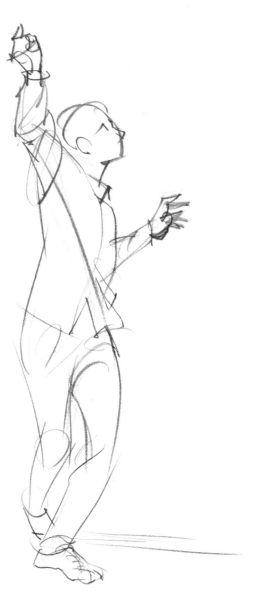

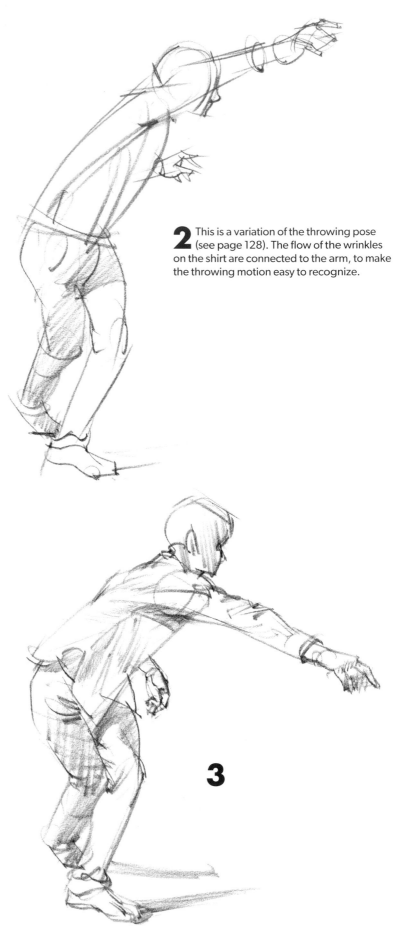

2 This is a variation of the throwing pose (see page 128). The flow of the wrinkles on the shirt are connected to the arm, to make the throwing motion easy to recognize.

1 Use a long curving line to connect the right arm to the left leg, to express the flow of the movement.

3

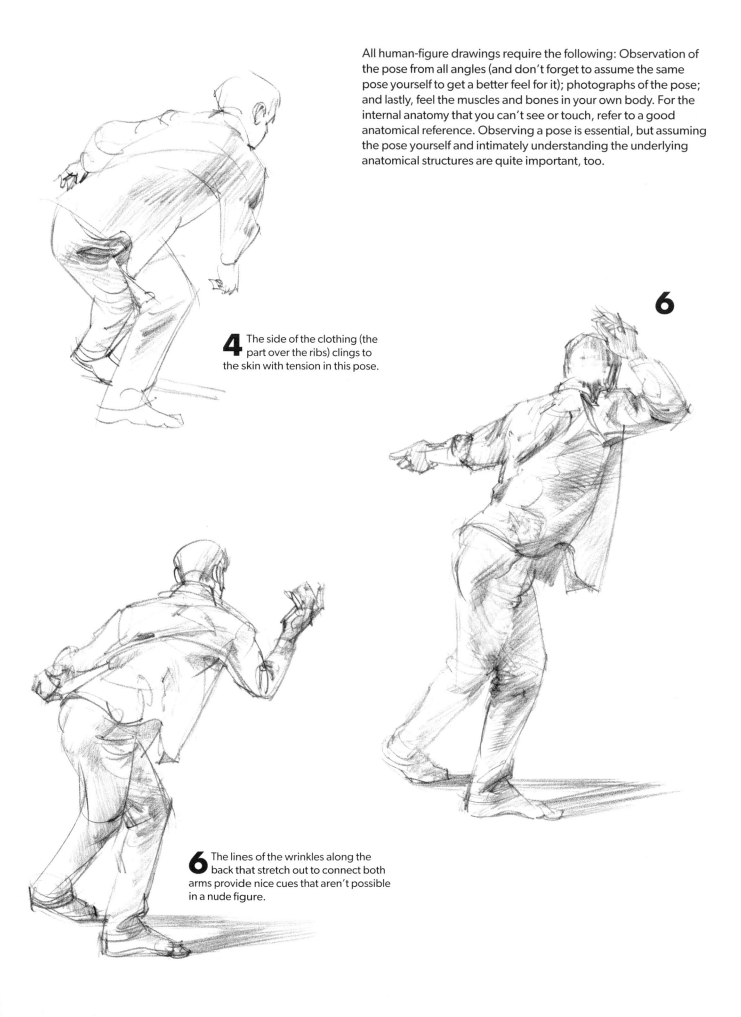

All human-figure drawings require the following: Observation of the pose from all angles (and don't forget to assume the same pose yourself to get a better feel for it); photographs of the pose; and lastly, feel the muscles and bones in your own body. For the internal anatomy that you can't see or touch, refer to a good anatomical reference. Observing a pose is essential, but assuming the pose yourself and intimately understanding the underlying anatomical structures are quite important, too.

6

4 The side of the clothing (the part over the ribs) clings to the skin with tension in this pose.

6 The lines of the wrinkles along the back that stretch out to connect both arms provide nice cues that aren't possible in a nude figure.

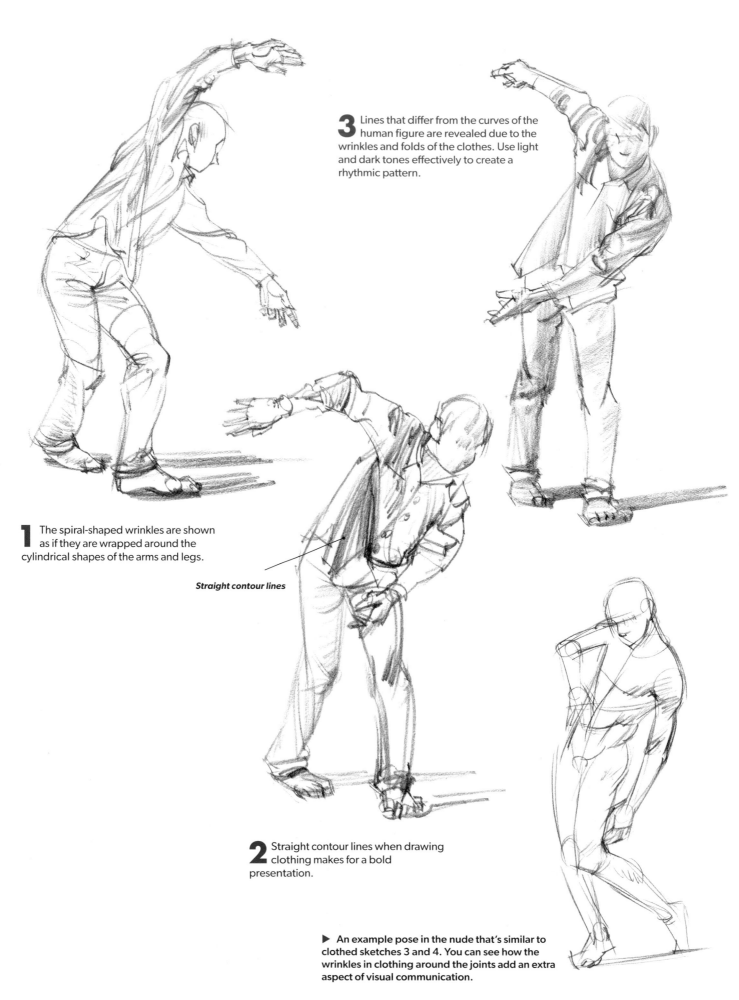

3 Lines that differ from the curves of the human figure are revealed due to the wrinkles and folds of the clothes. Use light and dark tones effectively to create a rhythmic pattern.

1 The spiral-shaped wrinkles are shown as if they are wrapped around the cylindrical shapes of the arms and legs.

Straight contour lines

2 Straight contour lines when drawing clothing makes for a bold presentation.

▶ An example pose in the nude that's similar to clothed sketches 3 and 4. You can see how the wrinkles in clothing around the joints add an extra aspect of visual communication.

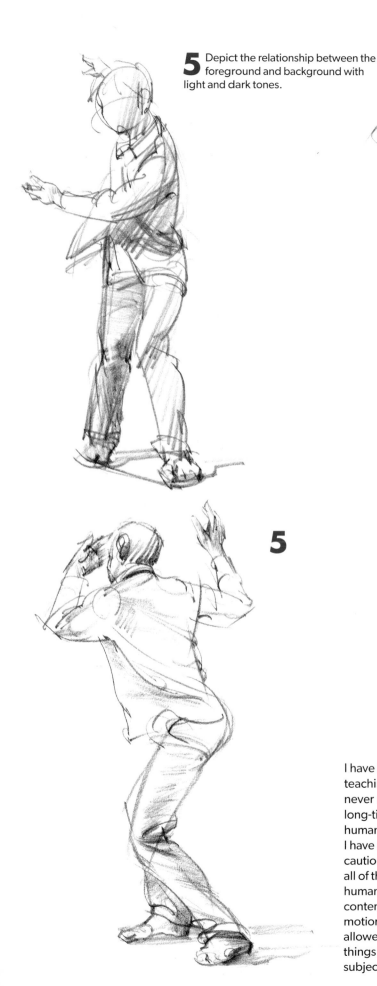

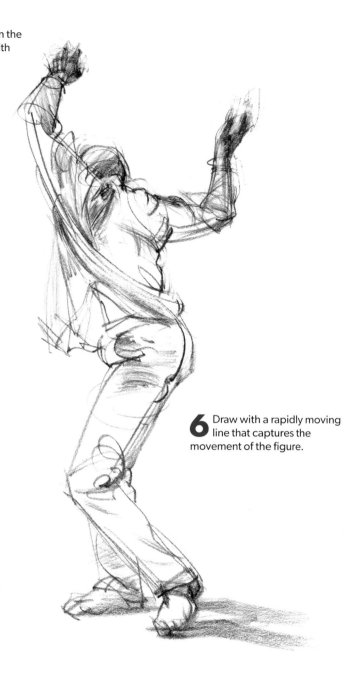

5 Depict the relationship between the foreground and background with light and dark tones.

6 Draw with a rapidly moving line that captures the movement of the figure.

5

I have been drawing the human figure for 30 years. When I was teaching life drawing, I was able to make many new discoveries that I never noticed when I was working on my art alone. And, thanks to my long-time study of Aikido, I have gained a great understanding of the human bone and muscle structure from observing its various postures. I have also been able to listen to a Judo practitioner who's related some cautionary tales about incorrect posture and injury recovery. I believe all of these things have helped me to better understand and draw the human figure. I have also been observing the expressions of contemporary dance; its movements, which extend the range of motion of the joints and exaggerate everyday movements, have allowed me to appreciate the beauty of the human figure. All these things have come together to inspire me and keep me supplied with subject matter for these exercises. Keep drawing!

Books to Span the East and West

Our core mission at Tuttle Publishing is to create books which bring people together one page at a time. Tuttle was founded in 1832 in the small New England town of Rutland, Vermont (USA). Our fundamental values remain as strong today as they were then—to publish best-in-class books informing the English-speaking world about the countries and peoples of Asia. The world is a smaller place today and Asia's economic, cultural and political influence has expanded, yet the need for meaningful dialogue and information about this diverse region has never been greater. Since 1948, Tuttle has been a leader in publishing books on the cultures, arts, cuisines, languages and literatures of Asia. Our authors and photographers have won many awards and Tuttle has published thousands of titles on subjects ranging from martial arts to paper crafts. We welcome you to explore the wealth of information available on Asia at **www.tuttlepublishing.com**.

Published by Tuttle Publishing, an imprint of Periplus Editions (HK) Ltd.

www.tuttlepublishing.com

JINBUTSU WO TEBAYAKU EGAKU KIHON DANSEIHEN
Copyright © 2018 Koichi Hagawa, Tsubura Kadomaru/HOBBY JAPAN
All rights reserved
English translation rights arranged with Hobby Japan Co., Ltd. through Japan Uni Agency, Inc., Tokyo

English Translation © 2020 by Periplus Editions (HK) Ltd.
Translated from Japanese by Makiko Itoh

ISBN 978-4-8053-1602-3

Staff (Original Japanese edition)
Author Koichi Hagawa
Editor Tsubura Kadomaru
Planning Yasuhiro Yamura (Hobby Japan)
Overall structure and rough layout Midori Hisamatsu (Hobby Japan)
Design and desktop publishing Masayasu Hirota
Reference photo model Taketeru Kudo
Model photographs Katsuyuki Kihara (Studio EN),
 Kohei Kasahara

Distributed by

North America, Latin America & Europe

Tuttle Publishing
364 Innovation Drive
North Clarendon, VT 05759-9436 U.S.A.
Tel: (802) 773-8930
Fax: (802) 773-6993
info@tuttlepublishing.com
www.tuttlepublishing.com

Japan
Tuttle Publishing
Yaekari Building 3rd Floor
5-4-12 Osaki
Shinagawa-ku
Tokyo 141-0032
Tel: (81) 3 5437-0171
Fax: (81) 3 5437-0755
sales@tuttle.co.jp
www.tuttle.co.jp

Asia Pacific
Berkeley Books Pte. Ltd.
3 Kallang Sector #04-01
Singapore 349278
Tel: (65) 6741 2178
Fax: (65) 6741 2179
inquiries@periplus.com.sg
www.tuttlepublishing.com

25 24 23 22 21 10 9 8 7 6 5 4 3 2
Printed in Singapore 2012TP